Dreams, Doubt, and Dread

Dreams, Doubt, and Dread

The Spiritual in Film

EDITED BY

Zachary Settle and Taylor Worley

FOREWORD BY Robert K. Johnston
AFTERWORD BY Gregory Alan Thornbury

CASCADE *Books* · Eugene, Oregon

DREAMS, DOUBT, AND DREAD
The Spiritual in Film

Cascade Books
An Imprint of Wipf and Stock Publishers
199 W. 8th Ave., Suite 3
Eugene, OR 97401

www.wipfandstock.com

PAPERBACK ISBN: 978-1-4982-2308-9
HARDCOVER ISBN: 978-1-4982-2310-2
EBOOK ISBN: 978-1-4982-2309-6

Cataloging-in-Publication data:

Names: Settle, Zachary, editor. | Worley, Taylor, editor.

Title: Dreams, doubt, and dread : the spiritual in film / edited by Zachary Settle, Taylor Worley.

Description: Eugene, OR : Cascade Books, 2016 | Includes bibliographical references and index.

Identifiers: ISBN 9781498223089 (paperback) | ISBN 9781498223102 (hardcover) | ISBN 9781498223096 (electronic)

Subjects: LCSH: Motion pictures—Religious aspects.

Classification: LCC PN1995.5 D68 2016 (print) | LCC PN1995.5 (ebook)

Manufactured in the USA.

For Anna, who endured more movies with me than
she cares to remember . . .
—T.B.W.

For Meg, my partner in crime and life, with all my love. I am grateful for
your support and patience, which certainly made this project possible.
—Z.T.S.

Our bond is no little economy based on the exchange
of my love and work for yours, so much for so much
of an expendable fund. We don't know what its limits are—
that puts us in the dark. We are more together
than we know, how else could we keep on discovering
we are more together than we thought?
—Wendell Berry, "The Country of Marriage"

Table of Contents

Contributors

David Dark—*Contributor*
David Dark is the author of *The Sacredness of Questioning Everything* (2009), *Everyday Apocalypse: The Sacred Revealed in Radiohead, The Simpsons and Other Pop Culture Icons* (2002), and *The Gospel According to America: A Meditation on a God-blessed, Christ-haunted Idea* (2005). Following years of teaching high school English, Dark completed his PhD in Religion at Vanderbilt University. He currently serves as a faculty member in the College of Theology and Christian Ministry at Belmont University. Dr. Dark also wrote, "Bell Rings True: A Review of Rob Bell's *Love Wins*" in *The Other Journal* (Vol. 19, Fall 2011).

Crystal Downing—*Contributor*
With a PhD in English from the University of California, Santa Barbara, Crystal Downing has published on a wide variety of literary topics, from Shakespeare to the Brontes, and has won both national and international awards for her essays on film. Much of her recent scholarship focuses on the relationship between postmodernism and faith, an issue which informs her books *Writing Performances: The Stages of Dorthy L. Sayers* (2004) and *How Postmodernism Serves (my) Faith* (2006). Downing is Professor of English and Film Studies at Messiah College in Grantham, PA, where she has been honored with the Smith Award for Excellence in Teaching.

Robert K. Johnston—*Foreword*
The author or editor of fifteen books, Johnston has published in a variety of fields, including theology, selected Old Testament topics, evangelical theology, theology and film, and theology and culture. His recent books include *Useless Beauty* (2004), *Finding God in the Movies* (co-written with Catherine Barsotti, 2004), *Life Is Not Work/Work Is Not Life* (co-written

with J. Walker Smith, 2001), and *Reel Spirituality: Theology and Film in Dialogue* (2000, 2nd ed. 2006). He is editor of *Reframing Theology and Film: New Focus for an Emerging Discipline* (2007), co-editor of *Don't Stop Believin'*, an Old Testament general editor of the Understanding the Bible Commentary Series (Baker), and co-editor of both the Engaging Culture and the Exegeting Culture series for Baker Academic, as well as the Religion and Film series for Routledge.

Joe Kickasola—*Contributor*
Joe Kickasola is the author of *The Films of Krzysztof Kieslowski: The Liminal Image* (2004). Select publications include articles in *Quarterly Review of Film and Video, Journal of Moving Image Studies*, and several forthcoming anthologies focused on the cinema as it intersects with epistemology, religion, and metaphysics. In addition to his academic publishing, Dr. Kickasola has directed and/or produced film and video projects for distribution and/or broadcast around the world. He lives in New York City, where he runs the Baylor Communication in NY program, a unique combination of study-abroad and internship experiences, aimed at giving students the skills and experience to compete in the world's top communication companies.

Eric Kuiper—*Contributor*
Eric Kuiper is the founder and executive director of Into the Noise, a non-profit that dynamically and intentionally engages popular culture and the makers, thinkers, and creators in our world. Introducing Into The Noise to the most eminent festival experiences, they explore the cultural stories being shared and the many ways those stories disrupt and transform people. Kuiper is the director of alternative programming for Celebration! Cinema, and serves as an adjunct professor of theology and film at Western Theological Seminary in Holland, Michigan. He lives in Grand Rapids.

Michael Leary—*Contributor*
Michael Leary is co-editor of *Filmwell*, a film blog hosted by *The Other Journal*. He currently teaches Religion and Biblical Studies coursework at universities in the US and Australia and is a research ethicist at Washington University in St. Louis. He frequently publishes on film, the arts, and biblical studies in an array of magazines and journals (such as *Books and Culture, Twitch, Image Journal*—*Good*

Letters, and *The Curator*). He is a founding juror of a local filmmaker award at the St. Louis International Film Festival, and host of a popular podcast on research ethics in emerging biomedical and social sciences.

Carl Raschke—*Contributor*

Carl Raschke is Professor of Religious Studies at the University of Denver. He specializes in continental philosophy, the philosophy of religion, and the theory of religion. Raschke is an internationally known writer and academic who has published numerous books and hundreds of articles on topics ranging from postmodernism to popular religion and culture to technology and society. His latest book, *The Revolution in Religious Theory: Towards a Semiotics of the Event* (2012), looks at the ways in which major trends in continental philosophy over the past two decades have radically altered how we understand what we call "religion." Raschke is also a permanent adjunct faculty at the Seattle School of Theology and Psychology and has been a visiting scholar and lecturer at the University of Vienna. Dr. Raschke has been writing for *The Other Journal* since 2005.

Kathryn Reklis—*Contributor*

Kathryn Reklis is Assistant Professor of Modern Protestant Theology at Fordham University in New York City. She holds a PhD in religious studies from Yale University, where she concentrated in historical and constructive Christian theology. Her first book, *Theology and the Kinesthetic Imagination: Jonathan Edwards and the Making of Modernity*, explores the intersection of theology and performance studies to investigate the role of the body, desire, and beauty as sources for theological knowledge in the making of modernity. She is also co-director of the Institute for Art, Religion, and Social Justice at Union Theological Seminary, where she served as Director of Theological Initiatives and Senior Adviser to the President from 2008–11.

Zachary Thomas Settle—*Editor and Contributor*

Zachary Thomas Settle is currently a PhD student in the Graduate Department of Religion at Vanderbilt in the areas of political theology and political economy. He is the theology editor for *The Other Journal*, and he has written for numerous publications, including the *Journal of Cultural and Religious Theory* and *The Other Journal*.

Gregory Alan Thornbury—Afterword
Gregory Alan Thornbury is President of The King's College in New York City. He was previously professor of Philosophy, Dean of the School of Theology & Missions, and Vice President for Spiritual Life at Union University. He serves as Senior Fellow for *Kairos Journal*, and he is the author of *Recovering Classic Evangelicalism: Applying the Wisdom and Vision of Carl F. H. Henry* (2013). He is co-editor of *Who Will Be Saved?: Defending the Biblical Understanding of God, Salvation, and Evangelicalism* (2000), *Shaping a Christian Worldview: The Foundation of Christian Higher Education* (2002), and *Convictional Civility: Engaging the Culture in the 21st Century, Essays in Honor of David S. Dockery* (2015).

Taylor Worley—Editor and Contributor
Taylor Worley serves as the Associate Vice President for Spiritual Life and University Ministries, Visiting Associate Professor of Faith and Culture, and Managing Director of the Center for Transformational Churches at Trinity International University in Deerfield, Illinois. He completed a PhD in the areas of contemporary art and theological aesthetics in the Institute for Theology, Imagination and the Arts at the University of St. Andrews. He edited *Theology, Aesthetics, and Culture: Conversations with the Work of David Brown* (2012). Dr. Worley also wrote "Redeeming Body Knowledge: Contemporary Art and the Reshaping of Theology" in *The Other Journal* (Vol. 23, Fall 2013). He sits on the board of directors for CIVA (Christians in the Visual Arts).

List of Illustrations

Acknowledgments

As will become clear throughout this book, the editors not only hold that films offer spiritual phenomena but intrinsically social phenomena as well. The regular occurrence of sitting completely alone in a dark theater with hundreds of strangers prompts the very natural desire to discourse with like-minded cinephiles. We continually process our own cinematic experiences in dialogue with others. In this way, we believe that the spiritual phenomenon of film most fully satisfies itself when received through the good of community. Ultimately we give thanks that we are never watching alone. As such, we need to offer several words of thanks.

The evidence of this grace is nowhere better represented than in the wonderful cast of colleagues and conversation partners in this volume. It has been all joy to work with these scholars and to receive not only their immense contributions but also their thoughtful reflections and gracious responses in dialogue with one another. Hopefully, the spirit of give-and-take here engenders more of the same in our readers.

The genesis of this book project, however, has its roots in the simple but gracious invitation from Gregory Alan Thornbury to take over a fantastic elective course he designed and taught. From the earliest days, this project has been nothing less than a lively conversation between faculty colleagues and their students. The mutual appreciation for film's imaginative and philosophical potential has therefore led to numerous conversations, film nights, and even the odd presentation or essay publication. The editors of this book met in that first iteration of the course, and from that point on, the conversation continued and unfolds to this day. Along the way, several more instances of the course have been offered with their own creative attempts at revising the experience. Multiple cohorts of undergraduates took part in the conversation and added their own distinctive takes on the topic. Without the aid of these students this project would certainly not have progressed as far as it has. The most notable

include Andrew Norman, Caleb Stallings, and Trey Weise. No doubt, like many of the contributors in this book, the editors wish to thank all the bright and quizzical undergrads that helped refine our approach.

Many friends and colleagues also gave encouragement and feedback on the shape of this volume. Numerous recommendations and suggestions came at us from multiple directions. All of this input we received as tokens of a mutual love and appreciation for film. So thanks, Matt Altobell, Jonathan Paul Gillette, Dan Rhodes, and Tom Ryan.

Most of all we wish to thank and acknowledge the love, support, and sacrifice of our families in allowing us to see this project through. If "leisure is the basis of culture," as Josef Pieper once said, then family is surely the good ground for human flourishing. Your unquestioning confidence in us and your tireless support of our work are beyond anything we deserve in this life. We receive them as nothing less than God's good gifts to us.

Taylor Worley and Zachary Thomas Settle
All Saints Day, 2015

Foreword

Religion and film studies is a relatively new discipline. Its body of scholarship has only begun to build in the last twenty-five years. In the first decade, scholarship centered chiefly on the dialogue between a movie's content and a particular religious tradition, usually Christianity. Insights proved productive, but also partial. As the millennium turned, however, it became increasingly apparent both to those of us within the discipline and to those outside that a broader perspective was needed. Clive Marsh's *Cinema & Sentiment* (2004)[1]; John Lyden's *Film as Religion* (2003)[2]; Brent Plate, *Representing Religion in World Cinema* (2003)[3]; and my own *Reel Spirituality* (2000, 2006)[4] are representative of early books that sought to broaden the discussion. But they were only a beginning.

Another result of this recognition of the need to deal more comprehensively with the topic of religion and film was the three-year consultation on theology and film which was sponsored by the Reel Spirituality Institute at Fuller Theological Seminary and funded by the Henry Luce Foundation. Its findings were published in 2007 in the book, *Reframing Theology and Film: New Focus for an Emerging Discipline.*[5] The study made six suggestions as to where scholarship in theology/religion and film needed to turn during the next decade of scholarly work in the field. The participants encouraged their colleagues (1) to move beyond a "literary" paradigm—image, music and word are all essential for understanding a movie's unitary narrative; (2) to broaden our film selection—world cinema can no longer be ignored; (3) to extend our conversation part-

1. Marsh, *Cinema & Sentiment.*
2. Lyden, *Film as Religion.*
3. Plate, ed. *Representing Religion in World Cinema.*
4. Johnston, *Reel Spirituality.*
5. Johnston, ed. *Reframing Theology and Film.*

ners—other academic disciplines such as sociology and history should play an important part in bringing film's meaning to light; (4) to engage the experience of the viewer—the film viewer is integral to any meaning-making; (5) to reconsider the normative—the roles of normative criticism and interreligious dialogue need reassessment and deepening; and (6) to make more substantive use of the Christian theological tradition—for example, might the use of icons or the interpretive patterns of Christian medieval biblical interpretation illumine theology and film scholarship?

Writing as this decade of renewed scholarship comes to a close, the authors of *Dreams, Doubt, and Dread* address these agenda in nuanced and significant ways. The book represents a further maturing of the discipline. In particular, the volume makes use of "a specific tradition of philosophical thought that lends itself to film reception and aids us in understanding film *as* experience," to quote the editors. The diverse group of authors each interprets film through the lens of a particular continental phenomenologist. Rather than simply use film narrative to illustrate various issues in the field of the philosophy of religion as early volumes did, *Dreams, Doubt, and Dread* creatively engages a broad range of film texts themselves, using continental theorists to help readers understand how representative movies affect their viewers. With Gilles Deleuze, the volume asks, "How is it that cinema is so adept at stirring up spiritual life?" And the answers are consistently enlightening.

The authors in the essays that follow, thus, join a growing chorus of scholars, reviewers, and filmgoers who seek to understand film's possibility as a spiritual experience, extending our understanding in significant ways. Using philosophy as their conversation partner, the essayists illumine for their readers what cinema is able to do so well—to capture the imagination of the viewer through our senses and usher him/her into another reality. The pleasure of film, as one of the essayists writes, is in being moved "toward unexpectedly fitting approximations of that which constitutes our humanity." Through watching a Wes Anderson movie, or a film by Ingmar Bergman, viewers participate in fictions that have direct bearing on their own lives and beyond. The movie's fiction becomes a window into alternate, S(s)piritual narratives for our own lives.

Here is a book that is a delight to read.

Robert K. Johnston
Professor of Theology and Culture,
Fuller Theological Seminary in Pasadena, California

Bibliography

Johnston, Robert K. *Reel Spirituality*. Grand Rapids: Baker Academic, 2000.

————., ed. *Reframing Theology and Film: New Focus for an Emerging Discipline*. Grand Rapids: Baker Academic, 2007.

Lyden, John. *Film as Religion: Myths, Morals, and Rituals*. New York: New York University Press, 2003.

Marsh, Clive. *Cinema & Sentiment: Film's Challenge to Theology*. Milton Keynes: Paternoster, 2004.

Plate, S. Brent, ed. *Representing Religion in World Cinema: Filmmaking, Mythmaking, Culture Making*. New York: Palgrave Macmillan, 2003.

Introduction: Thinking How Film Feels

Taylor Worley and Zachary Thomas Settle

> And I should say that to me who has always had a propensity to
> get tired of what I have the habit of seeing—what in reality, that is, I
> do not see anymore—this power peculiar to the cinema
> seems to be literally redeeming.
>
> —GABRIEL MARCEL[1]

Film and Phenomenology

The story of film and philosophy emerges alongside the advent of phenomenology and for that reason also issues from a place of protracted conflict and confusion. While numerous philosophers from the twentieth century and beyond have readily confessed their fascination and admiration of the cinema, few ever venture into the apparently dangerous territory of incorporating reflections on film into the main currents of their philosophical projects. In theory, phenomenology presents itself as the most amenable to the purposes of a thoughtful engagement with film for the very fact that it privileges the first-person experience of the world in its method. Despite this advantage among others, the story of film and philosophy as filtered through phenomenology has a fraught and somewhat ironic history. Two examples will suffice to demonstrate the drama.

The year 1859 marked the birth of two thinkers who would exert an immense, if indirect, influence over the future of the philosophy of film. As is often the case, these figures stand for the German philosophical tradition on the one hand and the French philosophical tradition on

1. Marcel, "Possibilités et Limites," 304.

the other. Apart from nationality, they actually shared many similarities. Perhaps chief among them were their feelings toward film. Ironically, Edmund Husserl (1859–1938) and Henri Bergson (1859–1941) did not care much for the cinema, but at the same time their contributions to phenomenology would prove vital for all philosophers of film that would come after them. Alongside his foundational work on the phenomenological method, Husserl's most notable contribution to twentieth century thought remains his tutelage of Martin Heidegger (1889–1976). While Heidegger decried the influence of modern technology and would have likely shared his mentor's views on film, his existentialism proved monumental in the last century and inspired philosophers of film and filmmakers alike. Even though Heidegger surely despised the synthetic worlds of film and rarely, if ever, addressed them theoretically, many of his respondents would apply his vision of authenticity to their own engagements with the cinematic realm. By contrast, however, Gilles Deleuze (1925–1995) would not only re-ignite scholarly attention to Bergson's body of work but also forge notions of perception beyond Bergsonian toward the most audacious and enterprising philosophy of film set forward yet. Indeed, Deleuze's *Cinema* 1 and *Cinema* 2 represent the most extensive and impressive body of reflection on film's value for philosophy ever introduced. From humble origins, it seems, phenomenology has produced the most arresting and intricate theories of philosophy and film. More will be shown below regarding the contributions of both Husserl and Bergson. A second example seems irresistible.

One of the more significant respondents to Heidegger's existentialism emerged in the figure of French philosopher Jean-Paul Sartre (1905–80). Initially, Sartre demonstrated a profound appreciation for the value of cinema. Early on he saw the potential within film and particularly prized its demands on the viewer, even as it presented the masses to the masses. During the war, he even wrote movie scripts for a French production company. Ultimately, however, Sartre abandoned his appreciation for cinema. This retreat was ironically precipitated by his engagement with phenomenology and his year of study in Germany during 1933. Eventually, Sartre would rank theater above cinema as an art form particularly suited to the interests of his existentialism. Despite these historical oddities, the phenomenological method still bears great promise for understanding the experience of film, and for this reason, the method itself must be explicated to some degree.

Put crassly, phenomenology is the philosophy of experience, and phenomenological investigation remains a distinctly helpful category and methodology by which we can properly engage and investigate film. Rather than speaking of philosophy broadly—i.e., any philosophical work in the Western world—there is a specific tradition of phenomenological thought that helpfully lends itself to film reception and aids us in understanding film *as* experience. Properly inaugurated in the work of Edmund Husserl, phenomenology privileges the phenomena of experience, or the life-world, as they are taken up as the grounds of human consciousness. Experience thus serves to ground meaning, be it in ourselves or the exterior world, and through a proper examination of the formation of that experience in consciousness, we can begin to make sense of the world. Such a privileging renders exterior phenomena a secondary status, only available in the wake of perception. Objective, exterior phenomena exist in an irreducible correlation to the subjective consciousness, a correlation beyond which no reduction can be allowed. Experience refuses to be reduced in its construction of the meaningful whole of human consciousness.

Intentionality

This irreducible correlation directs consciousness towards a present object and yields a sense of *intentionality*, which means an appropriate use or appropriate experience of an object in the world. Such intentionality is possible whether the phenomena be exterior or made objective through reflexive acts, such as memory or reflection. There are methodological tools available in the phenomenological process, which are particularly pertinent to viewing film as a distinct experience. Namely, the steps of the phenomenological method serve to reveal the sense of intentionality in each experience. The steps include 1) bracketing, 2) equalizing, 3) testing, and 4) interpreting. Let's review these steps in short order. First, Husserl argued that engagement of consciousness with phenomena is typically shaped by and through a presuppositional grid, which serves to normalize the phenomena in the minds of the observer. Bracketing one's presuppositions about the phenomenon prior to reflection and interpretation allows the experience to speak for itself and take the lead in guiding consciousness to a richer understanding of the phenomenon's intentionality. By bracketing presuppositions about the phenomenon itself,

the viewer then frees herself to experience and interpret the phenomena according to its clear constraints, its dichotomies and possibilities. The latent possibilities of the phenomenon become apparent only after the bracketing of the presuppositional grid. Secondly, equalizing each of the phenomenon's features serves to eliminate any hierarchies of significance that would result in an undue bias in one's understanding of the phenomenon. As an extension of the process of bracketing, equalizing injects a process of discernment and self-reflection, a critical re-evaluation of what one naturally privileges in perception. The proper naming and rendering of such presuppositions makes possible phenomenological experience *as such*. Thirdly, before direct interpretation can take place, testing imaginative variations on the horizons of meaning in the phenomenon must be allowed. By undertaking a certain amount of thought experiments regarding the phenomenon's significance, the viewer is able to properly interpret the phenomena on its own terms, for the sake of articulating the horizon of possibilities represented by the phenomena itself. Finally, one arrives at interpreting the lived significance of the object and opening up new possibilities of its meaning.

From here, phenomenology invites interpretation and implementation. The phenomena have been rendered according to consciousness itself, and the distinct horizons of possibilities have been named, ultimately freeing the viewer to decide and interpret the possibilities for herself. In many ways, the phenomenological method seeks to regulate and normalize the reflective approach to understanding experience and the broad range of phenomena in the world. While it cannot guarantee its results, phenomenology's method also serves to make us aware of both the possibilities and limitations of our own perceptive abilities. For this reason, phenomenology has also carefully considered the features of human perception in its pursuits.

Perception

In the history of phenomenology, no one has done more to explore the dynamics of our perception than Maurice Merleau-Ponty (1908–61). Among many things, his contributions to the phenomenological tradition chiefly emphasize the embodied nature of perception and the experiential processes it makes possible. Merleau-Ponty attempted to re-develop an analysis of the experience of embodiment that gave primacy to the study of perception. He argued that the phenomena of experience could

not be properly encapsulated in philosophical terms due to philosophy's tendency to swing between unsatisfactory opposites: empiricism and intellectualism.[2] Perception, Merleau-Ponty argues, is not the unfolding of a bodily process in which each organ plays its proper role; rather, perception must be regarded as a performative act in which the self perceives in and through the organs, the material of the flesh.[3] His conception of the philosophical task, properly performed by the self, then, leads him to reject all dualisms. Merleau-Ponty argued that certain interpretations and renderings of the body as an object led to the idea of an objective world that is merely "out there." According to Merleau-Ponty, the very notion of an exterior world completely distinguishable from the thinking subject itself begins to crumble once such a rendering of the body comes into question.[4]

Consciousness itself is both embodied and situated in the material, historic landscape, and it remains in a continued mode of "becoming." *Phenomenology of Perception*, Merleau-Ponty's most significant work in this regard, argues that we are our bodies, and our experience of embodiment negates any possible separation of mind from body, subject from object. David Macey highlights, "He described the primary philosophical act as a return to the lived world that exists before it is objectified by science or metaphysics."[5] Perception, Merleau-Ponty argues, involves a concrete situation of the one perceiving; there is no vacuous space from which the spectator interprets phenomena. For Merleau-Ponty, there can be no real distinction between the one perceiving and that which is being perceived. Human being is manifestly more complicated and ambiguous. There can be no more detachment from the particulars of the object of perception than from the background apparatus framing our perception of the thing—i.e., use, history, culture, intention, etc.[6]

Merleau-Ponty was able to capture Husserl's and Heidegger's vision of transcendental phenomenology—ultimately aimed at the essence of that which is being perceived—and translate it into the raw material of existence so as to make sense of the dynamic nature of the phenomena of experience. Vivian Sobchack points out that, according to Merleau-Ponty, "Embodied consciousness can never quite catch up with or be

2. Reynolds, "Maurice Merleau-Ponty."
3. Ibid.
4. Ibid.
5. Macey, "Merleau-Ponty," 247.
6. Reynolds, "Maurice Merleau-Ponty."

fully disclosed to itself through acts of reflection, however rigorous—this not only because it is always situated but also because it is always both behind and ahead of reflection, always engaged in acting and 'becoming' something other than it presently is."[7] Phenomenology remains provisional, then, constantly caught in the play of forces at work in the embodied world. The import of Merleau-Ponty's insight is its excising of the transcendental ego in such a way that remained faithful to the tools at work in the phenomenological method.

For Merleau-Ponty, film is not understood or interpreted in terms of its constituent parts—soundtrack, frames, or editorial process. Rather, the meaning and import of film rests in its totality, its construction of a singular object for experience that lends itself to all of our senses at once.[8] Cinematic meaning occurs in the viewer's perception of the world. Of perception, Merleau-Ponty writes, it is "peculiarly suited to make manifest the union of mind and body, mind and world, and the expression of one in the other."[9] This newly conceptualized understanding of perception makes possible new understandings through its unification of mind and body, of subject and object through the embodied apparatus that legitimizes the experience of the object. Through the experience of this unified totality, new meanings become possible.

Phenomenology provides unique, imaginative tools for film. Chiefly, these include directing us toward a sense of intentionality with the object and underscoring our embodied perception. Relating phenomenology's particular resonance to cinema, Vivian Sobchack writes, "Phenomenology generates not only an *experiential* but also an *experimental* methodology that begins with a commitment to the openness of its object of inquiry, rather than to any *a priori* certainty of what that object already 'really' is."[10] The phenomenological approach to film fosters a remarkable openness to the textuality being screened. It also makes present the viewer, which exists in active participation—in an irreducible correlation—to

7. Sobchack, "Phenomenology," 438.

8. Merleau-Ponty, "Film and the New Psychology," 54.

9. Ibid., 58.

10. Sobchack, 436. She continues: "The intentional directedness of subjective consciousness toward its intended object demands a description of the film experience that includes the "spectator" as well as the "text"—that is, it presumes an active (rather than passive) viewer and calls for focus not only on elements of the film viewed but also on possible modes of engaging and viewing it. In this conjunction of viewer and film, the dynamics, modulations, and effects of acts of visual and aural cinematic perception are correlated with the structures of cinematic expression."

that which is screened. In rendering this relationship, it dictates certain responsibilities and expectations according to the methodology by which the viewer interprets and makes meaning in the text itself. Sobchack continues, "The cinema both enacts and dramatizes the intentional correlation as an actively lived structure through which meaning is constituted as such."[11] In this sense, phenomenology presents itself as the most helpful mode of philosophical engagement with film because of the way in which it prioritizes the experience of cinema and maintains a place for a legitimately reciprocal relationship between the viewer and the viewed.

The Logic of Cinema

"How is it that cinema is so adept at stirring up spiritual life?"[12]

—GILLES DELEUZE

Though his monumental work cannot be contained within the field of phenomenology alone, Gilles Deleuze has had a greater impact on the understanding of film and its potentialities than any other philosopher to date.[13] Deleuze, himself and his adherents, represents a cinematic turn in postmodern theory and has paved the way for thinkers like Alain Badiou (1937–) and Jean-Luc Nancy (1940–) among others to consider film in new and generative ways. Within his project, Deleuze was principally interested in exploring film as a means to aesthetic sensation. For him, the production of sensation through film, and the subsequent implications for philosophy, constitute his driving interest in experiencing, studying ,and reflecting upon cinema. Sense, for Deleuze, occupies the gap in our understanding between the empirical effects of the world we experience and the innate categories of the mind that organize those impressions through sensation into rational propositions about the object, the subject, or other propositions. In his early work *Logic of Sense*, he comments on the mysterious character of sense in this way: Sense "cannot be confused with the proposition which expressed it any more than with the state

11. Ibid., 437.

12. Deleuze, "Brain is the Screen," 48.

13. While many philosophers of film like Stanley Cavell and Christian Metz have pursued the relationship of language to film and photography to film as topics of analytic inquiry, Deleuze's interest in cinema is not limited to a semiotics of film. Cf. Gilles Deleuze, "The Brain is the Screen," 48.

of affairs or the quality which the proposition denotes. It is exactly the boundary between propositions and things."[14] Thus, for Deleuze, sense is not properly an idea but rather an event, and that event takes place within the fragile environment of aesthetic affects. This means that sense verges closely on becoming non-sense.[15]

Deleuze therefore applies his logic of sense to films, which ultimately resulted in his two-volume work *Cinema 1* and *Cinema 2*. Published in 1983 and 1985 respectively, he takes up the particular question: "What exactly does the cinema show us about space and time that the other arts don't show?"[16] His logic of the cinema, thus, describes the relationship of the viewer's gaze to the film's space/time structure. While this relation may seem quite abstract, he succinctly explained it to an interviewer this way: "The relation between cinema and philosophy is that between image and concept. But there's a relation to the image within the concept itself, and a relation to the concept within the image: cinema, for example, has always been trying to construct an image of thought, of the mechanisms of thought. And this doesn't make it abstract, quite the reverse."[17] Deleuze admits that while the cinema attempts to present to the viewer another mode of "natural perception," in reality the constructed gaze of all films represents a quite unnatural perception—a foreign or alien perception that is given and not actually present at hand to us in the world.

> The cinema can, with impunity, bring us close to things or take us away from them and revolve around them, it suppresses both the anchoring of the subject and the horizon of the world. Hence

14. Deleuze, *Logic of Sense*, 22.

15. Deleuze and Guattari, *What is Phiolosophy*, 164. Cf. also in "Gilles Deleuze" *Stanford Encyclopedia of Philosophy*: "For Deleuze, the task of art is to produce 'signs' that will push us out of our habits of perception into the conditions of creation. When we perceive via the re-cognition of the properties of substances, we see with a stale eye pre-loaded with clichés; we order the world in what Deleuze calls 'representation.' In this regard, Deleuze cites Francis Bacon: we're after an artwork that produces an effect on the nervous system, not on the brain. What he means by this figure of speech is that in an art encounter we are forced to experience the 'being of the sensible.' We get something that we cannot re-cognize, something that is 'imperceptible'—it doesn't fit the hylomorphic production model of perception in which sense data, the "matter" or *hyle* of sensation, is ordered by submission to conceptual form. Art however cannot be re-cognized, but can only be sensed; in other words, art splits perceptual processing, forbidding the move to conceptual ordering."

16. In pursuit of this question, Deleuze sets forward what he terms "a book of logic, a logic of the cinema." Quoted in "Gilles Deleuze," *Stanford Encyclopedia of Philosophy*.

17. Deleuze, "Doubts About the Imaginary," 64.

it substitutes an implicit knowledge and a second intentionality for the conditions of natural perception. It is not the same as the other arts, which aim rather at something unreal through the world, but makes the world itself something unreal or a tale. With the cinema, it is the world which becomes its own image, and not an image which becomes world.[18]

To be precise, Deleuze isolates this complex exchange down to the mechanics of viewership, what he calls the "sensory-motor schema."[19] With this term, he names the conditioned supposition of cause and effect that most straightforwardly narrative films utilize as a backdrop for viewers to follow the flow of the film. The degree to which a film preserves continuity for movement (i.e., through time and space) determines the nature of the image that the film represents. For his purposes, Deleuze identifies two primary categories for the film image. *Cinema 1* takes up the theme of his first category, the movement-image.

Cinema 1: The Movement-Image

The "movement-image" is so named for its ability to preserve the viewer's natural perception sensibilities by replicating a continuous translation of movement through time and space. In such films, the continuity of movement takes precedence and makes possible a certain narrative or conceptual stability in the viewer's experience. This is done by perpetuating a "sensory-motor schema" that by its regularity invests confidence in the viewer's ability to make connections between unobservable changes in the movement of the film. The power of this illusionary aspect of film lies at the very heart of its universal appeal. We become willing participants in the lie of the screen. Deleuze, however, explains the mechanics of this illusion as a conflation of the object and the gaze: "The thing and the perception of the thing are one and the same thing, one and the same image."[20] Thus, with the movement-image, the only difference between the thing in itself and our perception of it is the relationship of each to other images in the field of vision. He relates that, "We perceive the thing, minus that which does not interest us as a function of our needs."[21] In

18. Deleuze, *Cinema 1: The Movement-Image*, 57.
19. Ibid., ix.
20. Ibid., 63.
21. Ibid.

other words, our motivation for conflating the two stems from our desire to trace a center of movement in the image.

Deleuze then parses out three manifestations of the movement-image, or objects of desire in our perception. These are the perception-image, the affection-image, and the action-image. In each case, the film subordinates the cinematic imagination to the centralizing effect of either a perception, an affect or an action. In order to do this, the "sensory-motor schema" of the film, in effect, trains the viewer's gaze to follow the movement of one or other of these central aspects of the film. But while the continuity of this translation appears automatic or natural to the viewer, its synthetic nature often belies an ideological aim behind the film's straightforwardly narrative development. For example, Deleuze criticizes sharply the action-image in American filmmaking and in doing so provides a helpful insight into the limitations of a contemporary cinema that purports to have no limitations.

In *Cinema 1*, Deleuze takes pains to describe the dependence upon the action-image in American filmmaking from its earliest days. He remarks with acerbic wit, "The American Cinema constantly shoots and reshoots a single fundamental film." What film does he believe American filmmakers are making over and over again? Deleuze understands the basic story of American cinema to be "the birth of a nation-civilization, whose first version was provided by Griffith."[22] In these comments, he's referring to the pioneering American filmmaker D. W. Griffith, who made many of the greatest silent films of the early age of cinema, including the infamous *Birth of a Nation* from 1915. He describes this strategy thus: "The American cinema is content to illustrate the weakening of a civilization in the milieu, and the intervention of a traitor in the action. But the marvel is that, with all these limits, it has succeeded in putting forward strong and coherent conception of universal history, monumental, antiquarian and ethical."[23] In other words, the action-image in American cinema usually produces an attractive picture of how things are and where the world is going, a powerful filmic logic of history. And while this makes for great profits at the box office, the fortitude of such films rests on the easy identification of a common enemy and the swift pursuit of totalizing solutions and happy endings. For Deleuze, this means that, "A strong ethical judgment must condemn the injustice of 'things,' bring compassion, herald the new civilization on the march, in short,

22. Ibid., 148.
23. Ibid., 151.

constantly rediscover America . . . [and] from the beginning, all examination of cause has been dispensed with."[24] Such time-tested strategies for filmmaking have hung around a long time, and the deluge of super-hero blockbusters and military campaign epics is not likely to cease anytime soon. Deleuze, however, identifies another, perhaps more promising, stage in the evolution of film: the time-image.

Cinema 2: The Time-Image

While studying the post-war cinema of Italian Neo-Realism and the French New Wave movement—the progressive cinematic forms of his youth, Deleuze uncovered what he terms a Kantian revolution in modern filmmaking. He explains that while cinema began with a movement-image it creates a "self-moving image." The Kantian revolution for the film image takes place in instances where the experience of time in a film is no longer subordinated to motion and where motion is now dependent upon time.[25] In this way, the time-image is so named for the way in which it provides a direct presentation of time in the film. In order to do this, the time-image acknowledges in unavoidable ways the fragile illusions of film itself—making false the deceptive truths of the screen. He explains this revolution thus: "Making-false becomes the sign of a new realism, in opposition to the making-true of the old."[26] In other words, the experience of time in a film is no longer incidental to where the film is going or implied within the conventions of storytelling.

This means that with the time-image the viewer's experience of the film (i.e., the personal reconciliation of time in the film) actually matters and the narrative trajectories of the film are no foregone conclusion any longer. In this way, the time-image renders the viewer's senses to be formative in creating the film's meaning. Rather than the familiar or belovedly didactic approach of the movement-image, we enter into a dialogue of meaning with the time-image. Deleuze explains the affective possibilities of the time-image in this way, "in creative works there is a multiplication of emotion, a liberation of emotion, the invention of new emotions, which distinguish themselves from the prefabricated emotive models of commerce."[27]

24. Ibid.
25. Deleuze, "Doubts About the Imaginary," 65.
26. Deleuze, *Cinema 2: The Time-Image*, 213.
27. Deleuze, "Brain is the Screen," 52.

We typically understand this transformation, however, only as an experience of loss or frustration. When we begin a film and recognize that the narrative logic of the film does not fit into any pre-established categories of expectation, we usually feel annoyed and turn the film off. We do not like for movies to ask very much of us. If we experience the dissolution or problematizing of the "sensory-motor schema" that constitutes the playful time-image, we tend to disengage rather than surrender ourselves to the experience more and more. Most Hollywood filmmakers view the movie-going public with the soft bigotry of low expectations, and for this reason we enjoy pre-digested narratives like some sort of fast food entertainment. For this reason, our preference for the simplicity of movement-images has not prepared us well to engage deeply with the most artistic and philosophically provocative films of recent years. Deleuze would therefore alert us to the pitfalls of thinking *through* film: no matter how profound the film, in the end we are the screen for the imaginative experience. He chides: "Cinema, precisely because it puts the image in movement, or rather endows the image with a self-movement, never ceases to trace and retrace the circuits of the brain. There again, it's for better or for worse. The screen, namely ourselves, can be the tiny deficient brain of an idiot as much as a creative brain."[28] With these problems and possibilities in mind, we turn now to consider three experiential forms of the cinematic spiritual imagination.

The Spiritual in Film

By this time, no doubt, fragmentation, spacing, exposition, piecework,
and exhaustion have begun to arrive at their most extreme limit. We have
done so much fracturing, fraying, wounding, crumpling, splintering,
fragilizing, shattering,
and exceeding that we would seem to have begun to exceed excess itself.
This is why worldliness may appear to be the reverse, in tiny pieces,
of a totalization madly in love with itself.
Today, there is a chagrined, reactive, and vengeful tone in which this is often said.
It gives its auditor to understand that our art, thought, and text are in ruin,
and that one must call for a renewal.[29]

—JEAN-LUC NANCY

28. Ibid., 49.
29. Nancy, "Art, A Fragment," 123.

Film is the ultimate example of the fragment of meaning in our day. Whether they delight us or disturb us, we can take them or leave them. Films are instantaneously accessible and simultaneously obtuse and distant from us. Meaning appears so close that it is ungraspable in an ultimate sense. For these reasons, films continue to occupy us and remain for us modern spiritual phenomena. They function as such in at least three profound ways: world projection, thought experiments, and catharsis (i.e., as dreams, doubt, and dread). Understanding film from this vantage point, however, allows for a theological account of the experience that speaks to the religious possibilities of film that far extend the portrayal of religious themes or content. The conversation this project seeks to initiate will move us beyond the question of content in film and explore film's singularly wonderful means of addressing our senses. Here we provide a sense of the philosophical background that informs how these different experiences (i.e., film as dream, film as doubt, and film as dread) might be understood.

Dreams

Serge Lebovici remarks, "Film is a dream . . . which makes [one] dream."[30] Indeed, the philosophical and theological discourse of world projection has natural connections to literary and filmic genres such as fantasy, science fiction and dream theater and necessarily involves reflection on the issues such as politics, social ethics and codes of public morality. But what is the value of world projection in film? World projection, as a philosophical enterprise, casts visions of other worlds, better worlds or lesser worlds for the purposes of exploring the social norms, traditions and the status quo in this world. On a theological level, world projection entails imagining and ultimately beckoning those worlds.

A formal genesis for world projection can be perhaps located in Plato's *Republic*, the student of Socrates's attempt at picturing the ideal state ruled and ordered by the philosopher-kings. Similar attempts are numerous, especially in the Enlightenment, but most significantly Karl Marx and Friedrich Engels, in their vision of a classless society achieved through communist economics, provide for the first of many projects aimed at establishing a social utopia (literally a "good place"). The diverse utopian projects of modernity have employed a host of different tools for

30. Lebovici, "Psychanalyse et Cinéma," 163.

creating "the good place": economic theory, politics, eugenics, technology, and war—to name a few. In light of the historic traumas of the twentieth century, the project of a social utopia has been largely abandoned in favor of colonizing the last frontier: the *terra incognita* of the self. In this way, world projection oscillates between questions of object (i.e., the ideal or fantasy world in view) and questions about the viewing subject (e.g., perspectivalism, "ways of seeing," and the "gaze"). From either direction, it seems that world projection tells us more about the alterity of the dreamer than the alterity of the dreamland.

Doubt

Doubt, like our mortality, remains inescapable. In this way, skepticism as a philosophical—even theological at times—discourse has been a perennial interest in the history of philosophy. Beginning with the ancient Greek philosopher Pyrrho of Elis, who taught that all human knowledge involved some measure of uncertainty and that knowledge of the truth was impossible, the lineage of skepticism has frustrated any straightforward or uncomplicated accounts of epistemology (theory of knowledge). In ancient accounts of skepticism, demonstrated chiefly in Plato's Academy and the influence of Pyrrhonism, the philosopher's doubting served an intensely practical function in allowing for a reflective life of quietism and detachment (e.g., the mythic account of the solemn sage), and it provided a theoretical counterpart to the ethical systems of Epicureanism and Stoicism.

For modern and contemporary accounts of skepticism, the Enlightenment's preoccupation with epistemology yielded a host of critically engaged discourses on the nature of human knowledge. Most significantly, witness the contrast in continental rationalism and its emphasis upon the innate tools of thought within the human mind (René Descartes, Gottfried Leibniz, Baruch Spinoza, and Immanuel Kant) and British empiricism's reliance on knowledge gained through the senses (Thomas Hobbes, John Locke, George Berkeley, and David Hume). Through careful interaction with the insights of British empiricism and sustained examination of the functions of human perception, Kant's 1781 volume *The Critique of Pure Reason* remains the most influential work on epistemology in modernity and one of the greatest works in the history of philosophy. Kant's contribution to epistemology limits the parameters of objective knowledge to

mathematics and the empirical sciences, thereby necessarily excluding metaphysics from this group. In many ways contemporary epistemology works with whatever is left to us after Kant. Indebted to Kant's discussion of the mind and the tradition of Thomas Reid's Scottish common sense realism, analytic philosophy extends the discourse of skepticism to include its rigorous analysis of language in the work of G. E. Moore and Bertrand Russell. Such thought, though, is best represented by the paradigm-shifting work of Ludwig Wittgenstein.

Following Kant's ethical imperatives and incorporating the insights of phenomenology, the skeptical emphasis in Continental philosophy has continued in the questions not of what we say or read but rather *how* we read (i.e., mode rather than content). Hence, we find skeptical insights in the hermeneutics of Hans Georg Gadamer, the ethics of Emmanuel Levinas, and Jacques Derrida's literary theory of (de)construction. As a philosophical companion to film, skepticism lends itself to examining the narrator over the narrative. Along these lines, film becomes a conduit for doubt when the reliability of the narration comes into question for either the film's protagonist(s) or the viewers. Film offers a unique meditation on the experience of uncertainty as it reconstructs such embodied moments through the editing, framing, and sequencing of its narrative.

Dread

The philosophical concern with human anxiety and authenticity has an inherent link to theater and dramaturgy and has featured most prominently in the reflections of humanism, existentialism and nihilism. Dread is the psychic state of intense anxiety and concern for one's ultimate authenticity in the face of unrelenting realities such as suffering, evil, and death. The inverse of indifference, dread ponders the uncertainties of faith and human freedom and laments the inertia of modernity to reduce every life to the mathematical sum of labor power and consumer buying potential. Discussion about living an authentic life has deep roots in the ancient philosophy of Plato and Aristotle, along with numerous other sources from antiquity, but the concern for authenticity has become a particularly modern preoccupation in the thought of Søren Kierkegaard, Friedrich Nietzsche, and Martin Heidegger. Whether through Kierkegaard's articulation of the "leap of faith" or Nietzsche's discussion of life after "the death of God," dread—as a conduit of modern experience,

represents an entrenched resistance to the cold rationalism of Idealist philosophy. In this way, Edmund Husserl's phenomenology and Heidegger's existentialism take the sheer fact of our embeddedness in the world as the starting point for philosophical reflection. With both Christian (e.g., Jacques Maritain and Gabriel Marcel) and atheistic (e.g., Jean-Paul Sartre, Maurice Merleau-Ponty, and Simone de Beauvoir) strands, existentialism remains a particularly generative force in the arts (e.g., literature: Fyodor Dostoevsky, Franz Kafka, Samuel Beckett, Albert Camus; visual art: Alberto Giacometti, Francis Bacon, Mark Rothko; film: Ingmar Bergman, Federico Fellini, Woody Allen; and theology: Paul Tillich and Rudolph Bultmann). The culturally disruptive forces of both Dada and Surrealism issue forth from an inability to escape these concerns.

In postmodernity, Heideggarians like Emmanuel Levinas and Jacques Derrida and cultural theorists like Jean Baudrillard allow the lingering questions concerning the authentic life to shape their respective projects and maintain their reverent posture toward the "other." Whether left alone on the disenchanted landscape of modernity's religionless wasteland or lost in the fragmented experience of the post-industrial, globalized city of postmodernity, we cannot access the concern for authenticity without attention to the complex and problematic entanglements of history, philosophy, and economics that threaten our existence. The arts contribute by providing outlets for vicarious catharsis of a common human experience.

This project therefore aims to address films as spiritual experiences. Its collection of short essays and dialogues examines films phenomenologically. Each of the authors has been invited to take one of the main themes and creatively consider how film, in their experiences, has provided opportunities for new modes of thinking (i.e., world projection, thought experiments, and catharsis). Contributors then were invited to engage one another in dialogue about the similarities and differences in their descriptions of film as spiritual phenomena. The aim of the efforts represented within this text is to shift contemporary theological film engagement away from a simple mode of analysis in which theological concepts are simply read into the film itself and to begin to let films speak for themselves as profoundly spiritual experiences. Let's agree that a movie is never just a movie; it's an experience—a multi-sensory and often profoundly psychological and spiritual experience. And yet, we have few models for deeply reflecting on them. The conversations within this text wish to do something about that.

Bibliography

Brough, John B. "Showing and Seeing: Film as Phenomenology." In *Art and Phenomenology*, edited by Joseph D. Parry, 192–214. New York: Routledge, 2011.

Casebier, Allan. *Film and Phenomenology: Towards a Realist Theory of Cinematic Representation.* Cambridge: Cambridge University Press, 2009.

Deleuze, Gilles. "The Brain is the Screen: Interview with Gilles Deleuze on *The Time-Image. Discourse* 20.3 (1998) 47–55.

———. *Cinema 1: The Movement-Image.* Translated by Hugh Tomlinson and Barbara Habberjam. Minneapolis: University of Minnesota Press, 1986.

———. *Cinema 2: The Time-Image.* Translated by Hugh Tomlinson and Barbara Habberjam. Minneapolis: University of Minnesota Press, 1989.

———. "Doubts About the Imaginary." In *Negotiations: 1972–1990*, translated by Martin Joughin, 62–67. New York: Columbia University Press, 1995.

. *Logic of Sense.* Translated by Mark Lester with Charles Stivale. New York: Columbia University Press, 1990.

Deleuze, Gille, and Felix Guattari. *What is Philosophy.* Translated by Hugh Tomlinson and Graham Burchell. New York: Columbia University Press, 1994.

Kracauer, Siegfried. *Theory of Film: The Redemption of Physical Reality.* Princeton: Princeton University Press, 1997.

Macey, David. "Merleau-Ponty." In *Dictionary of Critical Theory,* edited by Leonard Orr, 247–48. New York: Penguin, 2001.

Marcel, Gabriel. "Possibilités et Limites de l'art Cinématographique." *Revue Internationale de Filmologie* 5.18–19 (1954) 333–58.

Merleau-Ponty, Maurice. "The Film and the New Psychology." In *Sense and Non-Sense.* Translated by. H. L. Dreyfus and P. A. Dreyfus. Evanston, IL: Northwestern University Press.

Nancy, Jean-Luc. "Art, A Fragment." In *The Sense of the World.* Translated by Jeffrey S. Librett, 123–39. Minneapolis: University of Minnesota Press, 1997.

Reynolds, Jack. "Maurice Merleau-Ponty (1908-1961)." *Internet Encyclopedia of Philosophy.* Online: http://www.iep.utm.edu/merleau/.

Shaw, Spencer. *Film Consciousness: From Phenomenology to Deleuze.* London: McFarland, 2008.

Smith, Daniel, and John Protevi. "Gilles Deleuze." *Stanford Encyclopedia of Philosophy.* 2012. Online: http://plato.stanford.edu/entries/deleuze/

Sobchack, Vivan. "Phenomenology" in *The Routledge Companion to Philosophy and Film,* edited by Paisley Livingstone and Carl Plantinga, 435–45. New York: Routledge, 2009.

———. *The Address of the Eye: A Phenomenology of Film Experience.* Princeton: Princeton University Press, 1992.

Dreams

All Secrets and Darkness

The Profoundly Prophetic Witness of David Lynch

By David Dark

I'm seeing something that was always hidden. I'm involved in a mystery. I'm in the middle of a mystery. And it's all secret.

—KYLE MACLACHLAN'S JEFFREY BEAUMONT IN *BLUE VELVET*

I'm from Deep River, Ontario, and now I'm in this dream place.

—NAOMI WATTS'S DIANE SELWYN'S DREAM-SELF BETTY IN *MULHOLLAND DRIVE*

I have had a dream, and there is no one who can interpret it.

—PHARAOH TO JOSEPH, GEN 41:15

Everything assumes a dream.

—MICHEL DE CERTEAU, *CULTURE IN THE PLURAL*

In what sense do I drink David Lynch's Kool-Aid? Let me count the ways.

There's the memory of a black and white film with a black and white poster that jarred my Star-Wars-saturated ten-year-old mind in 1980. It was a man, *The Elephant Man*, staring at me—I presumed because there was no face to be seen—from underneath a mask made of fabric in the foggy London lamplight alongside a caption announcing emphatically that the figure before me was *not* an animal but a *human being*.[1] Was this a movie grown-ups went to see? Were there people out there who

1. Lynch, *Elephant Man*.

21

would see an advertisement like that and think, "Now *that's* what I want to watch?"

Yes, there were. Yes, there are. And Lord, how I wanted (and want) to be in that number. I'd gotten my first glimpse of David Lynch's way of addressing the world and I wanted in. I was too young to know that Lynch's first feature film, *Eraserhead* (1977), was *also* black and white and had thrived on the "Midnight Movie" circuit with a similarly evocative poster image of an odd man with a Lyle-Lovett-like haircut staring at the camera with a look of . . . distress?[2] Bewilderment? Challenge? It was difficult to say, but the difficulty—the raw weirdness of it—was not, as it turns out, a problem but an opportunity, an invitation even. There's an audience with a penchant for the uncanny, folks who *want* to be unsettled, who seek out films they might find themselves mulling over for the rest of their lives, who imagine this is probably one of the things the medium of cinema is for, to haunt and to weird us out into renewed consciousness. The feeling would deepen after I actually saw the films, but as my memory has it both posters symbolize a very specific ethical and aesthetic undertow that would have me—tugging on me—from there on out.

In everything he does, Lynch calls me to a certain wakefulness, a certain solitariness of thought, when it comes to people, places, and images, my expectations for interactions, architecture, and the mood I sense when I walk through a door. The ineffable is everywhere, and for most of my life Lynch has served as one of the primary artisans who keep me looking for it. What would Lynch make of an odd or confusing moment with a stranger on an elevator? He wouldn't repress, ignore, or explain it away. He'd let the mystery be *and*, I imagine, probe it for what insight might yet arise by looking deeply, by staying with it, by giving due, meditative reverence to the weirdness without and within that comprises our life together.

"They took the David Lynch out of that building," my wife once remarked, and I knew exactly what she was talking about. Mere blocks from our home, an ancient, chalky white, brick structure has long left onlookers bemused. The big black letters on the front read, "S & M Communion Bread." In spite of the somewhat paradoxical associations the description inspires as one rounds a wooded corner to suddenly spy some industry, it is what it says it is.[3] Except not in quite the way it once was.

2. Lynch, *Eraserhead*.

3. Stacey Earle and Mark Stuart purloined an image of the site for an album cover and title. The S & M signified the last names of the savvy sister team, Lera Moore and

The business it houses really does bake, sell, and ship communion bread here, there, and yon. But, in recent months, the place has been fancied up, trendified, and the letters painted over. It remains a fine building, but it's been made to now evoke very little in the way of time passing or inspiring juxtaposition. The David Lynch—perhaps in line with very sound financial investment logic—has been taken out. The place seems somehow robbed of its own sense of place. At least for a couple of casual drivers-by, that which once evoked a certain thoughtfulness, a deep sense of history, a feeling of what nature will do, over time, to all our artifacts (the collaboration we call rust, for instance), has been removed from the scene. The David Lynch quality is, in this sense, not just an aliveness to organic process in what our eyes behold but also an alertness to ourselves as beings who are always *in* process.

Lynch represents the popular, tried and true artist who constantly taps that feeling of ghostliness at work in the sights and sounds that populate our existence. Although it's generally deemed a commercial flop and an artistic failure, Lynch's adaptation of the science fiction novel *Dune* even manages this feat with space ships and futuristic technology. It's as if every object within every frame is somehow beautifully aged. An aura of untold story in every minute particular pervades his every vision.

So for many of us who have chosen to pay him heed, the very name of Lynch is a specific call to a specific kind of consciousness. Consciousness of what? The ineluctable weirdness of our everyday? You bet. But this is just a starting point. To drink Lynch's Kool-Aid is to commit to meet his witness with your own, to be awake to certain connections that make our lives richer and stranger but which the hurried and harried world at large often finds most convenient to ignore.

According to Lynch's witness, there are people everywhere (Agent Dale Cooper of *Twin Peaks*, Alvin Straight of *The Straight Story*) who struggle with some degree of success toward dwelling redemptively among their fellow creatures, even managing a kind of transcendence from time to time.[4] But it's also the case that a reigning unawareness presides in human affairs, and the mass of humankind lives in general denial of . . . something. All kinds of things, actually. Secrets. In spite of this, we're all bearers of deep intuition that we each ignore at our own peril

Sadie Shelton who undertook the baking that gave rise to the business. The family who inherited the business has since altered the brand to mean "Son & Mother" in reference to Jesus and Mary.

4. Frost and Lynch, *Twin Peaks*; Sweeney, *The Straight Story*.

and the peril of others. The denial of intuition leads to deep suffering. And this is especially evident when Lynch directs his sights upon Los Angeles and its environs.

"Cast out this wicked dream which has seized my heart."[5] This, as it happens, is not a line from one of Lynch's films. It is in fact a line from a film within a film, a caption actually from a silent film starring a young Norma Desmond whose older, sadder, madder self is the central character of Billy Wilder's masterwork *Sunset Boulevard* (1950). It chronicles a breakdown that exceeds its ostensible subject.[6] And it's relevant to our discussion, because I believe, in at least three instances, it largely inspired Lynch's cinematic consideration of Hollywood as a symbol, a place, and a culture. Lynch has remarked that *Sunset Boulevard* is a film he watches obsessively and repeatedly, seeing something new and instructive with every viewing.[7]

But back to Norma Desmond, as played with extreme tragicomic effect by real-life once-silent-film star Gloria Swanson. The prime witness to her decline is also the film's narrator, William Holden's Joe Gillis, who describes the rotting mansion in which she sits alone in the dark watching reels of her former glory on a screen as follows: "The whole place seemed to have been stricken with a kind of creeping paralysis, out of beat with the rest of the world, crumbling apart in slow motion."[8] It's a slow burn, but we're gradually made privy to the process involving investors, producers, writers, directors, and (lest we forget) audiences that have put her in the state she's in—screaming, "Say you don't hate me!" when she doubts a man's affection, reading fan letters forged by her butler as a daily peace offensive, and endlessly readying herself, as the famous line has it, for her close-up. There are so many hearts and minds involved in the degradation of her soul and the transmogrification of her person.

Cecil B. Demille (played by Cecil B. Demille) politely plays to her vanity in her presence but privately grieves what's been lost when he recalls her as "a lovely little girl of seventeen with more courage, wit, and heart than ever came together in one youngster."[9] The film industry, he

5. Wilder, *Sunset Boulevard*.

6. Ibid.

7. Marshal, "David Lynch Lists His Favorite Films and Directors."

8. Wilder, *Sunset Boulevard*.

9. Ibid.

notes, "can do terrible things to the human spirit."[10] Something sacred has been commodified and rendered unrecognizable, desecrated even. We won't be allowed the hope of critical detachment from the situation as we're made to understand that we're complicit too and, in myriad ways, equally enthralled. We're funding the nightmare party, after all, with our dollars and cents as well as our hearts and minds. The culture that makes and breaks a Gloria Swanson or a Michael Jackson or a David Hasselhoff is *us*. Before it's all over, Gillis addresses the public we are in an aside as "those wonderful people out there in the dark."[11] Who will deliver us from this wicked dream that has seized our hearts?

It seems obvious to me that, with one film in particular, David Lynch has set out to perform this emancipatory exercise. If art is a feat of attentiveness, perhaps this could be said of all his creative efforts, but there's one I believe succeeds on the level of exorcism (or public service announcement) like no other. *Sunset Boulevard* seems to me to operate as a kind of a template for *Lost Highway* (1997) and *Inland Empire* (2006), but it also performs the function of the call—perhaps one of many calls— that has elicited the *response* I believe to be Lynch's masterpiece, *Mulholland Drive* (2001).[12]

FIGURE 01

Here's Lynch on what cinema does: "Cinema is a language. It can say things—big, abstract things. . . . It's not just words or music—it's a whole

10. Ibid.

11. Ibid.

12. Lynch, *Lost Highway*; Lynch, *Inland Empire*; Lynch, *Mulholland Drive*.

range of elements coming together and making something that didn't exist before. It's telling stories. It's devising a world, an experience, that people cannot have unless they see that film."[13] If describing a film as an exorcism or a freeing spell seems a little overwrought, let's at least accept that viewing a film—taking in the cinema—as the purposefully orchestrated experience (following Lynch) of a world, an experience that can't be accessed in any other way. Lynch is famously articulate when it comes to teasing this out. What's the message of the film? The theme? The film *says* it. It's all there, *holding* abstraction. Lynch again: "When something's abstract, the abstractions are hard to put into words . . . unless you're a poet. . . . Cinema is a language that can *say* abstractions. Cinema can say these difficult-to-say-in-words things."[14]

I don't think there's any getting to the bottom of what *Mulholland Drive* says, but I have a wide range of thoughts concerning what I take it to be. It is, for instance, a beautiful dream vision and a gift of sacred insight to anyone interested in taking it on. Taking his cue from the promise and thoughtfulness of *Sunset Boulevard*, Lynch is giving us a view of something that happens to people; something—we begin to sense—that's probably happening to us (we're made to *feel* it happening before the closing credits).

What's happening? I draw on proclamations peppered throughout the film itself: "Something bad is happening." "Someone is in trouble." "The girl is *still* missing." "There was an accident."[15] Who is speaking to whom and to what end? It seems that we're being invited to a scene of recognition in which Hollywood is itself the crime scene, and the criminal activity is simultaneously a global export with its powers of proselytization like no other *and* a local economy, an illusion factory, in Blaise Cendrars' phrase, that functions as a mecca of fantasy, drawing lonely and hopeful souls unto itself for a hundred years or so. But, to be clear, Hollywood might also be said to function primarily as a symbol to encapsulate liturgies also concentrated in places like New York and Nashville. In this broader sense, *Mulholland Drive* is a vision of what the entertainment industry can do to the human psyche, a chronicle of a few of the terrible things it works on and within people, and an alarmingly

13. Lynch, *Catching the Big Fish*, 17.

14. https://www.youtube.com/watch?v=gkIQyoiblQE#t=80

15. Lynch, *Mulholland Drive*.

coherent consideration of, as Joni Mitchell has it, the star-maker machinery at work behind the most financially profitable pop culture offerings.

Lynch is in Los Angeles, and he has a principality to unmask in confronting Hollywood as a spiritual reality that claims lives, often absorbing its most fervent pilgrims into a felt oblivion. The scene that centers this realization involves an exchange between a man who has arranged to meet another man (possibly his therapist) to discuss and contend with a deeply disturbing dream that occurred in the very café in which they're sitting. The café is called Winkie's and it's located—you guessed it—on Sunset Boulevard. Initially, their exchange seems to have no relation to other events in the film, but in time, it becomes clear that it draws into daylight the monstrosity, the very chaos, that Lynch wishes to somehow expose.

FIGURE 02

The man with a dream to recount, played by Patrick Fischler, speaks as one who can barely contain his own fear but somehow summons up the nerve to engage it. They sit in broad daylight. They are surrounded by talkative customers. Yet he is embarrassed and so clearly shaken by the memory of the dream that it is as if he is still stuck within it. With wide-eyed trepidation, he describes the experience:

> I had a dream about this place. . . . I'm in here, but it's not day or night. It's kind of half night, you know? But it looks just like this . . . except for the light. And I'm scared like I can't tell you.

. . . I realize what it is. There's a man in back of this place. He's the one who's doing it. I can see him through the wall. I can see his face. . . . I hope that I never see that face ever outside of a dream.[16]

And now, he believes he will be able to regain his composure if his friend will just join him on a quick trip outside the restaurant to look behind a nearby dumpster to verify that this man, "the one who's doing it," and whose face is so cosmically unsettling isn't there at all. This, he believes, will do the trick. Slowly and nervously, they make their way to the troublesome spot.

I'd like to interrupt this recollection to urge the reader to consider the wisdom of refraining from reading further if it's the case that you have yet to see the film. If you're with me (and Lynch) when it comes to the conviction that, with great cinema, you're on the threshold of a world you can't quite access apart from watching the thing, why disrupt it by depriving a gift of awareness of its ability to dawn on you slowly? Isn't the slow dawn worth the wait? If you don't think so, you've been warned.

Presuming you've seen it, you know what lurks behind the dumpster and its place as the guiding centerpiece of this purposefully fragmented, often necessarily non-linear film. That man (Creature? Power? Principality?) in back of the place—the one who's doing it—represents the sad and horrible realization, for Naomi Watts's Diane Selwyn, of what's been done to, by, and through her. The wicked dream that has seized her heart—and that constitutes the majority of this extraordinary film—is hers.

Within the first few minutes of *Mulholland Drive*, we have music and dancing a little reminiscent of the ritual Louis Buñuel's Satan in *Simon of the Desert* (1965) refers to as "Radioactive Flesh."[17] Amid the frenzied dance scene, we also have Diane Selwyn (or more specifically her dream-self, Betty) gazing with adulation upon the arrivals section of the Los Angeles airport alongside an elderly couple who will assure her, with what we might come to regard as a malevolent, lying optimism, that she's going to be a star (we'll see them behind the dumpster and soon driving her to final despair before it's all over). *And* we have the sound of Selwyn's labored breathing as the camera assumes her perspective as she drops her head (our head?) on a pillow for something close to the last time.

16. Ibid.
17. Buñuel, *Simon of the Desert*.

Something bad is happening. Dianne Selwyn has been defeated by her own despair. In her dream, her name is Betty, and she's come to Los Angeles to stay in her aunt's apartment while trying to break into acting ("I'm from Deep River, Ontario, and now I'm in this dream place").[18] And in fairy tale fashion, a beautiful and kind woman suffering from amnesia awaits her there, having wandered in and fallen asleep following a head injury involving a car accident (which prevented her murder) on Mulholland Drive. Spying a poster for the film *Gilda* (1946) starring Rita Hayworth, she decides her name is Rita when asked.[19]

But this is the dream of one hopelessly and tragically estranged from her own intuition. Slowly and surely, the dream is both playing to Selwyn's best fantasies about herself while simultaneously breaking the news about what's really happening. Someone's *still* in trouble. The girl is *still* missing. Time for a little sleuthing. Betty knows just the thing for it, "It'll be just like in the movies. We'll pretend to be someone else." Why? "Just to see if there was an accident on Mulholland Drive."[20] Betty *winks* at Rita as she tries to glean information while also misleading the police concerning her own identity on a payphone at Winkie's. Sitting at a table for a bite to eat, Rita sees a waitresses nametag which reads "Diane." This suddenly brings to mind the name of Diane Selwyn. Maybe *that's* who Rita really is. As they try to call the Diane Selwyn in the phone book, Betty remarks, "It's strange to be calling yourself."

We begin to see that there's hardly a moment in *Mulholland Drive* that *isn't* Diane Selwyn somehow calling herself in one way or another. It isn't the case that every episode in her dream draws on real life events to which we're eventually made privy, but we can easily guess at their referents in reality. For instance, her beamingly expectant smile, as she exits a taxi having perfected her lines as she arrives for an audition, is accompanied by powerfully sad music that wouldn't have been out of place on *The Elephant Man* soundtrack.[21] Upon entering, she's surrounded by a small crowd of polite film professionals, presumably on hand to observe her promise as an actress. The leading man they invited to help her demonstrate her mettle is a smarmy actor who is clearly her senior by decades. He lets Becky and the director know the way he'd like to operate:

18. Lynch, *Mulholland Drive.*
19. Vidor, *Gilda.*
20. Lynch, *Mulholland Drive.*
21. Lynch, *Elephant Man.*

"I wanna play this one nice and close like we did with the other girl . . . Whatsername? . . . the one with the black hair. It felt kind of good. We're gonna play this nice and close. Just like in the movies."[22]

In an achingly awkward scene that is, to my knowledge, without precedent in cinema, we watch Becky respond to his groping advances with such convincingly passionate enthusiasm (seemingly lost in erotic abandon) that the actor and the onlookers are left in a state of shock. But just before their scripted scene concludes, she fixes her tear-filled eyes upon a man she's only just met and made out with and delivers her line: "Get out of here before I kill you. I hate you. I hate us both."[23]

While we don't know for sure that Betty's eye-rubbingly degrading audition is based in events that occurred in Diane's waking life, we know all too well that these words of murderous self-hatred were spoken and acted upon by Diane in one of her last exchanges with Rita's real life self, Camilla Rhodes. We know that they were intimate friends and sometime-lovers, and we are made to see, in the gradual unfolding of the moral vision of the film, how one beautiful and gifted woman is reduced to a state of trauma, betrayal, and diminishment so isolating that she makes arrangements to have the love of her life murdered.

Most movingly, Lynch tells the long, complicated, numinous tale of Diane's failure to hide the fact of what's happened to, in, and through her from herself. The film is, in this sense, a chronicle of tragic realization. It is also, in more ways than anyone can keep track, an intense work of mourning. By way of phone calls and extensive sleuthing, Betty and Rita together make their way to Diane Selwyn's own apartment where they behold and grieve her decomposing body. And guided by the totem of a mysterious blue box (arising, it appears, from the real-world blue key Diane's contracted killer leaves as an agreed-upon sign of the murderous deed done), they make their way to an exotic and darkly lit theater where they listen to Rebekah Del Rio singing Roy Orbison's "Crying" ("Llor-ando") with what looks to be her last breath. In sync with the song, Rita weeps, Betty shakes uncontrollably, and our lead characters mourn the loss of their own lives, crying over each other, themselves, and the whole sad surreal situation. Perhaps we can say that the scene, the song, and the film as a whole mourn a failure (personal, collective, and cultural) to

22. Lynch et al., *Mulholland Drive.*
23. Ibid.

somehow turn longing into *be*longing. Such failure, needless to say, is in no way limited to the alternative realities of Los Angeles.

FIGURE 03

In a turn of events I imagine might please Lynch immensely, one of the best known and intensively attentive reads of *Mulholland Drive* comes from a screenwriter and online essayist who's chosen to don the moniker Film Crit Hulk while also adopting, in a sometimes deceptively comic tone, Hulk's distinctive mode of communication. I commend to you the whole of his lengthy and appreciative breakdown, but in the meantime, consider this take on Lynch's accomplishment:

> DOESN'T IT ALL COME TOGETHER TO PAINT AN INCRED-
> IBLE PICTURE OF THE PSYCHE OF GUILT AND DISPLACE-
> MENT? THE IDEAS OF WHAT WE WANT FROM PEOPLE
> AND WHAT WE DON'T WANT? THE TRUTHS WE FACE
> ABOUT OURSELVES AND THE FEELINGS WE BURY? HULK
> CHALLENGE YOU TO NAME ONE CHARACTER YOU FEEL
> YOU "KNOW" BETTER THAN DIANE SELWYN (sic.)? WE'VE
> GOTTEN TO SEE EVERY CREVICE OF HER MIND.[24]

As I extend Film Crit Hulk's challenge to students of *Mulholland Drive* and other forms of cinema, I'd like to note how the thoroughness of Lynch's meditation on Diane Selwyn's life constitutes a prophetic sum-mons to attentiveness and care in our relationship to one another. In its

24. Hulk, "Film Crit Hulk Smash." I thank Nathan Johnson for calling my attention to this breathtakingly thorough analysis.

unveiling of certain processes that would and do break down human souls, it performs the work of apocalyptic—challenging systemic evil that's been normalized as harmless, inevitable, and relentlessly profitable. In a deeply paradoxical way, Lynch shows us what cinema *can do* in masterfully chronicling what entertainment industry *actually does*—and is often even orchestrated to do—to countless vulnerable and hopeful people. *Mulholland Drive* brings into light a sacred insight concerning what we're up against in our taking in of image and story and song and dance, the business of showing—the showing business—whether the fire we think we have before us is false or true.

"Nothing can stay hidden forever," Lynch insists.[25] And if we receive this mantra as a trustworthy adage, we might begin to see that the time to enlarge our sympathies, to increase the scope of what we feel, of what we know, of what we might yet do in the way of regarding ourselves and one other compassionately and imaginatively is now. There's many a Diane Selwyn among us (without and within). It is never too soon to undertake this sacred work. One can develop a taste for it. It is the name of the human game after all. Or, as Lynch puts it, "I love seeing people come out of darkness."[26]

Bibliography

Buñuel, Luis. *Simon of the Desert*. Criterion Films, 1970.

Certeau, Michel de, and Luce Giard. *Culture in the Plural*. Minneapolis: University of Minnesota Press, 1997.

Frost, Mark, and David Lynch. *Twin Peaks*. Paramount CBS, 1990.

Hulk, Film Critic. "Film Crit Hulk Smash: Hulk vs. The Genius of Mulholland Drive." March 3, 2012. Online: http://birthmoviesdeath.com/2012/03/04/film-crit-hulk-smash-hulk-vs-the-genius-of-mulholland-drive.

Lynch, David. *Blue Velvet*. MGM Home Entertainment, 1986.

———. *Catching the Big Fish: Meditation, Consciousness, & Creativity*. New York: Penguin, 2006.

———. *Eraserhead*. Criterion Films, 1978.

———. *Inland Empire*. Rhino Entertainment, 2007.

———. *Lost Highway*. Universal Studios Home Entertainment, 1997.

———. *Mulholland Drive*. StudioCanal, 2001.

———. *The Elephant Man*. Paramount, 1980.

———. *The Straight Story*. Buena Vista Home Entertainment, 1999.

25. Lynch, *Catching the Big Fish*, 109.

26. Ibid., 129.

Marshal, Colin. "David Lynch Lists his Favorite Films and Directors." *Open Culture*. September, 18, 2013. Online: http://www.openculture.com/2013/09/david-lynch-on-his-favorite-directors-including-fellini-wilder-tati-and-hitchcock.html.

Vidor, Charles. *Gilda*. Columbia TriStar Home Video, 1946.

Wilder, Billy. *Sunset Blvd*. Paramount, 1950.

Leaving Earth To Find Home

Eric Kuiper

Mystery creates wonder and wonder is the basis
of man's desire to understand.

—NEAL ARMSTRONG[1]

A future flight should include a poet, a priest and a philosopher . . .
we might get a much better idea of what we saw.

—ASTRONAUT MICHAEL COLLINS[2]

And I'm floating in a most peculiar way . . .

—DAVID BOWIE[3]

Introduction

My great-grandmother went to her grave convinced Neal Armstrong never set foot on the moon. She believed the lunar landing took place on a Hollywood sound stage—a made-for-TV moment—broadcast as a hoax. Her refusal to accept this "giant leap for mankind" wasn't based in conspiracy theory. She was unwilling to accept the implications of such an event. While a sharp and witty woman, the idea of a man on the moon was more than she could digest. It was easier and more comfortable to call it a lie.

Outer space has long been a source of wonder and fear for humans. Its vastness is more than we can conceive, its mysteries beyond

1. http://www.hq.nasa.gov/alsj/a11/A11CongressJOD.html.
2. http://www.nmspacemuseum.org/halloffame/detail.php?id=37
3. David Bowie's "Space Oddity," July 11, 1969.

our comprehension. Psalmists and poets have been looking upward in awe for millennia. We can't help but wonder what's out there and what it means for us on Earth. Recent news stories of water on Mars only increase this feeling, as our imaginations run wild.

Space has been a rich context for films for decades, most notably, Stanly Kubrick's *2001: A Space Odyssey*; practically every space film (and many science fiction films) stand on its shoulders.[4] Just as it did for my great-grandmother, space represents an unknown, filled with inconceivable realities, pushing our understandings of what is possible to a breaking point. Beyond stretching our scientific minds to their limits, space can also provide a context where we as humans are at our most vulnerable state. While we may be able to enter space, we know it is a hostile environment and that we can't stay there permanently. We strive to go nonetheless, though, in part, because voyages return us home anew, as changed people. This is fertile ground for cinematic storytelling.

Paul Tillich defines revelation as experiences that shake, transform, or heal us. Two recent films have provided unique and intense encounters with space that do just that—creating cinematic encounters with disruption and healing. In what follows, we will explore the implications of experiencing space through acclaimed director Christopher Nolan's *Interstellar* and the Academy Award winning film, *Gravity*.

Theorizing the Final Frontier

When Lewis and Clark first gazed in awe at the wild western landscape I dare say neither of them imagined the Hoover Dam. Those mountains and rivers seemed untamable, powerful beyond any human strength. They must have felt so small. But now humans stand as a greater threat to the wilderness than the wilderness poses to us. A day may come where outer space will feel as hospitable to us as Yellowstone National Park does to thousands of travelers each year. While there seems to be an element of inevitability about that, we don't believe it. We don't live it. We can't feel it. Space feels untamable—within reach, yet dangerous to touch—bigger than our minds and our machines. Thus space, in our storytelling, becomes much more like the wilderness of old; a place we go to test our strength, to find our limits. It is still bigger than us—more dangerous to us than we are to it. "Space," as we employ the term, is more a construct

4. Kubrick, *2001: A Space Odyssey*.

for naming our late modern sense of "Manifest Destiny" than serving as an apt, scientific designation for the intergalactic physical environment space. Therefore, it is a context ripe for gaining perspective and, ultimately, humility. Space confronts us with not only the limits of our human bodies, but of our thinking and technology as well.

Space makes us feel small, maybe even insignificant. Therefore, it is a natural context for stories that call for our expansion. As humans, we've climbed every peak, sailed every sea, and explored Earth from pole to pole. Outer space is all that is left—and as explorers and conquerors, we seem destined to go. Beyond existing as the next challenge or place for us to plant our flag, the rules that govern space are not like those on Earth. That is, space doesn't just lack oxygen and gravity. The most elemental things of our world, such as light and time, behave differently there. We have only just begun to wonder about the implications of our entering into these other realities. Space begs for us to think bigger, to dream with greater boldness, to imagine how we might tame its unpredictability. Space calls for us to become what we have yet to believe is possible.

But in making us feel small, space also creates an environment where we embrace our limits. Spurred on by its disorienting perspective, space may be the greatest location for stories of introspection and healing. Space is a wilderness that, while confronting us with our finiteness, opens doors to possibilities that only exist when our human fragility is acknowledged and embraced. The humility that space generates creates the kind of existential strength that comes through the embracing of our weakness—the kind of life that only exists on the far side of death, the brand of hope that comes after experiences of profound despair. In making us feel small, space grounds us in our limits. With *Gravity* and *Interstellar,* space becomes about much more than space itself, than the geographical just beyond the edge of Earth's atmosphere. In both films space takes on new meaning altogether, ultimately signifying a new vantage point from which we can come to see Earth—and our life on it—with new eyes.

Floating in a Most Peculiar Way

Your heart rate is elevated; your adrenaline is pumping. As the door of the airlock opens, the moment that should bring relief is instead an encounter with regret, denial, and wonder. Your eyes, along with the eyes of the two surviving astronauts who have just narrowly escaped death, settle

on the face of the elderly man right in front of you. They knew before they left that the stakes were high. Things had not gone the way they had hoped—there would be no reward for the risk they took. And now, standing in the doorway of the ship, greeting them with his aged face is Nikolai Romilly, the physicist and crewmate they left behind. With three words he confirms their (and our) fear, "I've waited years."[5] Twenty-three years, to be exact.

There are white-knuckle sequences and heart wrenching relational moments throughout Christopher Nolan's 2015 film *Interstellar*, but none are more weighted with implications than this scene with Romilly. All of the film's deepest concerns are represented in this single moment, this singular encounter. *Interstellar* expands the imagination of its viewer through the blending of fact and fiction, cultivating a tension between what we know, what we can imagine and what we believe. Nolan is not looking to simply entertain; he intends to disrupt our understanding of self—and with it, everything else.

Cooper, played by Matthew McConaughey, is a former NASA astronaut who is mysteriously drawn into an undercover space mission to save humanity. He is also the calm, bright widower father of two children, living with his father-in-law on a farm somewhere in America. Earth is becoming an impossible home for humanity. Blight, a plague of biblical proportions, is ravaging crops around the world, one variety at a time. Food is running out. Time is running out. Soon Earth will no longer be a sustainable home.

Cooper is a complicated character. When he is asked to pilot what is likely humanity's last-ditch effort to find a new place to live, his motivations feel mixed. It seems obvious that his desire would be to give his children a chance at life, and this is no doubt a driver, but the decision is not that simple. At one point he says to his ten-year-old daughter Murph, "We've forgotten who we are. Pioneers, explorers, not caretakers."[6] He is speaking of humans in general, not just himself. He goes on to say, "We used to look up at the sky and wonder at our place in the stars, now we just look down and worry about our place in the dirt."[7] These are not the words of a simple family man willing to risk his life for his children's future. Exploration is at the core of Cooper's being.

5. Nolan, *Interstellar.*
6. Ibid.
7. Ibid.

Having made the two-year trip to and through the wormhole that gives them access to new planets, the crew is now exploring their options. Romilly's chilling sentence, "I've waited years," greets Cooper and fellow crewmate Brand (Anne Hathaway) as they return to their ship after attempting to connect with astronaut/explorer, Dr. Miller.[8] When the pod Cooper and Brand took from Endurance to land on Miller's planet arrives, they find only wreckage. Dr. Miller, who was sent into space years before as a part of the Lazarus Mission, a secret NASA project to find inhabitable planets, is dead. The planet is not only uninhabitable, its environment is hostile, killing one of their crewmates, Doyle.

With this, we return to the chilling scene with Romilly. If the loss of Miller and Doyle was not enough to deal with, Romilly embodies something more they have lost: time. Due to relativity, one hour on the watery planet from which they barely returned is equal to seven years on their ship and back on Earth, millions of miles away. This near total disaster cost them a quarter decade. If Cooper left to save his children, this is quickly turning into a fool's errand. In Romilly, Cooper faces the reality of what he has chosen. If Romilly's grey hair and wrinkles are not enough to make the point, Cooper's watching of a series of video transmissions his family has been sending him from Earth over the years certainly is. In one of the most emotional scenes in the film, Cooper is overwhelmed as he watches his son, Tom, not only age before his eyes, but also lose hope that he will ever see his father again.

The final video is Murph. She has not communicated with her father since he decided to leave. She is now the same age as Cooper when he left. She too is giving up on the idea of him ever coming home. Cooper weeps at his virtual death in the minds and hearts of his children. He is confronted with the pain he is causing the ones he loves. He must wonder if they see him as a failure, a fool. His regret streams down his face.

As a viewer, there are a number of experiences that this scene back on Endurance might trigger. Depending on our own individual stories, the story on the screen might overlap in different ways with each of us. Murph's sense of abandonment might mirror our own experience with our father—her resentment unearthing our own. As a parent, and more specifically a father, I cannot help but vicariously live this moment along with Cooper. While I am far from being an astronaut—playground swings make me nauseous—I'm at a point in life where my career and my

8. Ibid.

family seem to be in tension with each other more than in harmony—each asking and hoping for more of my attention all the time. As Cooper deals with the cost of his choice to leave, the chasing of a dream and hope that maybe was as much for his own thrill as it was anything, I not only empathize with him, I feel his regret as well. What am I working towards each day as I leave home? For whom do I work and sacrifice? What am I missing as I step away for yet another meeting or event? And when I am at home, my mind or attention is often elsewhere (flipping through social media feeds or answering one more email). I may not be on a spaceship orbiting an unnamed planet light years away, but I might as well be. As Cooper watches the film of his son growing without him, becoming a husband and then a father, he comes to grips with what he has missed. Might I feel the same some day? *Interstellar* invites me to consider the cost of my absence cathartically, experiencing the absence of both Cooper and his children.

While *Interstellar* nudges us to consider our own familial realities, thus opening the door to some healing in our lives, it is at its most powerful as it works to disrupt our sense of the universe. As Romilly's grey hair and fragile frame incarnate the reality of relativity, it's not just our understanding of time that is disrupted; our entire framework for understanding ourselves is affected. The narrative no longer stems around complicated math equations and scientific jargon that we can't understand. It leaves behind the question of *will he (Cooper) make it home?* and crashes headlong into the question *what has home become?* In this brief moment, time relativity is experienced on a human level. Its effects are manifested in front of us and cannot be undone. This is when we feel the weight of a reality that is impossible to understand.

FIGURE 04

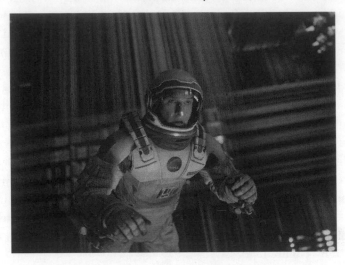

Our sense of time as a singular, universal thing has not just been disrupted; it has been demolished. And while Christopher Nolan is far from creating a scientifically infallible script, he did rely heavily on research and data. This is no Marty McFly with his flux capacitor. *Interstellar* can fairly be called science fiction, but it's also loaded with scientific fact. Relativity opens the door to questions for which most of our philosophical and theological frameworks are light years away from being ready to properly engage. Late in the film, as Cooper is moving through the matrix of bookshelves looking for specific moments in time where he and Murph are in her room, what's left of our concept of time is vaporized; time is now seen as not only inconsistent, it's nonlinear as well.

Dr. Brian Greene, a professor of physics at Columbia University, gave a highly entertaining lecture at Calvin College in 2001 on the mathematical concept of string theory. He wasn't ten minutes into his talk before I was almost entirely lost. At one point he explained that string theory is pointing towards the possibility of there being not only five dimensions, but ten or eleven dimensions. I remember laughing out load at this idea. I can't even begin to conceive what a fifth dimension would be let alone six through eleven. I walked out of the lecture hall dazed and full of wonder. Understanding or conceiving these ideas seems impossible right now, but what Nolan creatively depicts in different ways maybe more real than we dare imagine.

If time is relative and non-linear, what does that do to our sense of self? What happens to our beliefs about past and present? How do we understand growth, healing, and forgiveness? What does this do to our understanding of God? How much of our narrative about our own spirituality is tied to our understanding of time being something that we can use to measure and chart our transformation? What happens to our theology when all time is present now? It's impossible to list all the questions that are raised when our understanding of time is shifted so dramatically. While it is easiest to simply dismiss these questions as a waste of time and a product of science fiction, focusing instead on our understanding of things as they are now (much like my great-grandmother and Murph's teachers do), is it time we ask whether our theology is large enough, powerful enough, to go intergalactic?

Humans like boundaries. We want to know where things start and stop. We want to know where the outer edges of things lie. We want ins and outs, the us and them. While most people believe in some sort of a deity, many of us spend much of our time trying to understand our God through doctrine and dogma. We labor over systematic theologies in order to bring limits to the limitless, understanding to the unknowable. In viewing Earth from space the arbitrariness of our created boundaries is confronted. The lines we use to separate one country from another are not erased, they are revealed for what they are—figments of our imagination, dreamed up fences that bring comfort through perceived control. Our understanding of time is a way of making boundaries as well—something with which to build fences. It's a form of measurement that brings predictability and that predictability supplies comfort.

Interstellar goes beyond moving the boundaries of time in a way that most time traveling stories do, simply making it a linear reality that can be moved along in either a forward or backward direction. Nolan disrupts us on a much more existential plane by removing the boundary all together. He leaves us with the questions of whether time, as we understand it, is really anything more than a human construct, a figment of our own collective imaginations. The measuring stick we have been using to bring comfort through understanding isn't just broken, it evaporates before our very eyes. In viewing this film, we are confronted with the level to which we have crafted our idea of the universe by using the boundaries of our understanding. As a part of that we must confront the levels with

which we create God in our own image as well. Our systematic theological frameworks strive to wrestle the divine into an understandable, predictable being. What will happen (maybe better said, is happening) as that understanding shifts and expands? Will our theology adjust as easily? The history of the church does not suggest that shifting theology in response to science is a strength.

Interstellar invites, possibly even demands, that we expand our thinking. But what will our response be? Will we look up to the stars filled with wonder or will we look down and worry about our place in the dirt? Will we respond with humility and openness to that which we cannot understand or with resistance and fear as we cling to what we know?

Reentry and Rebirth

Gravity, Alfonso Cuarón's 2013 Oscar winning film, opens with simple white text on a black screen describing the harsh realities of space—its massive temperature swings and the absence of oxygen. As the score of the film crescendos, a final statement is added: life in space is impossible. Just as the sound of the film begins to overload the speakers, the film's title flashes on the screen for a moment and then cuts to total silence and a shot of Earth from 600 kilometers above.

Viewing Earth from space has a measurable effect on people.[9] Being confronted with the fragility of our planet as it hangs in the black expanse of space shifts our consciousness. Cuarón opens with this image, doing more than setting a context for his film akin to showing the skyline of a city. This opening shot is meant to affect us on the deepest level. This extended, silent look at Earth shifts our consciousness, calling us to consider both our fragility and our assumed centrality. Much like Carl Sagan reflected on the image of Earth as a pale blue dot, we are invited to consider how this planet represents the "aggregate of our joy and suffering."[10] Cuarón makes it clear from the beginning that this film, at its core, is about gaining a new perspective that will change everything.

Sandra Bullock plays Dr. Ryan Stone, a medical engineer on her first space mission. When a Russian missile shoots down a malfunctioning satellite, it sets off an unintended chain reaction of destruction by sending debris hurtling through space. A routine spacewalk for Ryan and her fellow astronauts quickly becomes a nightmare. The flying shrapnel

9. Frank, *The Overview Effect.*
10. Sagan, *Pale Blue Dot,* xv–xvi.

reaches their locations, killing the entire crew other than Ryan and Matt Kowalski, a space cowboy of sorts played by George Clooney. And while they survive the first pass of the space junk, Ryan becomes untethered and spins into the void of space. Kowalski, thanks to his jetpack, is able to track the panicking Ryan down and begin the process of trying to find their way back to Earth.

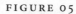

FIGURE 05

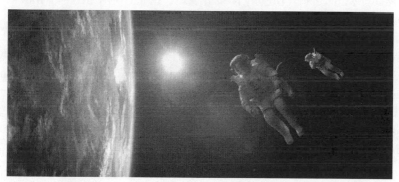

However, as mentioned before, Cuarón's space is not primarily for thrills and adventure. It is a place of perspective and revelation. As Ryan is tumbling into the black vastness she breathlessly repeats, "Does anyone copy? Please, copy. Please . . ."[11] An unexpected, unintended tragedy has struck her, and she is now lost. Does anyone see her? Can anyone hear her? Is she alone? Is she going to die out here?

I first watched *Gravity* with my wife in IMAX 3D. I went in expecting to be wowed by the sound of crashing space objects and ducking and diving as shrapnel flew by my head. While there was some of this sort of action, the real power of seeing this film in this large format was the silence and void of the film, particularly as it was created by such a massive auditorium. As Ryan tumbled out into space, pleading, praying that someone would hear her in her isolation, I was overcome by my vacuous surroundings. As she drifted further and further away from me (the use of 3D here was spectacular), my own despair came flooding in. Her fear was obvious and understandable, and we were made to experience that fear ourselves.

We soon learn that Ryan is living through tragedy on multiple levels. While making their way to the International Space Station (ISS), Ryan

11. Cuarón, *Gravity.*

tells Kowalski about her four-year-old daughter who died. Playing tag, she slipped and fell. Just like that—gone. While some may feel that Ryan's back-story is an unnecessary device used to generate an emotional response in viewers—preferring rather to let Ryan, as a person, be enough for us to care about and the metaphor less heavy handed—this multilayered storyline transitions the film from a simple thriller into a journey towards wholeness and rebirth.

The imagery in *Gravity* is clear. As Ryan narrowly makes it into the airlock of the ISS, she removes her suit and floats into the fetal position. As she slowly rotates, the tubes behind her look like an umbilical cord. Not knowing how to live in the absence of her daughter, this near-death experience in space is exposing a deep desire to continue to live. Ryan is being formed into a new person before our eyes. We are witnessing a rebirth, feeling it ourselves. Where we were vicariously experiencing despair through Ryan earlier in the film, we are now being invited to imagine what healing looks like—both hers and our own.

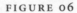

FIGURE 06

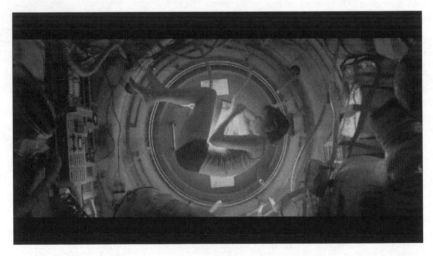

The profundity of the experience of watching *Gravity* is its simplicity. While it is filled with suspense and action, there are also extended moments where nothing is heard other than breathing—our most basic human function. In my years as a pastor, sitting with many people who are navigating grief and tragedy, a similar sentiment often arose. How do we continue to live in the midst of unexplainable tragedy? One day, one

moment, one breath at a time. How do we navigate life when waves of grief continue to show up like a cloud of debris, ripping at our being? We chose to take our next breath. We put one foot in front of the other and take the next step.

While *Gravity* relies heavily on imagery to drive home this point, it is not afraid to come right out and say it, here through a vision Ryan has of the now dead Kowalski:

> Listen, do you wanna go back, or do you wanna stay here? I get it. It's nice up here. You can just shut down all the systems, turn out all the lights, and just close your eyes and tune out everyone. There's nobody up here that can hurt you. It's safe. I mean, what's the point of going on? What's the point of living? Your kid died. Doesn't get any rougher than that. But still, it's a matter of what you do now. If you decide to go, then you gotta just get on with it. Sit back, enjoy the ride. You gotta plant both your feet on the ground and start livin' life. Hey, Ryan? It's time to go home.[12]

After all the heroic moments of *Gravity* have played out, Ryan finds herself back on Earth, crawling onto the shore of a lake she has crashed in. Again, she is presented as fragile and unsteady, her body having to learn again to walk in the presence of gravity. Her feet are heavy; her steps awkward like the first steps of a newborn as she rises out of the water. A new life is emerging.

Conclusion

Interstellar pushes us to wonder about our existence in a universe that is more vast and complex than we can possibly conceive. It screens dreams of a day when humans will live in places and ways that most of us cannot even imagine. It confronts us with the limits of our thinking and expands our imagination. It takes us away from Earth so we can see past its limitations. *Gravity* does something very different. It uses space as a wilderness-like canvas where clarity and healing can emerge. For Cuarón, life is impossible in space. We leave Earth so we can return to it in a new way. In each film we are invited to dream about a new future. In each film we can no longer see ourselves, our touch points back home, or our God in the same way. The first, out there, where the unknown is mind-boggling and

12. Ibid.

reality is ever expanding. The other, down here, reborn through healing, finding a home in a new way.

Like my great-grandmother, my generation also had a significant experience with space travel on a screen. I was nine years old, watching a TV set on a tall cart in the front of my classroom, when the space shuttle *Challenger* exploded before my eyes. I still don't know what an O-ring is, but the vision of one failing will never leave my mind. As a result, space has always been a scary, unpredictable place where I'm not sure we're meant to be. This early, on-screen experience with space no doubt influenced my interpretation of all those that followed. Where my great-grandmother met these realities with denial, I am more accepting, but I'm not sure I'm any less unsettled. It is along these unsettling lines that *Interstellar* and *Gravity* disrupt our understanding of self, exposing the mystery of our existence. Each, in their own way, phrase similar questions to us as viewers: Will we embrace the disruption and seek new understandings, or will we file these experiences away as science fiction and return to the comfort of the known? Will we look up at the sky and wonder at our place in the stars, or will we just look down and worry about our place in the dirt?

Bibliography

Cuarón, Alfonso. *Gravity*. Warner Home Video, 2013.

Kubrick, Stanley. *2001: A Space Odyssey*. Warner Home Video, 1968.

Nolan, Christopher. *Interstellar*. Paramount, 2014.

Sagan, Carl. *Pale Blue Dot: A Vision of the Human Future in Space*. New York: Ballantine, 1997.

White, Frank. *The Overview Effect—Space Exploration and Human Evolution*. New York: Houghton-Mifflin, 1987.

The Impossibility of the Black Hero

James Baldwin and the Cinematic

By Zachary Thomas Settle

The language of the camera is the language of our dreams.

—JAMES BALDWIN[1]

Introduction

With lucid writing and subtle argumentation, James Baldwin's investigation of cinema implies that the power of film typically exceeds the ways in which we make use of the medium; that is, we have yet to fully take advantage of film's potential. The force of a film rests in its ability to encounter the viewer on the affective register, shaping their imagination and thus informing their experience of the material world in and through their experience of the screen. These screened propositions are, in most cases, ideological realities fueled by a widespread, deeply established set of prejudices. Such ideological forces inevitably shape the dynamics of the viewer's vision, bringing a particular world into view by means of orienting the viewer's imagination, ultimately determining the way we see others, the material world, and ourselves.[2]

1. Baldwin, *Devil Finds Work*, in *James Baldwin: Collected Essays*, 503.

2. This essay was born out of dialogue with Scott Schomburg: the sort of constructive dialogue around film and theory that this volume seeks to inaugurate. I was fortunate enough to have the opportunity to edit Scott's essay on James Baldwin and Django Unchained for The Other Journal. Scott pointed me to James Baldwin and the implications of Baldwin's writings on film in general. He was also generous enough to give some helpful feedback on this particular chapter, and I am grateful for the ways in

47

Properly understood, film is not a medium that we experience and consume without simultaneously being affected and moved by it. The very nature of the medium requires a certain active participation, which also entails the viewer being acted upon, as the screen's recipient. All of this matters to the extent that it is a window into the mode through which film impacts the viewer's political-theological imagination. As history has shown—particularly in the American context—this political-theological imagination is a racialized one, rendering certain bodies to their supposed place within a mythological hierarchy of value. The unfolding of this entire process results in a preservation of the white gaze in and through its screening. Screened whiteness is at times, though, resisted and even disrupted by films that pick up the ideological tools of cinema and reorient them, using them against the purposes of whiteness as a disruptive act. Such acts inaugurate a new politic.

There seems to be no better conversation partner for investigating the affective nature of screened whiteness than James Baldwin—an American essayist, novelist, playwright, poet, and social critic who rose to prominence in the 1950s. Baldwin has much to say about overcoming ideologies grounded in whiteness. By investigating Baldwin's work, and locating ourselves in this racialized landscape, we can position ourselves to learn from him, to take cues from his own unique set of insights, experiences, and analyses. Baldwin helpfully analyzes the experience of the viewer in relation to screened realities as a means of speaking to the interconnectedness of vision, cinema, affectation, and everyday life, of taking those screened realities and being moved by them into the world. Works such as *Notes of a Native Son, Nobody Knows my Name,* and *The Fire Next Time* carefully and attentively analyze questions of racialization, identity formation, and existence in the midst of social and psychological conditions of disease and trauma. His lucid, direct writing points to the racial realities and histories that have created the dynamics in today's American consciousness. Baldwin can speak to these realities because he experienced them fully; his own identity as a black man in the 1940s was shaped by those normalizations. Film is a clear instance of racial imagination on display, as it crushingly informs and shapes our world through the imaginations of its viewers.

In the wake of his father's death, Baldwin slowly learned what it means to live with whiteness. He writes, "I learned in New Jersey that to be a Negro meant, precisely, that one was never looked at but was

which his thought enabled my own on the topic.

simply at the mercy of the reflexes of the color one's skin caused in other people."[3] Baldwin's experience of blackness, he tells us, was determined by a certain reflexivity. Baldwin learned to live with whiteness from an early age; whiteness was the operative norm by which his own body was determined and placed.

In a fascinating interview with Ingmar Bergman, in which Baldwin asked Bergman about the nature of his relationship with his father, Bergman explained that the two got along quite well and visited often. Baldwin reflects in the text, without saying it directly to Bergman, that such a reality was due to Bergman's relationship to his own past, because of his ability and willingness to use that history as he would.[4] Baldwin speculated that history itself might have the latent power to rupture systems of white power and dominance. History is the heaviest of burdens in the black experience of film, and it is not a burden that typically manifests itself in the white experience. In reflecting on his visit and conversation with Ingmar Bergman, Baldwin writes, "It did not seem likely, after all, that I would ever be able to make of my past, on film, what Bergman had been able to make of his. In some ways, his past is easier to deal with: it was, at once, more remote and more present."[5] Baldwin challenges us to turn to our histories, to attempt to bring into view the fractured narratives that make our lives possible.

Baldwin and the Slave Hero

Baldwin incessantly investigates racialized realities throughout his entire project, but in a few particular essays he sheds light on these notions of racialization through film analysis and criticism. This unique methodology comes to fruition most clearly in *The Devil Finds Work*, a truly genre-defying piece—a collection of personal essays with film criticism and cultural criticism interwoven throughout—in which Baldwin narrates his own experience growing up alongside, in conjunction with, and even through the experience of film. In this candid and brilliant work, Baldwin theorizes on issues of the gaze, cinematic experience in general, and blackness in conjunction with popular film, constantly treading on the racial subtexts at play in American film. And Baldwin's critique of screened whiteness, particularly as the reader sees it determine the

3. Baldwin, "Notes of a Native Son," in *James Baldwin: Collected Essays*, 68.
4. Baldwin, "Northern Protestant," in *James Baldwin: Collected Essays*, 246.
5. Ibid.

positioning of Baldwin's own black body in white spaces throughout the course of the text, is a timely example of the potential power of film. The force of Baldwin's analysis rests in its fluidity, in the surfacing of the sub-textual, in the way that Baldwin's commentary ebbs and flows between the films and his own life.

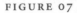

FIGURE 07

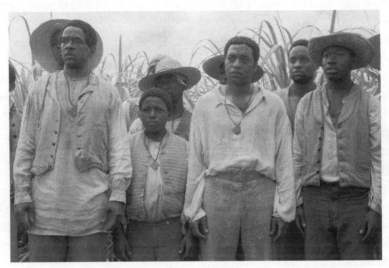

By no means the first screened investigation into the nature of slavery in American history, Steve McQueen's *12 Years a Slave* is perhaps the first popular film that deals with the subject in a way that gives proper weight to its history. Rather than attempting some abstracted overview of the history of slavery and racialization in America, the film, predominantly set in slave plantations in the antebellum south in the 1840s, tells the story of a single man's experience. The film centers around the experience of Solomon Northup, an accomplished musician and a free man in the North, who was drugged, kidnapped and sold into slavery away from his family in Washington D.C. Rather than forcing some heavy-handed critique or moralistic reading of an obviously painful set of atrocities, inadvertently bypassing any sort of constructive reflection on the very means by which a set of experiences get historicized, McQueen takes a different approach altogether. His pace is slow and intentional as he directs the gaze of the viewer into the heart of Northup's experience, thereby calling us, challenging us, to simply sit with the particulars of Northup's history before attempting to move beyond them. *12 Years a Slave* is attentive and nuanced, avoiding cheap narratives for the sake of

attending to the subtleties of Northup's history and experience with the institution of slavery and the white supremacy that produced it. As *New York Times* critic Manohla Dargis points out, "It's a brilliant strategy that recognizes the seductions of movies that draw you wholly into their narratives and that finds Mr. McQueen appropriating the very film language that has been historically used to perpetuate reassuring (to some) fabrications about American history."[6] Such an approach is made possible by the historical grounding of the text on which the film itself is based, and McQueen's film takes that historicity quite seriously.

The film's long-form shots, for which McQueen has now become famous, come to their most haunting form in *12 Years a Slave*. One shot in particular lodges itself deep within the moral imagination of the viewer. We see Solomon Northup hanging from a tree in a noose, with his feet barely touching the ground. Strung between an old barn and the scaffolding of a new one, Northup exists somewhere between life and death, as his suffering body remains juxtaposed between finished and unfinished projects in the background.[7] Northup's place between the two barns positions his black body into the confines of industry, rendering it a certain monetary value according to its ability to produce commodities. Northup's life is being disposed as an industrial product. McQueen's incessant patience with his own medium forces the viewer to come to terms with the reality of Northup's struggle, with the placement of his body into a system of whiteness. Perhaps the most affective aspect of the shot is its duration. The only cuts in the dreadfully long sequence reorient the viewer's gaze from a different angle, thereby fixating the gaze on the same individual from a new perspective, who struggles for life in white spaces. It leads the viewer past a mere acknowledgment of what is being screened, as we watch other slaves in the distance return to their work seemingly unaffected, while Northup struggles, hanging, straining for breath as life around the plantation continues on as normal. The reduction of black life to industrial terms is seen most clearly in the normalcy by which the other slaves continue working according to the norms of that social context: meaning is codified in terms of a market logic, in the slave's ability to produce and labor. These are the norms of the white gaze, a gaze which we momentarily see into and through.

McQueen's incessantly long framing of Northup's struggle reveals that white viewers are, in some ways, immune to the realities of historical

6. Dargis, "Blood and Tears."
7. Bohr, "Steve McQueen and the Long Take."

burden, which we've allowed ourselves to be conditioned to overlook. White history is built on the practice of ignoring black history. As Baldwin writes, "[White people] are, in effect, still trapped in a history which they do not understand; and until they understand it, they cannot be released from it."[8] It is for this very reason that activist and lawyer Bryan Stevenson points to his disdain for film as a child. He had to sit in a different section of the theater, and the films categorically refused to own up to the injustices weaved into the fabric of his own history; it was simply too much for him to bear as a child.[9]

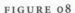

FIGURE 08

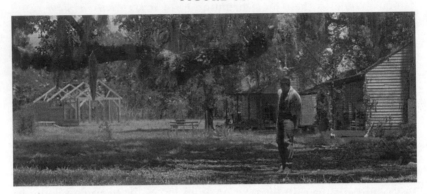

McQueen's articulation of whiteness is properly varied and nuanced, and it reveals a wide spectrum of involvement and complicity with the institution of slavery: economic and industrious profit in the perpetuation of the slave trade (Paul Giamatti's character as slave-trader), conscientious yet regrettable complicitness in the institution (Benbedict Cumberbatch's character as plantation and slave owner), demonic possession of and rule over the bodies of slaves (Michael Fassbender's character as plantation and slave owner) and sympathetic participation in the system itself through wage labor (Brad Pitt's character). Such representation troubles white histories, accounting for an array of forms of involvement typically overlooked in the white imagination, all of which served to participate in a system of control and domination. The experience of *12 Years a Slave* investigates racialized histories in a way that calls for the rendition of historical recitation in film as a re-investigation of the true past of whiteness.

8. Baldwin, "My Dungeon Shook," in *James Baldwin: Collected Essays*, 295.

9. Baldwin and Stevenson, "Bryan Stevenson Wants 'Equal Justice.'"

The Weight of History

George Yancy, in an op-ed piece for the *New York Times*, attempted to shed light on his own experience as black man in a land structured around the white gaze. He remembers and analyzes the experience as a teenager in which a white officer told him, "I almost blew you away! I thought you had a weapon," as he was walking through North Philadelphia in the late 1970s, armed with nothing more than a telescope.[10] He muses:

> This officer had already inherited those poisonous assumptions and bodily perceptual practices that make up what I call the "white gaze." He had already come to "see" the black male body as different, deviant, *ersatz*. He failed to conceive, or perhaps could not conceive, that a black teenage boy living in the Richard Allen Project Homes for very low income families would own a telescope and enjoyed looking at the moons of Jupiter and the rings of Saturn. A black boy carrying a telescope wasn't conceivable—unless he had stolen it—given the white racist horizons within which my black body was policed as dangerous. To the officer, I was something (not some*one*) patently foolish, perhaps monstrous or even fictional. My telescope, for him, *was* a weapon.[11]

Yancy goes on to explain that while the white gaze is a global, historically mobile reality, it stems from a distinctly European ideology and put down deep-seated roots in America.[12] He points out that David Hume plainly stated that even the most rude and barbarous of the whites existed in a plane of civility and nature far above black inferiority.[13] Immanuel Kant claimed that blacks "were vain but in a Negro's way."[14] Thomas Jefferson, in *Notes on The State of Virginia,* argued, "In imagination they [Negroes] are dull, tasteless and anomalous."[15] The first American Edition of the Encyclopedia Britannica defined the term "Negro" as "someone who is cruel, impudent, revengeful, treacherous, nasty, idle, dishonest, a liar and given to stealing."[16] These are the grounding principles in the foundation

10. Yancy, "Walking Black."
11. Ibid.
12. Ibid.
13. Hume, "Of the Standard of Taste," 238.
14. Kant, *Observations on the Feeling,* 111.
15. Jefferson, *Notes on the State of Virginia,* 142.
16. Yancy, "Walking Black."

of American ideology. Blackness, as Baldwin argues, is most commonly performed in reflexivity to another form of vision: the white gaze.

Baldwin, however, simultaneously bears witness to another form of black life that remains uncaptured by the white gaze—a black life that recognizes a disruptive truth buried beneath the lie of whiteness's narration of blackness. But such a form of black life requires constant resistance, constant subversion of the cultural norm and standard by which black bodies are determined. This is precisely why Baldwin is so preoccupied with the racial subtexts of film in *The Devil Finds Work*. He is keenly aware that mainstream cinema and media is operating according to—and in doing so, perpetuating—the white gaze.

Growing up watching films, Baldwin became aware that he was experiencing propositions which remained distinctly uncharacteristic of his own life. He writes, "Sylvia Sidney was the only American film actress who reminded me of a colored girl, or woman—which is to say that she was the only American film actress who reminded me of reality."[17] Baldwin is helpfully describing the myth of whiteness, a fantasy apart from which whiteness cannot cohere. Grounded in the fantastic, such mythological representations of the world remain characteristically untrue for Baldwin; this is another world altogether, which is precisely why any possibility, any memory, of his own experience as a black man in America prompted on screen remains so powerful. Speaking of the enormous difference between the stage and the screen, Baldwin highlights the affective presence of black bodies on stage, seeing them at work for the first time. He writes, "It is important to emphasize that the people I was watching were black, like me. Nothing that I had seen before had prepared me for this—which is a melancholy comment indeed, but I cannot be blamed for an ignorance which an entire republic had deliberately inculcated."[18] This is important for the very reason that it reveals how rare a legitimate screening of black life was, and arguably remains. Baldwin's own unpreparedness for such an encounter highlights something beyond the screen—the political-theological ideologies of whiteness so deeply imbedded and inculcated in American culture.

Baldwin, through growing up alongside and through these films, came to recognize a harsh disjunction between his own experience and what was being screened. This is what leads to his ironic critique of the

17. Baldwin, *Devil Finds Work*, in *James Baldwin: Collected Essays*, 493.
18. Ibid., 500.

impossibility of a black hero. He argues that, "Heroes, so far as I could then see, were white, and not merely because of the movies but because of the land in which I lived, of which movies were simply a reflection."[19] The discrepancies between his lived world and that which was projected onto the screen created a certain anxiety in him, an unease, of sorts, with the truthfulness of the screened proposition. He began recognizing and naming these screened propositions as untruthful, explaining, "The blacks have a song which says, *I can't believe what you say, because I see what you do.* No American film relating to blacks can possibly incorporate this observation. This observation—set to music, as are so many black observations—denies, simply, the validity of the legend which is responsible for these films: films which exist for the sole purpose of perpetuating the legend."[20] The screening of whiteness is a means of perpetuating control, and, as such, films functioning by that logic serve to prevent the revelation of the world.

FIGURE 09

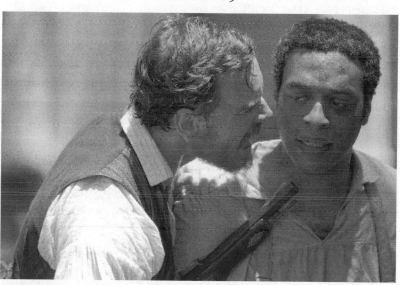

Baldwin's notion of the impossibility of a black hero is materialized in *12 Years a Slave*; the authenticity and historicity of the film ruptures the simplistic category of hero altogether. The narrative reveals the desecration of the humanity of all involved parties, and the hero rescues nothing

19. Ibid., 491.
20. Ibid., 522.

but his own humanity. McQueen demonstrates the impossibility of the category of a hero as a whole—Solomon Northup is a hero to an extent, but not in any recognizable manner. For Northup, there is no dramatic, fantastic shootout that undoes the institution of white supremacy; the weight of its history is simply too much for one man to bear.[21] Northup is forced to persist in the face of history's weight and perpetuation, to live under it, and his very redemption is to re-enter into the white space from which he was kidnapped in the first place. The American hero is the hero of history, and the burden of history is too great on the black body. McQueen reveals what other films conceal—the system of white supremacy cannot be overcome with a singular individual or through a single heroic act.

Baldwin's Tirade

Speaking of living under the tensions and pressures of the white gaze, Baldwin plainly states that, "It did begin to work on my mind, of course."[22] Baldwin's more famous experience of rage, which he carefully penned in "Notes of a Native Son," should serve as no real surprise, then. He exits a film in a daze of sorts, under the spell of the white gaze, unable to throw off its cold clutches completely. He writes, "When we re-entered the streets something happened to me which had the force of an optical illusion [different mode of seeing, materialization of a fantasy, illusion], or a nightmare."[23] He continues, "People were moving in every direction but it seemed to me, in that instant, that all of the people I could see, and many more than that, were moving toward me, against me, and that everyone was white. . . . I don't know what was going on in my mind, either; I certainly had no conscious plan. I wanted to do something to crush these white faces, which were crushing me."[24] After wandering into a restaurant, throwing a plate into a glass window and ultimately getting punched in the face for it, Baldwin finally comes to. He explains, "I returned from wherever I had been, I *saw*, for the first time, the res-

21. For an insightful analysis of Tarantino's *Django Unchained*—a film with such a dramatic shootout—through a Baldwinian lens, see Scott Schomburg, "Enduring World of Dr. Schultz."

22. Baldwin, "Notes of a Native Son," in *James Baldwin: Collected Essays*, 69.

23. Ibid., 70.

24. Ibid., 72.

taurant, the people with their mouths open, already, as it seemed to me, rising as one man, I realized what I had done, and where I was, and I was frightened."[25] The film itself served to perpetuate the white gaze, capturing and inundating Baldwin's imagination into an intense psychological state, one that he aimed to resist in the material world he inhabited. The construction of the social space itself—operating according to the logic of white supremacy—made such a movement of resistance difficult.

Baldwin himself was quite interested in both resisting and even disrupting the white gaze. In "The Northern Protestant," after interviewing Ingmar Bergman, Baldwin goes on to imagine his own film. He imagines, "My film would begin with slaves boarding the good ship *Jesus*: a white ship, on a dark sea, with masters as white as the sails of their ships, and slaves as black as the ocean."[26] Baldwin continues, explaining that his film would center around a singular figure: a slave, trapped in an eternal return of sorts, perpetually appearing in every generation. First in the good ship *Jesus*—a slave ship—as a witchdoctor or a prince, the figure is hurled into the ocean for protecting a black woman. In the era of Reconstruction, Baldwin continues, "he would be murdered upon leaving Congress. He would be a returning soldier during the First World War, and be buried alive; and then, during the Depression, he would become a jazz musician, and go mad. Which would bring him up to our own day—what would his fate be now?"[27] Baldwin's film idea functions historically, as a proper rendering of the historical situation, the screening of another world—our world in reverse—opens up our own world in a unique manner. For Baldwin, such openings of the world only become possible in the wake of historical investigations. The grounding of his film in the materiality of history allows us to see ourselves in light of the histories that have produced us, the histories we remained trapped in and continue to misunderstand.

Conclusion: Film's New Politic

Baldwin did not merely watch films; he *experienced* them fully. Speaking of the phenomenological relationship between the viewer and that which is being screened, Baldwin attests that, "In the theater, a current flowed

25. Ibid.

26. Baldwin, "Northern Protestant," in *James Baldwin: Collected Essays*, 245–46.

27. Ibid.

back and forth between the audience and the actors: flesh and blood cor-
roborating flesh and blood—as we say, testifying."[28] Though he doesn't
explore it in theoretical terms, Baldwin's film analysis is grounded in
phenomenological affectation. Baldwin is using explicitly relational and
spiritual terminology here, pointing to the dynamic call and response at
play in the pulpit. These affective powers at work in film were most pierc-
ingly experienced for Baldwin in terms of the white gaze. The theater is
bearing witness to a world, a world with overt similarities to our own, but
one that remains distinct, as an alternative possibility, a different world
trying to materialize itself in ours. By exposing the viewer to screened
realities, film materializes itself in and through the imagination and em-
bodied action of the viewer.

Similar to the way in which Baldwin's awareness of his role as a
viewer in the audience opened up a deeper analysis of his own experi-
ence, the screening of films creates a unique opportunity through which
viewers can self-reflect on the dynamics of their own vision, their own
way of seeing, which recognizes certain realities at the cost of overlook-
ing others.[29] Dan Flory, an important film and critical race theorist, ex-
plains that the harsh reality of these screened worlds is that they are not
merely entrapped on screen; they are materially affective claims, claiming
and becoming truths in the hearts and minds of their viewers.[30] These
claims become truths in the material landscape through the experience
of the viewer. Flory argues that the contingent, historically manufactured
myths of race at play in racialized film serves to influence and reinforce
popular conceptions of race, often without the viewer's explicit consent
or awareness. These racialized stereotypes, functioning according to a
subtle American logic, often sway us at subconscious level, reinforcing
hierarchies of fleshliness. He argues that any robust understanding of
film and its effects must account for "the contingent, historically deter-
mined social meanings attached to racialized images in art forms like
film, and how they may influence or reinforce ways viewers think about
race without their even realizing it."[31] Cultural representations affect cer-
tain psychological dispositions, which play a definite role in constructing

28. Baldwin, *Devil Finds Work*, in *James Baldwin: Collected Essays*, 524.
29. Schoback, "Phenomenology," 437.
30. Flory, "Race," 227.
31. Ibid., 229.

and altering the trajectory of the social landscape; film has the power to—and often does—perpetuate the white gaze.

Baldwin teaches us that film is a mechanism producing experiences by which the white gaze is both perpetuated and normalized, but it also contains within it the very means of disrupting and overthrowing such exclusionary ways of seeing and being. The possibility of rupturing the white gaze in and through film depends on a certain internal logic that manifests itself in the experience of the viewer. *12 Years a Slave* forces viewers to come face to face with the brutal history whiteness has conditioned itself to overlook, but it doesn't offer an easy way out. And such an experience sends us out of the theater and into the world differently than when we entered it. Perhaps, then, in the wake of such experiences, we will be able to more fully identify with Baldwin's tirade.

In capturing and reorienting the imagination of the viewer, thereby transforming the material reality she inhabits, film inaugurates a new politic, a politic that privileges difference through hospitality, making space for the materialization of screened realities bearing witness to a larger economic framework, one that constantly beckons us forward, towards more just horizons. It is precisely in the process of screening and imaging new worlds, other worlds, that film enables us to see our own in another way, with new eyes. Such a politic moves us further into our own worlds, inhabiting new ways of being that resist the status quo, imagining and inhabiting alternative economies and politics.

Bibliography

Baldwin, Alec, and Bryan Stevenson. "Bryan Stevenson Wants 'Equal Justice.'" *Here's the Thing with Alec Baldwin.* WNYC. February 16, 2015. Online: http://www.wnyc.org/story/bryan-stevenson/.

Baldwin, James. *James Baldwin: Collected Essays.* New York: Library of America, 1998.

Bohr, Marco. "Steve McQueen and the Long Take." Visual Culture Blog. January 31, 2013. Online: http://visualcultureblog.com/2014/01/steve-mcqueen-and-the-long-take/.

Dargis, Manhola. "The Blood and Tears, Not the Magnolias: *12 Years a Slave* Holds Nothing Back in Show of Suffering." *New York Time.* October 17, 2013. Online: http://www.nytimes.com/2013/10/18/movies/12-years-a-slave-holds-nothing-back-in-show-of-suffering.html?_r=0.

Flory, Dan. "Race." In *Routledge Companion to Philosophy and Film,* edited by Paisley Livingston and Carl R. Plantinga, 227–36. New York: Routledge, 2009.

Hume, David. "Of the Standard of Taste." In *Essays: Moral, Political, and Literary,* edited by Eugene F. Miller, 231–58. Indianapolis: Liberty Fund, 1985.

Jefferson, Thomas. *Notes on the State of Virginia.* New York: Penguin, 1999.

Kant, Immanuel. *Observations on the Feeling of the Beautiful and the Sublime.* Translated by John T. Goldthwait. Berkley, CA: University of California Press, 2003.

McQueen, Steve. *12 Years a Slave.* Twentieth Century Fox Home Entertainment, 2013.

Schomburg, Scott. "The Enduring World of Dr. Schultz: James Baldwin, Django Unchained, and the Crisis of Whiteness." *The Other Journal* 25 (2013). Online: http://theotherjournal.com/2013/09/12/the-enduring-world-of-dr-schultz-james-baldwin-django-unchained-and-the-crisis-of-whiteness/.

Sobchack, Vivan. "Phenomenology." In *The Routledge Companion to Philosophy and Film*, edited by Paisley Livingstone and Carl Plantinga, 435–45. New York: Routledge, 2009.

Wilderson, Frank B. *Red, White, and Black: Cinema and the Structure of U.S. Antagonisms.* Durham, NC: Duke University Press, 2010.

Yancy, George. "Walking Black While in the White Gaze." *New York Times.* September 1, 2013. Online: http://opinionator.blogs.nytimes.com/2013/09/01/walking-while-black-in-the-white-gaze/?_r=0.

Roundtable on Dreams

David Dark (DD), Eric Kuiper (EK),
Zachary Thomas Settle (ZTS) and Taylor Worley (TW)

TW: If we were to accept the methodological paradigm proposed in this book, in which we aim to receive films as spiritual phenomena to be experienced, how might our experiences with films shift?

DD: I'd like to flip the question around a little and assert that *until* we receive films as spiritual phenomena we're *already* experiencing, we delude ourselves and the truth is not in us. There's no spiritual on-and-off switch when it comes to story or song or lyric or image. Films are doing their work on us all the time. Even the bad ones. And they're spiritual phenomena whether we learn to think of them that way or not. But when we begin to take on this work of recognition, looking hard at what's happening to us in our reception of film, we're that much closer to living undivided lives. Undivided life is something I suspect everyone longs for in one way or another.

ZTS: The sort of investigation we are calling for here is a very material one. That is, even in investigating the phenomenological sense of attuning ourselves to the experience of the film itself, we are primarily concerned with concrete realities. This project is based on the experience of film as an embodied reality in which we, as viewers, are acted upon in confrontational ways by the film itself. There is a potential for film to move us into the world in powerful, constructive ways. Such possibilities are typically only mobilized and made possible through a particular sort of engagement as experience, though, which is what the investigation of this book is born out of. Taking that discourse seriously would manifest

61

itself in the ways that film opened up new possibilities of being in the world for us, as film itself confronted, changed, and moved us to the see our own realities with new forms of sight.

EK: I see it shifting why and how we show up to films. For so many people, film is locked into their "entertainment" category only. What we are talking about here is much larger than simply being entertained—although it isn't ruling that out either. This paradigm invites us to show up to film with expectation—something life altering may take place in that darkened theater. It's encouraging us to seek out disruptive, wonder inducing events in our lives. That's a much bigger thing than staring at a big screen while cramming popcorn in your mouth.

TW: At what point in your own development as a filmgoer did you begin to sense some philosophical potentialities in film? And how did that experience shape you? What kinds of spiritual phenomena through cinema should Christians and Christian communities be attentive to?

EK: I think I first became conscious of film's potential to create this kind of affective space my freshman year in college, thanks to *Pulp Fiction*. While I was certainly captured by Tarantino's ability to write dialog and his non-linear storytelling, it was the wandering and wondering of the characters that resonated deeply with my own sense of angst, desire, and hope. On one hand I had nothing in common with these roaming assassins, drug dealers, and thieves. But on the other, I was just like them. I saw my insecurities and dreams all over the screen. That affected me in profound ways. It got me wondering about who I was, where I was going, and what I was becoming. Like Jules Winfield, I wanted a greater sense of purpose in life and I was ready to leave things behind in order to find that purpose.

I think Christians should go to the cinema for likely the opposite reasons most do naturally. Rather than looking for films that affirm our way of understanding the world, we should be taking advantage of film's ability to disrupt us—letting our film viewing be part of our growth and expansion, rather than being a place we go to reaffirm what we already know and believe.

ZTS: I remember a friend showing me Wes Anderson's *Rushmore* for the first time when I was in the tenth grade, thereby opening my eyes to

this whole new world of cinematic possibility altogether. It wasn't that I didn't like film prior to this experience; I simply had never experienced the potentialities of film in this way before. I had no idea what to make of the film upon first watching, but I immediately knew that there was a certain force available in *Rushmore* that was altogether different than the films I typically watched. As a sixteen-year-old high school student, experiencing the very issues and anxieties that sixteen-year-old high schoolers typically do, there was a mode of being and authenticity made available to me in *Rushmore* that cut through the tensions and ambiguities of normal life. Seeing Max's struggle for meaning and the formation of an identity in ways that resisted popular standards of success, appropriateness, and growth into adulthood, which I proceeded to watch on repeat for the rest of that year, I experienced a sort of cathartic release. The experience of watching Max's absurd commitment to his own identity and values—values which flew in the face of the school he so loved, the values of its principle, and my own standard conceptions of growing into adulthood—created a space for me to navigate my own development free from the demand of complete and direct assimilation, free from the need to simply reproduce whatever limited understanding of adolescence and adulthood I had become conceived of at the time.

DD: My big moment, as I recall it, was *Raising Arizona*. I saw and was instantly enchanted by the grocery-centric, diaper-stealing chase scene in a clip on the Siskel and Ebert show and then rushed to a theater to see it one Saturday after taking my ACT exam. Upon emerging, I knew I was living in a slightly different world. The Coens' attentiveness to so much that fascinated me about my own weird American world left me breathless and inspired and eager to get in on their act in all I say, see, and do. I feel that way about everything they're up to. I'm hesitant to *should* on any community, but it seems to me that any community that aspires toward living up to the Christian vision would do well to perpetuate, support, and discuss such cinema. It's a gift to our species.

TW: In receiving Lynch's mantra that "nothing can stay hidden forever," David writes, "as a trustworthy adage, we might begin to see that the time to enlarge our sympathies, to increase the scope of what we feel, of what we know, of what we might yet do in the way of regarding ourselves and one other compassionately and imaginatively is now." What would it look like for us to let such a mantra guide our own engagements with film?

ZTS: I really appreciate David's essay in that it gets at something very elemental about film—its affective nature. This essay is really helpful in that it signals and calls for a sort of theological posture of openness, whereby we can let Lynch's films act on and in us in constructive ways. Rather than trying to get at the thing in and of itself through an analytic movement in the wake of a hermeneutical investigation after the credits role, David is calling for—along with Lynch, I might add—that we position ourselves to be the objects of questioning, to be inundated in the unfolding of the film itself. And that sort of posturing is precisely the means to experiencing film in ways that open up both the deepest parts of ourselves and the world for our own viewing. It is in that space that our sympathies and imaginations can be expanded. In that sense I'm trying to get my hands on as much of the Lynchian Kool-Aid as there is to go around.

EK: Film has a way of expanding our empathy. Great films develop their characters. We get a sense of not just what a character does, but why she behaves a certain way. We get context and back story that makes sense of the actions. As we encounter stories of others in this way, it's an invitation to increase our compassion and empathy towards ourselves and others. The moment we live in is not in a vacuum, separate from our past. We are who we are and do what we do precisely because of the complex story we are living. And this is true of our neighbor as well. While what has happened to anyone in their past is never justification for all types of behaviors in the present, the recognition that we all are the unfolding of complex stories is a gateway to empathy and grace. It begs for us to seek deeper understanding of ourselves and others.

DD: I appreciate Eric's language on the duty of recognition of recognizing, in all out taking of tales, commercials, film, that we are each "the unfolding of complex stories." This recognition, I agree, is essential to the possibility of empathy and grace. I think *Mulholland Drive*, as a work of mourning, is a sort of sorrow song about the reigning absence of empathy and grace in an awful lot of entertainment culture. Might y'all see a similar vibe in the work of other film-makers? And relatedly, do you think Lynch is right? Billy Ray Cyrus, who appeared in *Mulholland Drive*, recently indicated that his involvement in Lynch's work contributed to the dysfunction of his domestic life. I found this very pradoxical and evocative, because I think *Mulholland Drive* unmasks the culture of celebrity

(what it does to us . . . what it does to "them") better than anything in the world.

Yes, to the posture of openness Zac sees in my essay. I wonder what y'all imagine it is that keeps us from viewing films with open hands, minds, and hearts? Do you think we often want to keep our guilty pleasures to ourselves? Is it a fear that naming everything in our lives (films, social media, food) a form of liturgy might leave us with nowhere to hide? What's behind the block?

EK: That is so fascinating. Without knowing a single thing about Billy Ray Cyrus's life, I won't speculate on what actually was going on with him, but I can't help but hear that story and wonder about the fragility of my own realities. What is it about encountering certain stories, or in Cyrus's case, embodying them, that can actually disrupt our world on that level? I think about this with film and how I want to approach it (and other art). I hope it exposes the unexamined parts of my life. It forces me to look in a mirror that I otherwise would turn away from.

ZTS: Those are really helpful insights, David. I'm still processing Billy Ray Cyrus's comments about working with Lynch being disruptive to the life he'd pieced together at that time. I think there's something profound in that that actually speaks to your question about why we don't engage films with a posture of openness. I think there's a vulnerability and risk that necessarily comes with that sort of engagement. Nobody is safe when Lynch is at work, and the decision to engage in a manner of openness means that we might discover ourselves incomplete, inauthentic, and in need of something more, be it empathy, imagination, or some other gift at play in our communities.

DD: "Nobody is safe when Lynch is at work." This is a remarkable adage. Borrowing Eric's language, film places the whole of life on the examination table (for better and worse).

TW: Through dialogue with the poignant and poetic reflections of writer James Baldwin, Zac seeks to address the powers of film to either reinforce hegemonic views of the world or disrupt them. He utilizes Baldwin's insights to remind us that the gap remains between the screen's representations and the unrepresentable realities of history. How do these

reflections help us to account for the fact that some of us experience the dreams of history as more nightmares?

DD: Zac's reflection on Baldwin's reflections was especially helpful to me in the way it addresses the question of how film, at it's best, *reminds us of reality*. This is the phrase Baldwin drops in his praise of the actress Sylvia Sidney, and it brought to mind the call to communal discernment Christian communities (or any collective of people committed to seeing, speaking, and conceiving their worlds truly and righteously) would ideally be taking up at all times. Wondering aloud and together with others over, in Zac's phrase, "the truthfulness of the screened proposition" is a joy undertaken by folks everywhere, whether in-person or via social media. Receiving the witness of others concerning their experience of the false witness (or sometimes true) of particular films is the good work to be done, especially if we believe, as I do, that failing to do so will only serve, as Zac puts it, to prevent revelation of the world.

EK: Blind spots are just that—realities you can't see. And the more privileged of a position you occupy in a culture, likely the broader are your blind spots. As a white, middle class, American man, that pretty much makes me legally blind. It also means that with whom I watch films, or at very least, with whom I discuss and process them, needs to include the voices and views of people who don't share my same perspective of things. There are realities that I simply cannot see in any given film. I need the eyes of others to see fully. If I don't invite those other voices into my processing of a film, my ears are closed to the potentiality waiting for me in the narrative.

ZTS: I really appreciate those insights. I think you are both right that accounting for the possibilities of film in either perpetuating or disrupting certain ideological principles has to lead to the task of viewing film as a communal project of discernment. It's in that sort of process of engagement with one another that our own ideologies are brought to the surface, interrogated, and questioned. It's the revelation of those blindspots through someone with a very different form of vision that grows us as individuals and actually enables us to begin to develop new forms of sight ourselves.

DD: Zac has me thinking about receiving the testimonies of others in their responses to film, letting their experience (I'm thinking of friends of color) of certain films form my own. If I bring a multitude of counsel to my consideration of film (and social media makes this alarmingly possible) my own experience is deepened. Friends don't let friends process cinema all by themselves.

ZTS: Exactly, David: "Friends don't let friends process cinema all by themselves." That's a terrific line. I think that Baldwin signifies that film itself can interrogate and disrupt our corrupted, truncated ways of seeing, but that process has to materialize in that sort of reception, in receiving the witness of those who are already at work seeing the world from a different point of view than my own.

EK: To Zac's point—it calls not only for film to be engaged in community, but also with people that we don't live in community with, if we are going to be honest about our tendency to segregate ourselves politically, culturally, ethnically, etc. I remember seeing *Crash* in a theater that was very diverse. It wasn't intentional, it just happened to be who my wife and I shared the theater with that night. It was such an eye opening experience. People responded to such different moments in the film in such different ways. I remember thinking that I would have missed 80 percent of that film had we watched it with just the two of us at home.

DD: Do I want my own read on films, celebrities, artists deepened and challenged or do I only seek out the opinions that affirm my own thinking? Do I seek confirmation or apocalypse?

TW: By questioning our fascination with outer space, Eric seeks to catalyze these cinematic experiences as moments of wonder and awe that can still, "disrupt our understanding of self, exposing the mystery of our existence." If we tremble before science fiction's engrossing depictions of the galactic unknowns—wormholes, space shrapnel, et al.—to what end? What can the wonder of these visions and dreams still do to us?

DD: I think Eric's right to attribute to Christopher Nolan's determination to somehow disrupt the film viewer's understanding of self in the direction of self-reflection, as the best science fiction always does. By making

Interstellar an occasion for reflecting on the tensions at work in his own life and the trade-offs between everything he wants to be to his family and the pressures of, as the saying goes, making a living, Eric exemplifies the kind of thinking this book urges. We get to let film rearrange our mental furniture, and we do well to develop a taste for it. And if we believe we're all too prone to lie to ourselves and others about the nature of the world to better serve our perverse need for control, we *have* to. Our souls, in fact, depend on it.

ZTS: Eric's investigation of film's use of space as a popular trope was really helpful. He is able to make sense of two popular films of recent history in ways that reveal something very human about our experience through its use of space. At the same time, though, he sheds light on what are, for me, the most exciting aspects of science fiction. There is a new perception of human being that emerges in and through the investigation of its finitude and limits, and Eric does a tremendous job teasing out those subtleties from a trope typically oriented around transcendence, around the overcoming of those limits. It's in these engrossing depictions of the unknown and the screening of alternative universes that our own world is brought into brutal clarity. These visions and dreams, he is careful to argue, are revelatory experiences in that they rupture our preconceived notions and demand for reinterpretations and broader investigations of the familiar through the screening of the unfamiliar.

EK: David's line "We get to let film rearrange our mental furniture, and we do well to develop a taste for it" is really the core of the issue for me. I think we are either eager for the expansion of our understandings or we are not and we approach everything with that posture. Film is just one of the arenas that this plays out in. What's makes this interesting is that our theological starting point contributes to this significantly. You either have a theological/philosophical posture that has space for or maybe better said, begs for newness, or you might have one that takes its confidence from having things all figured out. If you believe you already pretty much know what there is to know about God, then you don't look for that to change. The changing of that is to leave one God behind and swap for another. That will feel like sacrilege for many. But if we are not open to the expansion of our thinking, we close our eyes and ears to the things that could expand us and it becomes a self-fulfilling prophecy of sorts.

DD: I second Eric's emotion on the "You're either open or your closed" issue. My wife recently asked a fellow if he's read anything that's changed his mind lately. She wasn't trying to bring him down or challenge him, but the invite can be a disruptive one. Are we people with a taste for righteous disruption or not?

ZTS: I agree, Eric. I think it does require playing against that sort of sacrilege, which is its own kind of work. I think that conscious/subsconscious choice is definitely at play, but even when I want to have my imagination expanded, there's a certain sort of attententiveness I have to attain to in order to keep that task constantly in front of me. It's a good work, but it's work nonetheless.

DD: I'll throw in the Kafka line too. If the book (or film or song) we're taking in isn't like an ice-ax chipping away at the frozen sea inside us, we might do well to broaden our media diet.

EK: I think this becomes particularly important when it comes to film because we have such an ingrained idea of the place it holds in our lives. When I ask my theology and film students about there stories with film, it is clear to see how, from very early on, they were taught things about the place film holds in our lives. They either were brought up seeing a lot of films and really engaging with the content in their families or they saw very few films growing up and were almost always going into the theater knowing this would be an experience that entertained them a bit and didn't push back on their lives in any way.

DD: I think of this, Eric, as an issue of poor catechesis. I bet you do, too.

EK: Yeah, that's totally it. It does acknowledge the power of film to shape us, but it assumes that it will almost always be a bad thing . . . it will pull us away from truth, not rub our souls in it.

DD: I'm gonna quickly throw in (on the catechesis question) that my children may never forgive me for showing them *Grave of the Fireflies*.

TW: I want to push the three of you a bit further. I feel a strong urge in your comments to commend film's dreamlike qualities—for touching the

self, the unknown (e.g., "space"), or traumatic histories, but I want to put more on the line here. To what degree do we need dreams to engage our realities? Can we encounter the hidden character of our lives without such dreams?

ZTS: That's a terrific question. I think we certainly do. I think there's a sort of necessity to the encountering of the world made possible through the category of dream. That is, a certain dream-like phrasing of a/the reality seems required to make those things bearable to us, or at least palatable. This seems to be particularly true when we talk about a medium like cinema, in which dreams are ultimately re-phrasing something very familiar about us to ourselves. I think the distancing of ourselves is a sort of hermeneutical necessity by which we can come to see ourselves anew, from a different, critical perspective in ways that a sort of long-form home movie wouldn't be capable of.

EK: I think a case can truly be made for film as a unique experience with visions of life that beg for and cultivate our transformation as humans. Because of the use of story in film, if we are to truly engage what is on the screen on any level, our story is put into play as well. When we talk about a film "working" it is because it reaches in and touches the realities we as humans share. In doing that, and creating a space where we feel our realities in a new way, film creates what some have called "a thin space." Where what is and what could be, should be and what will be, are in sight of each other.

DD: This is where the saying attributed to Jesus in the Gospel of Thomas always springs to mind: "If you bring forth what is within you, what is within you will save you. If you do not bring forth what is within you, what is within you will destroy you." Relatedly, I love telling my students that, in Mark's Gospel, it was the Spirit that led Jesus into the wilderness (or *Into the Woods* if we'd like to recall the awesome musical and film). For the sake of family, friends, and anyone who dares to get near us, we have to do that hard work of trying to know and see the things we don't want to know or see. We have to come out of hiding. We have numerous figures in the Bible (Pharoah, Nebuchadnezzar, Pontius Pilate and his wife) who knew they were being called out by the prophets and dream interpreters. We're being called out too. As Lynch says, "Nothing stays hidden forever."

EK: Walter Brueggemann gets to this in his book *Prophetic Imagination*. The role of the prophet is to help us dream better. I think of filmmakers as our culture's prophets. Our imaginations are broken and thus, the people suffer.

DD: Amen to Eric's words.

Doubt

A Cinema of Second Chances

Doubt, Realism, and Bergman's "Silence of God" Trilogy

Michael Leary

In a well-known illustration, Ingmar Bergman (1918–2007) compares his filmmaking to the rebuilding of Chartres after it was damaged by fire in 1020.[1] In this creative account, he describes laborers streaming "like a giant procession of ants" to the site to ply their trade. He finds great beauty in the anonymity of their collective endeavor. The identity of each craftsman has been lost to history, but their work of building a space for the worship of God remains. Bergman's illustration evokes a contrast between this imagined past, during which art was primarily linked with the communal exercises of religion, and the present, in which art is a matter of market forces, awards' seasons, and platforms for personal recognition. In the former, "the ability to create was a gift" directed back toward God and others. In a present shaped by cultures of celebrity and modernity's rejection of its own past, art has turned inward, toward the artist and their own neuroses.

Though this Bergman anecdote dates to the four films of the late 1950s that popularized his work, including *The Seventh Seal* (1957) and *Wild Strawberries* (1957), it anticipates the plainly theological tone of his next three major films that became known as the "Silence of God" trilogy: *Through a Glass Darkly* (1961), *Winter Light* (1962), and *The Silence*

1. Bergman, *Four Screenplays of Ingmar Bergman*, 21–22. See also Shargel, *Ingmar Bergman: Interviews*, xiv–xv for additional reflection by Bergman on the Chartres illustration.

(1963).[2] A simple exegesis of this parable in context yields much. Cinema becomes an extension of the anonymous medieval public service that reminds us, in the stone arcs and ecclesial spires dotting European skylines, of our incurably religious nature. It calls out the increasingly self-involved nature of his contemporary cinema and the culture and finance machinery that would eventually grow into the Hollywoods of our age.

Most importantly for the purposes of this essay, it underscores one of Bergman's most compelling moods, which is an equal-opportunity sense of doubt in both collective religion and individual rationality. This is a helpful frame for Bergman's complicated work. While he remained deeply ambivalent about the validity of religious experience, his films consciously imitate a religious pose or orientation toward the mysteries of existence. As he expanded on the Chartres illustration:

> If I am asked what I would like the general purpose of my films to be, I would reply that I want to be one of the artists in the cathedral on the great plain. I want to make a dragon's head, an angel, a devil—or perhaps a saint—out of stone. It does not matter which; it is the sense of satisfaction that counts. Regardless of whether I believe or not, whether I am a Christian or not, I would play my part in the collective building of the cathedral.[3]

It is entirely possible for Bergman to deny the necessity of believing something specific about Christianity and retain its core images because he has adopted the role of one who, to continue the analogy, is simply reading the blueprints without quite knowing how it all fits together.

These are all deeply satisfying lines of thought, especially for the theologically attuned audience of Bergman, despite the caveats about the irrelevance of his actual belief in the symbols under construction. Such twists in perspective happen often in Bergman interviews, especially when interviewers pressed him about his religious convictions. As frustrating as these equivocations are, given that many of his films are clearly attuned to Christian faith and practice, his failure to let himself be pinned down as the arbiter of a particular religious conviction is a reminder that this whole task of art-making comprehends much more than any one of our ideas. It is, perhaps, the only way that we can keep his desire to build either "dragon's head, an angel, a devil" in proximity without becoming

2. The Criterion Collection box set of the films describes this set simply as a "trilogy," though common critical shorthand uses "Faith Trilogy" or "Silence of God Trilogy" for *Through a Glass Darkly* (1961), *Winter Light* (1962), and *The Silence* (1963).

3. Bergman, *Four Screenplays of Ingmar Bergman*, 22.

paralyzed by their incongruity. This conflicted description of art as a space for our deepest paradoxes is Bergman's sandbox; the heart of his legacy as "tunnel man building the aqueducts of our cinematic collective unconscious."[4]

An Intimate Realism

Bergman's lasting significance as a filmmaker extends beyond these ideas, as the focus on craft in his parable is its key component. The pleasure of cinema lies in being moved, with a filmmaker, toward unexpectedly fitting approximations of that which constitutes our humanity. André Bazin famously connected this capacity of cinema for reproducing human experiences to its material qualities of time, duration, and spatial depth, grounding anything we can say about film as a spiritual or psychological medium in the raw mechanics of the filmmaker making various choices to set a camera in a certain place or light a scene in a certain way.[5]

Contrary to many readings of Bazin, his sense of cinema as realism is not limited to a one-to-one correspondence between reality and film. There are a lot of philosophical problems with such a naïve take on being. Fortunately, Bazin's film ontology is a bit bigger than that. In *Le cinéma de l'occupation et de la résistance*, he makes the distinction between two different kinds of realism.[6] The first is "technical" in that the film camera mechanically captures an actual event as it happens. One thinks of the children running through the streets of Paris in François Truffaut's *Les mistons* (1957), or Alain Resnais's unadorned tracking shots over concentration camp detritus in *Night and Fog* (1955).

The second form of realism involves using the camera to frame the "plastic" or "dramatic" elements of human experience. This refers to the use of certain kinds of lighting, depths of focus, framing, and camera movement to transmit the "real" psychological texture of those experiences. For Bazin, mechanical realism inevitably leads to dramatic realism. And this is precisely where we find Bergman working, as his films achieve a deeply familiar psychological or dramatic realism. As one critic says of *Wild Strawberries*:

4. Field, "Bergman, Ever the Provoker."
5. Bazin, "Ontology of the Photographic Image," 4–9.
6. Bazin, *Le cinéma de l'occupation et de la résistance*, 91.

> Bergman took, decidedly and consciously, a new direction. The
> film became a vantage point where he could stage the crisis
> of man, taken in his uniqueness and singularity. And cinema
> became the means of expression that . . . could best enter the
> intimate dimension that soars between dream and reality.[7]

This "intimate dimension" of Bergman's films is a compelling space, full
of theological reflection despite his films' insistence that God probably
does not exist. We encounter "a peculiar mixture of the abstract and
concrete, the metaphysical and the realistic. This oscillation is perhaps
part of Bergman's stylistic uniqueness."[8] In his early films, it is a space
constructed in claustrophobic sets, the stark gradient of black and white
film, dramatic natural light and shadow, and a wide, steady framing of
his actors. It is a simple stage for the most basic questions about God(s),
fears, and self-perception. The simplicity of Bergman's dramatic realism
permits a great deal of space to think in several different ways about these
themes at the same time.

We tend to think of realism as a form of transparency or awareness
that grounds us in more objective presentations of the self. But we find
an opposite effect of realism in Bergman's cinema. Similar to becoming
disoriented by the dizzying proportions of a medieval cathedral, his films
destabilize our perspective on concepts that once felt quite simple and
direct. As it turns out, realism may be more about humility than rational
objectivity.

A Trilogy of Films

After about a decade as a young director, Bergman rose to international
prominence with *Smiles of a Summer Night* in 1955. This was followed by
The Seventh Seal and *Wild Strawberries* in 1957, both of which received
many festival awards and remain staple entries in the canons of classic
cinema. These three films vary in tone, but are exemplary of the Bergman
aesthetic, which is synonymous with a kind of dark and dreary tone—
shot through with subtle turns of absurdity. They are also rife with little
moments of pop theology, such as the *Wild Strawberries* dream sequence
in which its lead learns that he is "guilty of guilt."

7. Tonion, "Towards a Chamber Cinema," 20.

8. Koskinen, "Typically Swedish in Ingmar Bergman," 132.

In the 1960s, Bergman directed three similar films that have been accepted over time as a trilogy.[9] They are unarguably the high point of Bergman's convergence of cinema and our religious consciousness. These three films, *Through a Glass Darkly* (1961), *Winter Light* (1962), and *The Silence* (1963), are all connected by a consistent and recognizable style. Their architectural appreciation of light and space, due in no small part to innovative cinematographer Sven Nykvist, is often the only fleeting sense of divinity left in these stories about family, faith, and insanity. The heavy gradation of light and shadow, often directing the eye in predictable geometries through each frame, recalls the divine simplicity of medieval art. But these compositions draw in people struggling deeply with conflicts of religion and modernity, rather than saint or Christ images. We are often struck with a cognitive dissonance, the fragile beauty of these scenes are a cradle for the most transgressive, even obscene human moments. But they are cradled gently, even mercifully, within frequent visual reminders that they are taking place within a much larger story.

Through a Glass Darkly

The first film of the trilogy draws its title from the Apostle Paul's description of our inability to accurately know God by looking at a dark image in a mirror. A father (David), his son (Minus), his daughter (Karin) and son-in-law (Martin) are on vacation together on a remote island off the coast of Sweden. Karin has recently been released from a hospital, where she has been receiving treatment for what appears to be schizophrenia. David is a novelist struggling to finish his next book, and even though he has just returned from an extended stay in Europe, he reveals that he will be leaving them again to break through his writer's block.

Minus and Karin are obviously upset that their father is yet again choosing his vain pursuit of fame over their time together, and later that night Karin has her first encounter in the attic with voices she hears behind the peeling wallpaper. The next day tensions rise dramatically as Martin criticizes David for abandoning his daughter in such a crucial time. Meanwhile, Minus realizes that his sister is far more disturbed than they had initially thought, no longer able to distinguish between reality

9. A later edition of the scripts includes the following brief taxonomy of the films: "Through a Glass Darkly—certainty achieved. Winter Light—certainty unmasked. Silence—God's silence: the negative impression." This suggests that Bergman at least retrospectively recognizes their connection. (Bergman, *A Film Trilogy*, Inscription.)

and this fantasy that a voice is speaking to her through the attic. The film crescendos with a harrowing scene in which Martin and David watch her run to the attic to await the presence of God coming through a closet door. "I think it's God who will reveal himself to us . . ." she says, only later to reveal in bewilderment that "the god that came out was a spider."[10]

FIGURE 10

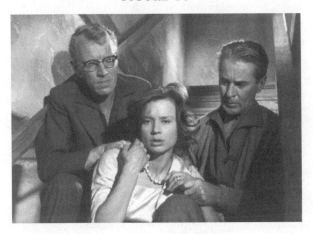

She returns to the hospital after this disturbing vision. Equally shaken by the experience, David talks to his son about her vision, the voices, and the existence of God. His parting advice is that "I don't know if love is proof of God's existence or if love is God himself," but at least love is "like a reprieve, Minus, from a death sentence."[11] This brief note of hope first feels a bit thin and undeveloped. The idea that God and the human experience of love are essentially the same thing is the very kind of moralizing Bergman's films tend to deconstruct. But this is David's recognition that reprieve exists. We are not all trapped, like poor Karin, with terrifying gods born out of fear and burdened conscience. The tenderness of this advice, shared with the son he has neglected, strikes us as the first point of hopeful clarity in the film. It is a hope that passes through a glass, darkly, but it makes its way to us in these final frames.

10. Bergman, *Through a Glass Darkly*.

11. Ibid.

Winter Light

Pastor Tomas Ericsson struggles to maintain a dwindling congregation in a small town as he grows more deeply mired in his own doubts about God's existence in light of the problem of evil. This dissatisfaction leaks out into his counsel to a congregant (Jonas) extremely worried about China's development of a nuclear bomb. He goes through the motions, but it is clear that he has no hope to offer.

Jonas later returns and Tomas reveals that he would really just prefer if God did not exist, since that would make it much easier to accept the constant cruelty of existence. Ever since his service as a chaplain years ago in the Spanish Civil War, he has not been able to coordinate his seminary training with the post-traumatic stress of this experience. Any attempt to understand God's presence on the battlefield only led him to a "revolting being, a spider God, a monster."[12] Or an "echo God" in which Tomas's own doubts and fears reverberated.

The shock of *Winter Light* unfolds in Jonas's suicide following Tomas's reckless pastoral advice. After visiting Jonas's wife to deliver the news, he travels to another church to lead an afternoon service. As the crippled sexton robes Tomas with vestments for the service, he asks him a question about Jesus' cry to God during the crucifixion: "Why have you forsaken me?"[13] The sexton is wondering if it is because at the very end, Christ himself was "seized by doubt."[14] We focus so much on the physical pain of Jesus in the crucifixion, but he had just been abandoned by his disciples, and now he was being abandoned by God. "Was not God's silence worse" than the pain?[15] Could this experience of abandonment entail Jesus' true suffering?

12. Ibid.
13. Ibid.
14. Ibid.
15. Ibid.

FIGURE 11

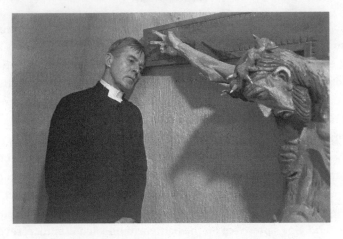

Tomas quietly agrees and steps into the church to perform the service to an empty room. No one else has showed up. But he stands at the pulpit and delivers the liturgy, enlivened by Jesus' shared experience of what Tomas had earlier described as an "echo God." There is also a potential note of hope in the translation of the Swedish title for the film, *The Communicants*, referring to those that gather to worship at the altar of Christ. Tomas is not as unique as he thought, as he shares the same fears about death and justice his congregation (and even Jesus) brings to the very thought of God. Doubt convinces us that we are alone; the very image of the suffering Christ shakes us from such delusion.

The Silence

This final film is made all the more harrowing by its lack of narrative. Es-ter and Anna are sisters, travelling home with Anna's young son (Johan) through central Europe. As Ester, an accomplished literary translator, is ill, they decide to stop for a while at a grand hotel to rest. They do not speak the language, and tanks have begun rumbling into place through the city, so Ester and Johan remain in the hotel as Anna drinks recklessly and sleeps with a waiter she met while out on the town. In the absence of any real backstory or plot, the film quietly swaps perspectives between Ester, Anna, and Johan, who has difficulty understanding what he sees and hears in the hallways of the hotel.

Old tensions begin to surface between Ester and Anna, who in-creasingly become caricatures of their fears and jealousies. This all leads

to a heated argument between the two in which it becomes clear that Anna has always envied her sister's success, and Ester is deeply afraid of her impending death. After Anna leaves the hotel with her son, Ester is racked with spasms in a lengthy scene, contorted by suffocation as the camera films her in a reverse overhead shot, her face a death mask. The film closes with Johan on the train, reading a final note his Aunt has given him, and it is titled: "To Johan—words in a foreign language," followed by some words in the language of the country they have just fled.[16] He sounds them out, his little brow furrowed, not able to understand what is written.

The first two films in this trilogy manage to provide a way out, an image or dialogue that directs us beyond the stuffy confines of each story to a sense that our fears and delusions are a legitimate part of the human experience. But this final moment, encrypted in a language we cannot read, firmly encloses the thematic space opened within *The Silence*. It recalls the famous image that Jonathan Edwards used to describe Adam's heart after the fall of man, as it was once extensive but now had "shrunk into a little point circumscribed and closely shut up within itself to the exclusion of all others."[17]

FIGURE 12

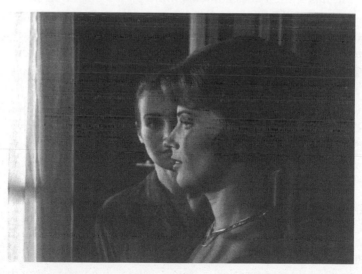

16. Bergman, *The Silence*.

17. Edwards, *Charity and its Fruits, Ethical Writings*, 252–53.

Cinema As Collaborative Doubt

There are several versions of God scattered throughout these films. The God of *Through a Glass Darkly* may simply be the product of mental illness. If there is any divinity in the world, it is to be found in domestic order. In *Winter Light*, God is an echo, a beast, a cruel magnification of our own inhumanity. He is seen not in Jesus, but in his abandonment. God is notable in *The Silence* only by way of total absence; Johan lost in a world whose only languages, sex and violence, he cannot understand.

Despite Bergman's appeal to both "dragons" and "angels" in the Chartres parable, the versions of God present here are dark and disturbing. Indeed, both *Through a Glass Darkly* and *The Silence* have been described as horror films in both form and tone. But Bergman's "protestant atheism" is not as monotone as these images suggest at first glimpse. Rather, "In the devastating world of the trilogy, a major concern—*the* major concern, Bergman said, is communication."[18] This deft psychology of collective therapy is a helpful lens for the trilogy. Our basic desire for communion with others is always present in tension with an equally strong impulse of self-preservation, which becomes encoded in what we find ourselves worshipping or naming as God.

But this tension does not remain merely a thematic element of his cinema. Bergman's "dramatic realism" renders the trilogy a potent reproduction of the very experiences Bergman is attempting to validate as our deeply felt convictions about God's existence. Accurate or not, these are the kinds of things we feel about God and each other. We simply cannot extricate our religious experiences, or lack thereof, from our webs of anxiety, sexual tension, jealousy, shame, regret, and even outright insanity. For that reason, these are films of such deep focus that our eye must search the frame. They are carefully composed, but not stylized in such a way that the drama derives from the edit, pacing, or technique. They carefully observe the emotion, the gesture, and the conversation.

In other words, Bergman's personal, thematic concern becomes the subject of a formal concern. A realist cinema is a space in which we can observe the play between things otherwise buried too deeply to observe. It emphasizes the pace of contemplation and presence over and against glossy symbol, pat convention, or more entertaining trope. Carol Brightman said this well when she observed Bergman's recognition that "When the objects take over . . . they displace a quality of human content, not

18. Alexander, "Devils in the Cathedral," 23–33.

'human content' itself. Man must remain responsible, even for his displacement. Again, it is the least we owe him."[19] And the easiest way to fight against our own displacement in cinema terms is to present our deepest doubts and insecurities as subjects to be communicated rather than objects to be cataloged and archived.

This is where we can begin to think of Bergman somewhat differently than we think of Antonioni, Fellini, or Buñuel. Their films all laid the ground work for the very theoretical, finely crafted, often cynical cinema of Europe in the 1960s and 70s. There are notes of this cynicism yet present in Von Trier, Lanthimos, Haneke, Noé, and other more contemporary European directors reflective of a similar impulse. But there is a sense of responsibility in Bergman's trilogy, at least, to avoid displacing concepts of God and morality as mere fictions of our psychological instability. If our conceptions of God derive from both our social or domestic conflicts and our most private insecurities, then neither can be trusted exclusively as filters for theology or cinema. In this way, Bergman's version of doubt becomes a communion, the prelude to more complicated, mysterious realities that cannot be subsumed by either an easy collective religion or individual rationality. It also becomes a formal statement about cinema as a mode of communication, a collaborative space to reimagine doubt as an opportunity, a recovery, or a second chance.

Bibliography

Alexander, William "Devils in the Cathedral: Bergmn's Trilogy." *Cinema Journal* 13.2 (1974) 23–33.

Bazin, André. *Le cinéma de l'occupation et de la résistance*. Paris: Union Generale d'Editions, 1975.

———. "The Ontology of the Photographic Image." *Film Quarterly* 13.4 (1960) 4–9.

Bergman, Ingmar. *Four Screenplays of Ingmar Bergman* New York: Touchstone, 1969.

———. *Smiles of a Summer Night*. Home Vision, 1957.

———. *The Seventh Seal*. Criterion Films, 1958.

———. *The Silence*. Criterion Films, 2003.

———. *Through a Glass Darkly*. Criterion Films, 1961.

———. *Wild Strawberries*. Criterion Films, 1959.

———. *Winter Light*. Criterion Films, 1963.

Brightman, Carol. "The Word, the Image, and 'The Silence'." *Film Quarterly* 17.4 (1964) 3-11.

Edwards, Jonathan. *Charity and its Fruits: Living in the Light of God's Love*. Wheaton, IL: Crossway, 2012.

19. Brightman "Word, the Image," 7.

Field, Todd. "Bergman, Ever the Provoker." *LA Times*. August 1, 2007: http://articles.latimes.com/2007/aug/01/entertainment/et-toddfield1.

Koskinen, Maaret. "The Typically Swedish in Ingmar Bergman." In *Ingmar Bergman: An Artist's Journey*, edited by R. W. Oliver, 126–35. New York: Arcade, 1995.

Shargel, Raphael. *Ingmar Bergman: Interviews*. Jackson, MS: University Press of Mississippi, 2007.

Tonion, Fabio Pezzetti. "Towards a Chamber Cinema: The Tension between Realism and Abstraction in Ingmar Bergman's Cinema." *North-West Passage* 5 (2008) 3–26.

Indispensible Doubts, Embodied Hopes

Tarkovsky's Andrei Rublev

Joseph G. Kickasola

The artist exists because the world is not perfect.

—ANDREI TARKOVSKY[1]

In eastern Tuscany, in the tiny medieval village of Monterchi, you will find a museum dedicated to a single, remarkable painting: *The Madonna del Parto* (circa 1457), by Piero della Francesca. Though the sterile building leaves one longing for the church that once held the fresco, the scene inside still evokes wonder.

The painting has much to commend it (pleasing symmetry, lovely color scheme, etc.) but the Madonna herself stands out above all other virtues. Her expressions—from her face to her delicate hand—exude a tangle of emotions. Is she sad, or is she just contemplative? Is she afraid? Is she melancholy? It does not seem that she is simply happy and content, despite the joy in her womb. It was somewhat rare for paintings in this era to depict a pregnant Madonna, and perhaps this is because its subject is necessarily liminal: a picture of living and struggling in faith in the in between time, where the object of hope has not fully arrived, but the Divine promise still abides.[2] In this interpretation of the painting, it seems she must live through this moment, carrying in her body the truth of her faith, as well as her doubts and fears.

1. From the documentary *A Poet in the Cinema.*

2. Lightbrown, *Piero della Francesca*, 188 (as referenced in James MacGillivray, "Andrei Tarkovsky's *Madonna del Parto*," 172).

For all of the mysteries this painting holds, one of them is not of the artist's making. As a fresco, the work has naturally adopted the cracks appearing on its surface. As a result, a single tear appears to be resting just below her left eye. Only the closest inspection reveals it to be a crack in the paint, but it is truly ambiguous to the average eye.[3] This interpretive and temporal addition mirrors our own ambiguities as we engage the artwork of another, at once considering what Piero has offered and affirming what it is we have received. The fragile dynamic between the past, the Madonna's spiritual endurance, and our own interpretive needs constitute her as both historic and ever contemporary.

Is she a "sad Madonna"? Can such a Madonna exist amid the lingering echoes of the Magnificat?[4] Time has affirmed it. We often forget there were nine uncomfortable and worrisome months following the Annunciation. There is room for doubt, it seems, even among the most favored among women. Yet, in counterpoint to her expressive face, her hand gently plays along the rift in her gown, a hopeful opening to the promise. "I believe; help thou my unbelief!" a desperate father once cried out to Jesus.[5]

Such is the productive role of uncertainty—artistic, intellectual, spiritual—in the art of great masters, as well as the films of Andrei Tarkovsky, who intently studied the *Madonna del Parto* during his travels through Italy in the 1970s.[6] Such ambiguity steers the image away from propaganda and forms the necessary platform from which the leap of faith can be taken. Those that leap, Tarkovsky argues, are not merely the ambitious "risk-takers" in search of reward, but those that truly worship and aspire to union with something greater than themselves. So it is with

3. Incidentally, this ambiguous tear also brings to mind several instances in the films of Krzysztof Kieślowski (a great admirer of Tarkovsky), within which tears are often confused with rain, and this ambiguity forms an aesthetic strength for the drama. A vivid example appears in one of the opening scenes of *The Double Life of Veronique* (1991). See Joseph G. Kickasola, *Films of Krzysztof Kieślowski*, 11.

4. Luke 1:46–55.

5. Mark 9:24, KJV.

6. "No reproduction can give any idea of how beautiful it is." Andrei Tarkovsky, *Time within Time*, 196. The painting actually features centrally in one of the first scenes of his 1983 film *Nostalghia*, which (like all the others) hinges on doubt and faith. In this scene, a beautiful, educated, yet skeptical and emotionally needy woman watches a ritual around this painting, wherein expectant mothers pray for the Madonna's blessing and strength. This scene establishes some of the primary spiritual and cultural tensions that drive the film.

the balloonist in the beginning of Tarkovsky's *Andrei Rublev* (1966): he escapes those who would shackle him from invention and discovery, launches himself from a church tower, catches a few moments of delirious freedom, and plunges to his death. It is a leap well beyond "risk." It is a type of aspiration joined with unrestrained worship; a sacrifice.

Indeed, the leaps of faith that artistry demands can be seen as dimensions of a larger spiritual dynamic. The intriguing ambiguity at the heart of Piero's *Madonna* creates a kind of doubt that actually expands its power. In a Western mindset, such uncertainties may be seen as the enemies of faith, chipping away at our surety until all is nebulous and lacking authority. But in an Eastern mindset—such as the Russian Orthodox tradition from which Tarkovsky came—rationalism takes a backseat to Divine presence, ritual, mysticism, and intuition. In this realm, uncertainties are often embraced as mysteries, assuming the Divine does not simply conform to our common expectations.

Clearly, the "doubt," "uncertainty," "ambiguity," and "leaps of faith" spoken of here are not radical intellectual skepticism, in the sense of insecurity about any truth at all. Rather, the term "doubt" here falls in line with the epistemological contours of Tarkovsky's own Eastern sensibilities: doubt is not weakness, just as "certainty" is not the paramount spiritual strength. The ultimate goal of faith is to remain faithful; to act in faith, and trust, *amid* doubt. It is in the somber, liminal space between unbelief and certainty that Tarkovsky finds living faith, and living cinema.

Different dimensions of this doubt may be traced throughout all of Tarkovsky's films, from his themes, to his characters, to his aesthetic/cinematic strategies. Unfortunately, space limits us to a few representative examples from *Andrei Rublev*, but in every film Tarkovsky's hope was that the aesthetic dimensions of the film would speak effectively in places where intellectual formulations have fallen short. In keeping with the themes of this volume, he prized human experience (body, spirit, feeling, intuition, etc.) over cold intellectual or scientific formulations. Likewise, he remained suspicious of easy symbolism but believed that his cinema could generate a type of productive and *experiential* doubt/revelation dynamic.

Callings and Doubts, Both Spiritual and Artistic

In his entire career, from Soviet film school in the late 1950s to his premature death in 1986, Tarkovsky only managed to make seven feature

films. Yet, in every case, he defies filmmaking conventions and breaks out of every temporal prison. Time and space do not function in the typical, predictable ways they might in other films. Characters disappear and reappear in shots with an almost nonchalant magical power. Dream and narrative seamlessly interweave almost indistinguishably. Again, Tarkovsky says:

> An artistic discovery occurs each time as a new and unique image of the world, a hieroglyphic of absolute truth. . . .Through the image is sustained an awareness of the infinite: the eternal within the finite, the spiritual within matter, the limitless given form.[7]

Or, elsewhere:

> I see it as my duty to stimulate reflection on what is essentially human and eternal in each individual soul. My function is to make whoever sees my films aware of his need to love and to give his love, and aware that beauty is summoning him.[8]

However, the Soviet government mandated a style that demanded ease of interpretation, glorious patriotic heroes, the strength of the "common man," and an overall socialist agenda. Tarkovsky continually fought this tendency throughout his career, much to the consternation of the authorities. He hated the narrative and intellectual simplicity of propaganda, and preferred to draw on Russian tradition, intuition, artistically reflexive themes, and religious mystery for his inspiration. This accounts for both the relative paucity of his output and the difficulty many find in following his plots. For example, *Andrei Rublev* does not consistently follow Rublev's story, but mingles it with the stories of at least seven other artists that can only be related thematically or metaphorically. In this sense, the film is less about the man, and more about all that he represents in art and faith.

As we might expect, doubt—spiritual and artistic—is a major theme. *Andrei Rublev*'s eight chapters can be seen as eight crucial steps in the development of an artist, with each stage catalyzed by various types of uncertainty. Rublev is a gifted practitioner with a heart for humanity, though not yet a prophetic voice. He wishes to move beyond technique

7. Tarkovsky, *Sculpting in Time*, 37.
8. Ibid., 200.

and act as a true Divine voice to all the world, rooting his vocation in an unchanging spiritual ground.

Yet, he is tested at every step, as he brutally collides with the problem of evil in the world, his fellow monks, and himself. Rublev's challenges are our own. What does it mean to transcend the mere technique of our vocation? How is personal faith instrumental in this worthy task? What impedes us? Tarkovsky has us ponder what it means to truly live in the world, suffering, repenting, caring for others, experiencing joy, and striving for meaning. He teaches us the value of the current struggle, between darkness and light, between our faith and our unbelief, between divine judgment and divine mercy.

In the film, medieval Russia is wracked with political tension as two brothers vie for power and the Church picks a side. It uses faith to subordinate the pagan peasants through preaching, ritual, and brute force, often simultaneously, while the ordinary workers are victimized between warring powers. In addition, Tatar raiders constantly threaten. Rublev finds it difficult to create art or maintain any authentic faith in this atmosphere. He finds himself caught in all kinds of tragedy, sin, and brokenness, even to the point of killing a man himself amid a horrendous and unmerciful raid on his town. In the scorched ruins of his church, he takes a vow of silence. He neither speaks, nor paints, for several years. Rublev lives as a man, no better and no worse than anyone else. Whatever he teaches us in this film, it is mostly by failing or having his successes undermined (or destroyed) by others. Tarkovsky suggests that suffering, even to the point of crippling doubt, is essential for the making of both artists and believers.

The monumental final section of the film seems to forget Rublev altogether, as it shifts to the story of a young peasant boy, who, through sheer force of personality, convinces a town to let him craft the new bell for the town church, which has been commissioned by the brutal Prince. He claims to have learned the secret of bell-casting from his dead father, and he knows that the punishment for failure is death. This story creates a bookend to the film, as paired with the opening story of the failed balloonist, who took an artistic risk from another church tower. Will the boy's confidence prove to be foolish hubris, or artistic genius?

Sometimes, in art and life, grace miraculously intervenes. The bell rings, and Rublev appears to witness it. The boy stumbles from the site and collapses in a nearby field, sobbing: "My father, that old snake, didn't pass on the secret. He died without telling me. He took it to the grave.

Skinflint Scoundrel!"[9] Rublev comforts him, his voice awakened from its vow of silence by the pealing of the hopeful bell: he has made the people happy, and that, it seems, is good enough reason for them both to persevere. "Let's go together . . . to the Trinity Monastery. You will cast bells, and I will paint icons."[10] The boy's extreme leap of faith has saved them both and begun the work of saving their people. There is a sense here, and in *all* of Tarkovsky's films, that artists not only speak prophetically to the people, but carry the responsibility to call on God to be himself. That is, they must articulate the doubts and struggles of humanity in a detailed, expressive way, in order to help the people to wait for God and, so, set the stage for him to arrive. There is a boldness in this, but also a humility in the end result, much like Jacob wrestled with the God: "I will not let you go unless you bless me!" . . . "I have seen God face to face, and yet my life has been delivered."[11]

As every Russian knows, Rublev went on to produce some of the most prized works of Russian art, and theology, in history. In a wonderful surprise, at the end of this very long black and white film, the images blaze into a full color pageant of Rublev's most famous icons, including his famous image of the Trinity: an anthropomorphic rendering of the Divine, as three equal (and identical) friends seated at a table, sharing something to eat.

Beyond the Picture: Tarkovsky and the Icon

In Orthodox theology, a Christian icon is held to represent the true nature of the object it depicts (e.g., Christ is literally made present in the icon that portrays him). As Johnson and Petrie have argued, the icon is not "an act of individual artistic aggrandizement," but "a window on the absolute."[12]

Father Leonid Ouspensky elaborates:

> Since the icon is above all the representation of a person (be it the divine Person of Christ or a human being) indicated by his proper name, its truth is conditioned by its authenticity: a historic authenticity, because "an image is of like character with

9. Tarkovsky, *Andrei Rublev*.
10. Ibid.
11. Gen 32:22–32, ESV.
12. Johnson and Petrie, *Films of Andrei Tarkovsky*, 86–89

its prototype," [cf. St. John of Damascus] and a charismatic authenticity. God, indescribable in His divinity, is joined "without confusion or separation" (dogma of Chalcedon) to describable humanity. Man unites his describable humanity to the indescribable Divinity.[13]

This is essential for understanding Tarkovsky's notion that the man-made artwork could reveal some higher ideal. Tarkovsky reflects:

> The artistic image is always a metonym, where one thing is substituted for another, the smaller for the greater. To tell of what is living, the artist uses something dead; to speak of the infinite, he shows the finite. Substitution . . . the infinite cannot be made into matter, but it is possible to create an illusion of the infinite: the image.[14]

Indeed, Tarkovsky never believed that meaning could be relegated to words and symbols. Rather, some revelations creep into the consciousness and shake it from its ordinary perspective, yielding a new way of living and suggesting a wider realm of experience beyond the temporal. Among the many thematic parallels between his art and the Orthodox faith, Tarkovsky believed that the image could function as what Mircea Eliade has called "a heirophany," an immanent means to a transcendental end.[15]

On occasion, at high spiritual moments in his films, Tarkovsky will have a character mimic a Russian icon. The effect seems to be a certain timelessness, a lifting of the character above the diegesis and into a more universal plane. Yet, overall, his images are not flat or ascetic in the same way traditional icons are. His style is typically robust, full of compositional depth and rich beauty, more in the style of Dürer or Brueghel than the historical Rublev himself.

13. Oupensky, *Theology of the Icon, Volume Two*, 484.
14. Tarkovsky, *Sculpting in Time*, 38.
15. Eliade, *Sacred and the Profane*, 11.

FIGURE 13

It seems that Tarkovsky remains in the essential spirit of iconography, in that the icon takes the strategy of de-familiarization. That is, they have atypical features that serve to make us look again with greater purpose. An icon is typically a figure, distorted in features and lacking verisimilitude (e.g., elongated face, hands, the Christ child might be given an adult face, etc.). It faces us and stands against a flat background, staring back and driving a spiritual vector deep into the contemplative viewer.[16] This style has very particular aims of bracketing off the everyday perception of the world and confronting the viewer with spiritual reality.

In Tarkovsky's films, a similar "de-familiarization" is at work.[17] Audiences more easily contemplate characters than sympathize with them. Time and space whirl in ways that suggest divine eternality and omnipresence, as in the single, uncanny shot in the burned church, wherein the ghost of Theophanes appears on Rublev's right, then his left, and then again on his right as Rublev changes direction.

16. Vacche, *Cinema and Painting*, 147–48. Also in Ouspensky, ibid., 492–95. She specifically notes how radically different this is from the later fascinations with perspective and the vanishing point: Renaissance painting reverses this vector completely.

17. This term comes from yet another Russian source, the neo-formalist critic Viktor Shklovsky, "Art as Technique."

FIGURE 14

Spiritual vision laces seamlessly with temporal events, and some-times miracles emerge, effortlessly, without fanfare or commentary. Just as an icon is intended to capture the interplay between divinity and hu-manity (archetyped in Christ's incarnation), so the filmic image can be the event where something sacred shows itself to us.

Sculpting in Time

Tarkovsky saw the moving image experience as capable of spiritual vi-tality. To that end, his stylistic elements emulate certain dimensions of spiritual life. To understand this, one must sit before them, live in them for a time, and float about in their wake for a few days after.

Tarkovsky felt the cinema owned the unique ability to "take an im-pression of time". At the same time, the director was not simply "record-ing" these impressions, but "sculpting" them, so they might fit together in a way that speaks experiential truths about the human experience.[18] He never believed the camera lens to be completely "impassive" in the way André Bazín famously characterized it.[19] Tarkovsky states outright that "documentary precision," within which all details are "exactly like real life," can still be "nowhere near reality."[20] Art exists, rather, to round out the full truth: the experiential, poetic, and spiritual joined to the objective and scientific. The verity of the film is not so much a matter of fidelity to

18. Hence the title of his book of essays, *Sculpting in Time*.
19. Bazin, *What is Cinema? Vol. 1*, 15.
20. Tarkovsky, *Sculpting in Time*, 21.

the profilmic reality or even the historical subject matter, but rather the full significance of the emotional dynamics the imagery generates.

His impulse toward visual abstraction also aligns him with other spiritually-concerned Russian artists. Art scholar Angela Dalle Vacche finds some comparisons with the Russian Suprematist painter Kazimir Malevich particularly meaningful.[21] Although Malevich is often associated with modern art (much of which Tarkovsky despised as spiritually vacuous), he "does not paint about painting and does not paint about the end of painting in a world of mechanical reproduction [as many modern artists do]" Rather, ". . . he seems to represent the unrepresentable through the effacement or the reduction of painting to a few hieratic signs: squares, lines, and circles."[22] This transcendent minimalism, built upon abstract geometry, finds its cinematic parallel in a particular sequence, at a high moment of artistic and spiritual doubt and anguish in *Andrei Rublev*. The scene begins in white. We the audience have no idea what we are looking at, or even if we are looking at anything at all. Suddenly, slashes of black appear on this newly designated "canvas," which we quickly gather is a wall. Rublev then appears, smearing the paint in spiritual anguish.

FIGURE 015

A kind of productive doubt is at work here in the experience of the film itself, as the audience may not exactly know what it has seen at first. There is a split second of cognitive search, where we cannot identify the form, but must reckon with it first as an experience-engendering form

21. Vacche, *Cinema and Painting*, 154–56.
22. Ibid.

before us. We then experience it "crystallizing" into something recognizable, as the action of the scene progresses, as when Rublev's hand smears the paint. In phenomenological fashion, the nebulous qualities of the images bracket our pre-conceived expectations and categories.

This is not the commodified logic of Hollywood, where an establishing shot makes everything clear and a closeup then amps up the emotion. Rather it starts with mystery, and that mystery demands a certain kind of faith—a trust—in the artist/director. For the faithful, it opens the door to an adventure in perception, and this primes us both for spiritual openness and revelation.

Tarkovsky's style is also "abstract" in the formal precision of his *mise-en-scene*, and the bracketing effect of his inexorable gaze. That is to say, the meticulous composition of a visual scene and the slow, patient camera form a visual strategy to "defamiliarize" the image and present it to the audience in a new, revelatory fashion. Even when we know precisely what we are looking at (white paint leaking into a forest stream, for instance) Tarkovsky forces us to look and look again. The object we see retains its identity, yet opens up before the camera as a thing of mystery and beauty, pregnant with manifold meanings. The effect is one of expectation, then frustration/boredom, then revelation as new, previously undetected riches in perception emerge. Indeed, one has the sense, continually in *Andrei Rublev*, that much more lurks beneath the substrate of physical reality, and under his unrelenting gaze, pedestrian items (such as roots, water, twigs, dirt, and embers) are painstakingly examined until they rise to the epiphanic level.[23]

These objects are both representations of themselves (pictures of actual things) and formal suggestions of a deeper spiritual core. Tarkovsky seems to point us to a truth that another sacramentalist, on another continent, once noted, "Earth is crammed with Heaven, and every common bush afire with God."[24] That is, such an experience becomes possible if one has the patience to struggle through the doubt such an aesthetic strategy engenders. Again, the very form of the film requires a type of faith to overcome one's typical doubts and truly perceive.

23. It has been well noted that Tarkovsky makes liberal use of the four elements in his most striking imagery: earth, wind, fire, and water.

24. Browning, "Aurora Leigh."

Reflections on Doubt and Transcendence
in Tarkovsky's Cinema

Tarkovsky once said: "Perhaps the meaning of all human activity lies in artistic consciousness, in the pointless and selfless creative act? Perhaps our capacity to create is evidence that we ourselves were created in the image and likeness of God?"[25] The adjectives "pointless" and "selfless" are key to our theme. This union of doubt and sacrifice form a whole: an offering that is foolish in the eyes of the world. Yet, it is not the selfish doubt of insisting on certainty before surrender. It is not the pointless doubt of making skeptical work of everything around us, including the plainly obvious before us. Rather, it is doubt and hope together in a holy dynamic: a gesture toward the God beyond all mystery as an act of worship.

In the end, what kept Tarkovsky's hope alive between films, vicious government criticism, and interference was the many letters of appreciation he received from the Soviet people over the years: "My childhood was like that . . . only how did you know it?" one woman wrote. Another testified, "You know, in that dark cinema, looking at a piece of canvas lit up by your talent, I felt for the first time that I was not alone." Yet another, a retired radio engineer, wrote: "I am stunned by your film. Your gift for penetrating into the emotional world of adult and child; for making one feel the beauty of the world around one; showing the true, instead of the false, values of that world."[26]

This last quote is indicative of how, for some, Tarkovsky's films function as full truth rather than isolated fact. Film scholars Vida Johnson and Graham Petrie testify that many do not "understand" Tarkovsky's more difficult, imagistic films (such as *The Mirror* [1975] or *Stalker* [1979]), but say they "know" and "feel" what they are about, and that they speak "directly to us."[27] This must be close to what Tarkovsky meant when he said, "We cannot comprehend the totality of the universe, but the poetic image is able to express that totality."[28] Such is the power and impact of art joined with spiritual insight, freed from the shackles of absolute certainty, struggling and sometimes rejoicing in the power of faith. Ultimately, for Tarkovsky, that expression has a redemptive aim:

25. Tarkovsky, *Sculpting in Time*, 241–42.

26. Ibid., 10–11.

27. Johnson and Petrie, *The Films of Andrei Tarkovsky*.

28. Ibid., 106.

The allotted function of art is not, as is often assumed, to put across ideas, to propagate thoughts, to serve as example. The aim of art is to prepare a person for death, to plough and harrow his soul, rendering it capable of turning to good.[29]

Note bene: Portions of this essay appeared in CIVASeen 3.1 (2002), the newsletter of the Christians in the Visual Arts organization. Many thanks to Cameron Anderson, Executive Director of CIVA, for permission to revise and integrate that material with the new material published here.

Bibliography

Baglivo, Donatella. *A Poet in the Cinema.* CIAK, 1984.

Bazin, André. *What is Cinema? Vol. 1.* Berkeley: University of California Press, 1967.

Browning, Elizabeth Barrett. *Aurora Leigh.* London: J. Miller, 1864.

Dalle Vacche, Angela. *Cinema and Painting: How Art is Used in Film.* Austin: University of Texas Press, 1996.

Eliade, Mircea. *The Sacred and the Profane: The Nature of Religion.* Translated by Willard R. Trask. New York: Harcourt, 1959.

Johnson, Vida, and Graham Petrie. *The Films of Andrei Tarkovsky: A Visual Fugue.* Bloomington: Indiana University Press: 1994.

Kickasola, Joseph G. *The Films of Krzysztof Kieślowski: The Liminal Image.* New York: Continuum, 2004.

Lightbrown, Ronald. *Piero della Francesca,* New York: Abbeville, 1993.

MacGillivray, James. "Andrei Tarkovsky's *Madonna del Parto.*" In *Tarkovsky,* edited by Nathan Dunne, 160–75. London: Black Dog, 2008.

Ouspensky, Leonid. *Theology of the Icon, Volume Two.* Crestwood, NY: St. Vladimir's Seminary Press, 1992.

Shklovsky, Victor. "Art as Technique." In *Russian Formalist Criticism: Four Essays,* translated by Lee T. Lemon and Marion J. Reis, 3–24. Lincoln: University of Nebraska Press, 1965.

Tarkovsky, Andre. *Andrei Rublev.* Criterion Films, N/A.

——. *Sculpting in Time.* Translated by Kitty Hunter-Blair. Austin: University of Texas Press, 1986.

——. *Stalker.* Shock Records, 1980.

——. *The Mirror.* Artificial Eye, 1975.

——. *Time within Time: The Diaries 1970-1986.* London: Faber and Faber, 1993.

Vacche, Angela Dalle. *Cinema and Painting: How Art is Used in Film.* Austin: University of Texas Press, 1996.

29. Ibid., 43

Betraying the Medium

The Doubt in Mass Appeal

Crystal Downing

Even though Jean-Paul Sartre enjoyed the mass appeal of cinema, he doubted the artistry of the medium. As noted by John Sturrock, a specialist in twentieth-century French literature, movie-watching for Sartre was merely "an unstuffy, proletarian thing to do."[1] Theater, in contrast, better visualizes the shaping of human consciousness by the temporal and spatial constraints of the particular arena in which individuals stage their actions. Furthermore, and consonant with existential phenomenology, theatrical performances encourage reciprocity between seers and the seen. As most actors attest, audiences can energize or deflate a live performance and, because real bodies take the stage, no two performances of a script are exactly alike. In contrast, what happens on screen remains the same, whether shown to a group of rowdy ten-year-olds or to a rapt audience of cinephiles.[2] Hence, as early as 1913, scholars were seeking "to distinguish cinema from theater, to determine precisely the basic creative

1. Sturrock, "M. Sartre Goes to Hollywood." The author of four books on French literature and theory, Sturrock here reviews J. B. Pontalis's 1986 edition of *The Freud Scenario*, by Sartre. He recounts how, in 1958, director John Huston asked Sartre to write a screenplay about Freud. When Sartre produced a script for a seven hour film, the two had a parting of the ways.

2. Of course, scratches on celluloid and the material conditions of a film's screening can affect viewer perception. As Paolo Cherci Usai noted in 1987, each time a film is shown "its aesthetic changes, since each copy ends up possessing an identity of its own, distinct from all the others" ("Unfortunate Spectator," 173). His point has less force today with the digitizing of movies, but nevertheless the location of a screening—in a 1940s art deco theater, a mall multiplex, or on a computer or phone screen—will affect perception.

elements of each and thus to set each on its own true path."[3] By 1951, film theorist André Bazin was invoking Sartre in order to clarify the particularity of each medium:

> As Jean-Paul Sartre, I think it was, said, in the theater the drama proceeds from the actor, in the cinema it goes from the décor to man. This reversal of the dramatic flow is of decisive importance. It is bound up with the very essence of the *mise-en-scène*.[4]

Rather than live bodies that are seen, Bazin privileges the *mise-en-scène:* a term borrowed from theater to describe everything depicted on the screen at any one moment—as in a photograph.

Though film scholars have challenged Bazin's emphasis on "the ontology of the photographic image," citing the tremendous power of editing, Bazin makes an important point: the reciprocity between viewer and viewed differs radically between theater and film.[5] It is ironic, then, that much of the work on religion/philosophy and film discusses movies no differently than if the narratives were enacted on a stage.[6] Extracting religious/philosophical insights primarily from story and characterization, often taking pride in how many movies they discuss in a single essay, scholars tend to ignore the phenomenological differences between theater and film. In this essay I therefore explore films that have been adapted from stage plays in order to affirm a statement made by Sartre's near contemporary, French filmmaker Carlo Rim (1902–89): "An honest adaptation is a betrayal."[7]

Indeed, movie directors who attempt to *honestly* reproduce every detail from a stage play make stultifying movies. Their commitment to accuracy *betrays* the distinctive artistry and phenomenological power of the cinematic medium. To create "honest" adaptations, then, filmmakers must doubt the sufficiency of elements in staged plays, betraying their source texts in order to *honestly* reproduce them. *Mass Appeal* by Bill C.

3. This comment was made in 1913 by Leonid Andreyev and is quoted in David Bordwell, *On the History of Film Style*, 31.

4. Bazin, "Theater and Cinema—Part Two," 102.

5. Bazin, "The Ontology of the Photographic Image," 9–16. For the influence of Bazin on film theory see Crystal Downing, *Salvation from Cinema*, 99–105.

6 Gregory Watkins notes that "the vast majority of work on film and religion" makes cinema "the object of [a] particular theoretical or theological point of view without careful consideration of the distinctive nature of the medium." See "Religion, Film and Film Theory," 82.

7. Truffaut, "Certain Tendency," 41.

Davis (1980 play; 1984 film) and *Doubt: A Parable*, by John Patrick Shanley (2004 play; 2008 film) provide telling examples. Because their screenplays were written by the same men who authored the stage plays, they demonstrate how playwrights have to betray their own work to create an honest adaptation. Furthermore, both adaptations are about priests, which illustrates, I will argue, that Rim's aphorism applies to Christianity itself.

The Adaptation of Christianity in Doubt and Mass Appeal

Set in 1964, *Doubt* features a priest who explicitly refers to adaptations in the Roman Catholic Church: "I think a message of the Second Ecumenical Council was that the Church needs to take on a more familiar face. Reflect the local community. We should sing a song from the radio now and then. Take the kids out for ice cream."[8] These upbeat words about Vatican II (1962–65) are spoken by Father Flynn, who teaches religion and coaches the boys at a parochial school in the Bronx. His antagonist is Sister Aloysius, principal of the school, who fights change of any kind—including the use of ballpoint pens. From the start, viewers, like the school children, are attracted to Flynn and frightened by Aloysius. However, unlike stories that reduce antagonisms to simplistic categories of heroes versus villains, *Doubt* generates overwhelming uncertainty about which character is the force for good. Having reason to suspect that Father Flynn's "more familiar face" with children has led to sexual abuse, Sister Aloysius gets him to resign: "His resignation was his confession," she asserts.[9] But was it? Viewers of both play and film inevitably argue about Father Flynn afterwards, some doubting his guilt, others absolutely certain of it. Viewer disagreement is adumbrated by something Flynn says in a sermon at the start of the play: "Doubt can be a bond as powerful and sustaining as certainty."[10]

Mass Appeal also begins with a sermon by the play's protagonist, Father Tim, a priest in the late 1970s who takes for granted the reforms generated by Vatican II. Using humor and pop-culture allusions, Father Tim puts on "a more familiar face" to connect with his parishioners. However,

8. Shanley, *Doubt*, 30. Page numbers from this edition will henceforth appear in the text. Flynn does not refer to the Ecumenical Council in the film.

9. Ibid., 58.

10. Ibid, 6.

while the antagonist in *Doubt* is a disgusted traditionalist, the antagonist in *Mass Appeal* is a disgusted progressive: a seminarian named Mark who is disturbed by Tim's propensity to be a people pleaser rather than a prophet. The settings of the two plays thus illustrate a trend throughout Christian history, wherein reforms doubted by one generation become the new status quo. In the case of *Mass Appeal*, changes generated in the 1960s had become *de rigueur*, for many, by the end of the 1970s. Father Tim, in fact, is so committed to maintaining his mass appeal that he often tells lies, not only to keep people happy but also to avoid obligations he finds distasteful. In contrast, seminarian Mark shocks others by truthfully proclaiming his controversial views. He publicly challenges Father Tim's opening sermon to assert that "women should be priests" and later protests when Tim's superior, Monsignor Burke, expels two seminarians for a homosexual affair, arguing that the two had not yet taken vows of celibacy.[11] Mark's heroism is undermined, however, by his dismissive impatience for anyone who disagrees with his progressivism. Mark's certitude, then, differs little from that of Sister Aloysius in *Doubt*.

Nevertheless, Sister Aloysius has far less mass appeal. Committed to being "a fierce moral guardian" of children, she interprets any sign of untraditional behavior as evidence of moral turpitude.[12] When Father Flynn says she has "not the slightest proof" of his sexual abuse, she responds "I have my certainty, and armed with that, I will go to your last parish, and the one before that if necessary."[13] Renouncing doubt of any kind, Sister Aloysius merely looks for proof that reinforces her certitude. We would easily dismiss her if Father Flynn, upon hearing her threats, didn't start backpedaling, especially after she points out that he has been transferred to three different churches in five years. He resigns soon after Aloysius tells him a nun in his previous parish told her of "his prior history of infringements."[14] This, however, was a lie; she never talked to the nun. Like Father Tim in *Mass Appeal*, Sister Aloysius manipulates human behavior by distorting truth.

11. Davis, *Mass Appeal*, 10.
12. Shanley, *Doubt*, 15.
13. Ibid., 54.
14. Ibid., 58.

FIGURE 16

In contrast, the seminarian Mark proclaims the truth unremittingly, disdainfully telling congregants during his first sermon that "you come with your Gap shirts and your cell phones and your blue hair. Those things are your shackles—they are accessories you have made essential."[15] Though his assessment may be accurate, Mark's disdain provokes resistance from his audience more than motivation for change, thus undermining his progressive agenda. Hence, the words Flynn speaks to Sister Aloysius, the contemptuous traditionalist in *Doubt*, are equally relevant to Mark, the contemptuous progressive in *Mass Appeal*: "Are we people? Am I a person, flesh and blood like you? Or are we just ideas and convictions?"[16] Whether coming from the right or the left, Christians often make ideas and convictions more valuable than the flesh and blood people who oppose them. Ironically, the Christ they follow, a flesh and blood medium of love, exhorts each follower to be a flesh and blood medium of love as well. Or, to put it another way, "the medium is the message."

The Medium is the Message

In 1964, the year in which Shanley sets *Doubt*, Marshall McLuhan pronounced "the medium is the message" in a book so influential that it was reissued in 1994 and again in 2003. In *Understanding Media*, McLuhan

15. Ibid., 24.
16. Ibid., 55.

argues that changes in human behavior, both mental and physical, are influenced more by *how* media communicate than by *what* they communicate.[17] In other words, the tangible presence of a medium has more power to shape perception than the "ideas and convictions" it presents. Significantly, media specialist Michael Wetzel has asserted that "McLuhan's 'The medium is the message' is as Christian as you can get."[18] Doctrine hammered out in the first five centuries of the Church emphasizes that salvation is mediated not through the "ideas and convictions" of Jesus, but through his material body that died and rose again. Proclaiming heretical the Docetist belief that Christ only *seemed* to be flesh and blood, the Council at Chalcedon established, in 451, that a fully human Jesus was the medium of God's transcendent divinity, that the two, in fact, were one. Christian orthodoxy therefore maintains that the medium was, and still is, the message.

It seems ironic, then, that most Christians tend to ignore the medium when they discuss the phenomenological power of film. Emphasizing spiritual insights and/or experiences of transcendence generated by film stories, they reduce cinema to a content delivery system, much as Docetists reduced Jesus to a divinity delivery system.[19] In contrast, specialists in film argue that "the unique *material basis* of the *medium*" should guide movie analysis, generating exploration of "the relation between *form* and effect, between the *material* basis of film and the cinematic experience."[20] The medium, in other words, is the message: a message that my discussion of *Doubt* and *Mass Appeal* has so far ignored.

The Material Basis of the Cinematic Experience: Doubt

Mass Appeal and *Doubt* provide superb examples of how the "material basis of the medium" can impact the cinematic experience. *Doubt* is especially telling, since John Patrick Shanley also directed the film adaptation, choosing to *visualize* motifs that he merely verbalized in his original play. In scene five, for example, Sister Aloysius talks with Father Flynn

17. McLuhan, *Understanding Media*.

18. Derrida, "Above All, No Journalists!," 86. Wetzel was one among several media specialists interviewing Derrida for the essay.

19. For an overview of Christian scholarship that ignores the medium, see Downing, *Salvation from Cinema*, chapter one.

20. Furstenau, "Introduction," 10, emphasis mine. A specialist in cinema, Furstenau is summarizing the concerns of film theory.

about an aging nun, Sister Veronica, who has recently fallen. When Flynn questions Veronica's eyesight, Aloysius says, "Her sight is fine. Nuns fall, you know. . . . It's the habit. It catches us up more often than not. What with our being in black and white, and so prone to falling, we're more like dominos than anything else."[21] Since Sister Veronica never appears in the play, we sense that this conversation has symbolic more than narrative value. Indeed, Sister Aloysius, in her black and white habit, has a "habit" of seeing things "in black and white," certain of her assumptions even when there is little proof. When she later interviews Mrs. Muller, the mother of a boy she thinks Flynn has abused, Mrs. Muller states, "Sometimes things aren't black and white," only to elicit from Aloysius, "And sometimes they are."[22]

Shanley reinforces the black and white of the domino-like nuns by adding scenes not in his original play. Not only does he put Sister Veronica in the film, but he also inserts meals among the nuns, the first one establishing Veronica's failing eyesight. The second meal, however, follows a scene of Flynn's dinner with fellow priests. After a close-up on red roast beef, browns and yellows fill the *mise-en-scène* as the priests drink wine and laugh at funny stories. The camera then cuts to a high angle shot of a dozen or so nuns eating in total silence, their black habits, disguising their faces, contrasting dramatically with the austere white table cloth around which they sit. The medium itself seems to challenge viewers to assess which image seems more trustworthy: the austere black-and-white of self-disciplined nuns, or the wine-warmed camaraderie of priests. Significantly, one of the accusations against Father Flynn is that he gave wine to Donald Muller. Mrs. Muller, however, so values Flynn's warmth toward her son that she does not care, implying to Sister Aloysius that Donald's homosexual proclivities may explain Father Flynn's interest in him.

In contrast, Sister Aloysius treats students with cold calculation, preaching her philosophy in black and white terms to her young protégé, Sister James, causing Flynn to say of Aloysius, "She's like a block of ice! Children need warmth, kindness, understanding! What does she give them? Rules."[23] In the film, Shanley visually communicates the sister's legalistic frigidity in several cinematically distinctive ways. He shoots the first image of Sister Aloysius (Meryl Streep) from behind, such that her

21. Shanley, *Doubt*, 26.
22. Ibid., 49.
23. Ibid., 40.

all-black habit disguises any "flesh and blood human" underneath. As she sits listening to a sermon by Father Flynn (Philip Seymour Hoffman), the camera remains behind her even when she rises from her pew and walks down a side aisle. The shot cuts to a side view as she slaps a misbehaving boy, but we still do not see her face. Finally, the black draped figure bends from the waist at an unnatural 90 degree angle to the level of a pew where the camera is now placed. Only then does the figure turn its face toward the lens, as though rotating on an axel, to wake a sleeping boy. The robotic movements of the black-and-white habit thus signal the dehumanizing black and white certitude of the nun underneath.

Like a "domino," Sister James (Amy Adams) eventually "falls" under the spell of Sister Aloysius, the younger nun telling her mentor, "I've been trying to become more cold in my thinking."[24] In a scene not included in the play, she follows Aloysius's advice to hang a glass covered picture from the blackboard in her classroom, so that as she writes on the board she can watch in its reflection what students are doing behind her back. Significantly, the picture she hangs is of Pope Pius XII, "the last pope prior to the Vatican II Council," as Conrad Ostwalt notes.[25] Hence the image not only challenges recent reforms, but also implies that behavior is regulated through the lens of the Church—including the behavior of Sister Aloysius. Indeed, when she tells Father Flynn about researching his past, he reverses his emphasis on progressive change by appealing to her "vows" of "obedience," arguing "You have no right to step outside the Church."[26] Whose behavior is most trustworthy? Viewers of *Doubt* see through a lens darkly, some doubting Flynn, others doubting Aloysius.

Their doubt is reinforced by that of the young Sister James, who tells Father Flynn "I don't know what to believe."[27] This comment takes place in a sunny garden, where the two sit on a bench near a statue of the Virgin Mary. Like our first image of Alyosius, however, the camera does not focus on the statue's face. Instead, we see the statue's black shadow cast on a white wall behind the priest and nun as they talk. The medium delivers the message as much as their words do: a shadow of doubt, cast by the black and white certitude of Sister Aloysius, affects the young nun's perception of the accused priest.

24. Ibid., 20.

25. Ostwalt, "No Easy Answers," 41.

26. Shanley, *Doubt*, 54.

27. Ibid., 40.

Most Hollywood movies, of course, resolve their mysteries and antagonisms. Shanley, however, sustains the play's ambiguity to the very end of his film, generating not resolution but antagonism among movie spectators themselves. Arguing about Flynn's guilt or innocence, viewers end up doubting each other's perception of the truth. Shanley thus inculcates a phenomenological experience of doubt that reflects, if even through a lens darkly, antagonisms that have divided Christians throughout history. Furthermore, because religious divisions reflect conflicting, often unverifiable, points of view, he inserts wordless point-of-view (POV) shots to keep viewers off balance. At one point we see a low-angle close-up of Aloysius on the left side of the screen as she glares at a pile of fluttering papers at the bottom right of the screen, making it appear as though she is looking off-screen to the lower right. Rather than giving us her POV, however, the shot cuts to a different location, a high-angle lens capturing Flynn from above as he enters through a door on the right side of the screen. Shanley thus establishes a visual metaphor: Aloysius contemptuously looks down on the priest. We next see Flynn stop to look *up* at something, an eyeline match-cut giving us his POV: a stained-glass window behind the dark wood banister of a staircase. An unusually long take on the window through the railings encourages viewers to notice the depiction of an eye at the center of the stained glass, as though alluding to the eye of Aloysius, stained by prejudice, looking *down* on Flynn. Indeed, earlier in the film, Aloysius literally looks down on the priest through a second story window, her reflection appearing on the glass as she peers through it, suggesting that her seeing *reflects* her own biased assumptions.

Viewers attentive to the medium are thus encouraged to consider how their own perceptions of Flynn may reflect, may even by stained by, reports of sexual abuse in the Church. We can't help wondering why Father Flynn looks at the empty staircase and the stained-glass window for so long. What is he seeing that we don't see? As though to answer this question, a bit later Shanley inserts a shot of Donald Muller sitting on the same staircase, staring through the same wooden railings in reverse, an eyeline match-cut establishing that he is watching Flynn, who is working with another altar boy. Considered together, these wordless shots generate questions: does the graphic match between the boy on the staircase and the man earlier looking at the same staircase imply an inappropriate encounter between them? Or does the sorrowful look on the boy's face

merely visualize what others suggest: that Donald feels "isolated"?[28] To keep us questioning, Shanley later inserts a wordless shot of Sister Veronica, the nun with vision problems, placing a lamb statue into a crèche. The motiveless shot encourages us to assess our own vision: is Donald Muller the sacrificial lamb in *Doubt*, or is Father Flynn?

As though symbolizing his desire to keep viewers off balance, Shanley starts using canted shots in the scene when Aloysius first accuses Flynn to his face. Such shots place the *mise-en-scéne* at odd angles in relation to the movie screen that frames them. The medium itself, in other words, encourages viewers to question what is off kilter in the diegesis: is the perspective of Sister Aloysius unbalanced, or is Flynn's behavior out of line? Shanley's only answer relates to the sacrifice of certitude. In the film's last scene, Sisters Aloysius and James sit on a bench in the same garden where Flynn and James had their earlier conversation. Rather than sunshine brightening a wall, however, we see the two nuns surrounded by snow, coldness enveloping them. Aloysius reports that, even though Father Flynn resigned due to her threats, he has received a "promotion" to a better parish. The one most hurt, then, is Sister Aloysius, revealed when she repeats something she had told Sister James earlier: "In the pursuit of wrongdoing, one steps away from God. Of course, there's a price." That price is recounted when she cries out, in the last line of both play and film, "I have doubts! I have such doubts!"[29]

FIGURE 17

28. Ibid., 21.
29. Ibid., 58.

By having Aloysius echo her earlier statement, "When you take a step to address wrongdoing, you are taking a step away from God," Shanley implies that, rather than doubting her certitude about Father Flynn, Aloysius instead doubts her faith in the "flesh and blood" medium of God's salvation.[30] Indeed, by its very definition, certitude is the opposite of faith. The film visually enhances the final moment of doubt with medium-specific devices: from a close-up on the nuns' faces, the camera pans left as Sister James puts her head in the lap of her superior. It then pulls back to a high-angle shot, such that the last image of the film is a mass of black surrounded by white snow. Not only have the two nuns become visually indistinguishable from each other, but all signs of flesh and blood humanity have disappeared under their dark habits—echoing the first image of Aloysius on screen as well as concretizing a comment Sister James made to Flynn in the same location: "I looked in a mirror and there was a darkness where my face should be."[31]

The Material Basis of the Cinematic Experience: Mass Appeal

Whereas *Doubt* leaves viewers with ambiguous doubt, *Mass Appeal* provides a more hopeful resolution. Unlike Sister Aloysius, who betrays her faith rather than her certainty, the progressive Mark learns to care for those he originally disdained. Written as a two-man play, however, *Mass Appeal* needed radical betrayal to make it work for the screen. Playwright Davis not only added extra speaking parts and scenes, but, in collaboration with director Glenn Jordan, he allowed the medium to speak for itself.

The film begins with crosscutting: a device that signals simultaneity of action in different locations. The camera cuts back and forth between tracking shots of Mark (Zeljko Ivanek) clad in shorts and sweatshirt, running through suburban streets, and shots of Father Tim (Jack Lemon) in traditional vestments slowly walking down a church aisle behind multiple altar boys. Totally apart from words, then, the medium captures the difference between Mark's progressivism and Tim's traditionalism. Nondiegetic music reinforces the contrast: we hear high-energy orchestral

30. Ibid., 20.
31. Ibid., 38.

brass as Mark runs, while mellow orchestral strings accompany shots of Tim.

FIGURE 18

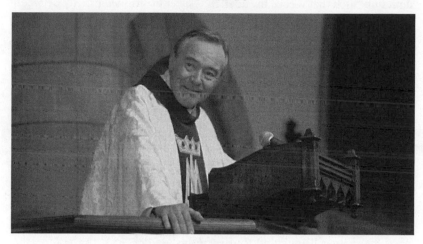

After the crosscutting of both image and music, we see Mark inside the church, still in his running clothes as he challenges Father Tim's sermon during a question-and-answer period. Later, seeking to engage him in conversation, Tim drives his Mercedes Benz alongside Mark as he runs, the medium visualizing the distinction between the priest's desire for ease and Mark's commitment to exercise prophetic rebuke. Davis, in fact, transfers into the Mercedes a scene from the play in which Tim records a sermon. In the comfort of his luxury car, Father Tim practices canned humorous asides while talking about the prophetic early days of his vocation. With no one to hear him, however, he slips into revelatory truth, quickly rewinding the tape after admitting, "I know I haven't been as close to Christ—since."[32] Because the camera films from inside the cramped space of the luxury car, viewers get a visual sense of prophetic vision suffocated by self-serving ease.

Just when viewers assume they have been given a clear distinction between the heroic Mark and the pusillanimous Father Tim, Davis generates doubt. In addition to showing Tim's ability to comfort hurting parishioners, he inserts a scene in which Mark converses with his sister during a seminary reception. Significantly, he places the two behind a closed gate, such that its wrought-iron bars fill the *mise-en-scéne,* as though to signal the barrier in their relationship. When Mark rebukes her

32. Davis, *Mass Appeal,* 14.

for an affair with a married man, the sister opens the gate to walk away from Mark. At this point, Father Tim joins Mark, taking the place of the sister in a conversation with him. The camera shoots from the opposite direction, such that we see the alienated sister positioned exactly between the two men as she walks away into the distance, her image getting smaller and smaller in the unusually long take. The medium thus implies that the vanishing woman's needs are getting smaller and smaller in the minds of both Mark and Tim, who are more concerned about their philosophical differences than about the subtleties of flesh and blood experience.

The remainder of the film, like the play, continues to explore tensions between Mark and Tim, until both become transformed by learning from the other. In the play, their reformation is signaled by contrasting sermons. While the text opens with Father Tim's innocuous platitudes, it ends with a sermon in which he challenges problematic practices in the church. In between, Mark gives two sermons, the first contemptuously looking down on the congregation, the second acknowledging his own need for change. Though all four sermons are delivered in the film, the cinematic medium symbolizes the mutuality of their influence in ways that exceed the play. For example, not only do we see Mark eventually join Tim inside the Mercedes, but we also see the two conversing while running, each opening himself up to the ways of the other.

The film then ends with an echo of its beginning, creating a symmetry that frames the film—much as the two sides of a medieval triptych frame a larger, more important central image.[33] It could be charted as follows:

<div align="center">

First shot: Mark running

Tim giving an innocuous people-pleasing sermon

Mark standing in the back left side of the church, where he challenges Tim

Mark delivering a sermon faulting the congregation

Multiple conversations between Mark and Tim

Mark delivering a sermon faulting himself

Mark standing in the back right side of the church, where he smiles at Tim

Tim giving a sermon that challenges the congregation

Last shot: Mark running[34]

</div>

33. I use the analogy of a medieval triptych in *Salvation from Cinema*, which discusses cinematic framing devices at length (see 43–45, 67–69, 155–56).

34. Jordan, *Mass Appeal.*

Medium-specific devices add complexity to the artistry of this framing device. During the crosscutting at the start of the film, a low-angle lens looks through the windows of cars driving by as Mark runs above them. However, no images of people appear inside the cars, as though alluding to a progressivism that places "ideas and convictions" above "flesh and blood" people. In the closing scene, however, the camera captures the start of Mark's run by filming its reflection in a glass-covered announcement sign outside the church. We therefore see Mark's image underneath the name "Fr Tim Farley" on the board. The medium is the message: each has left his mark on the other. Then, as the closing *coup de grâce*—grace, indeed—Mark's run is accompanied by a synthesis of the orchestral horns and strings that were separated by crosscutting at the start of the film. Dualism, both aural and visual, has been overcome. Consonant with Merleau-Ponty's phenomenological emphasis on consciousness as becoming, the consciousness of each man has changed through a flesh-and-blood encounter with the contrasting perceptions of the other.

Betraying Tradition

Significantly, when Mark's reflection appears on the glass sign outside the church, viewers see not only Father Tim's name, but also the title of his sermon: "On the Road to the Priesthood." Indeed, the priesthood is about being on a road with other believers, all encouraged to "run with perseverance the race that is set before" them.[35] In the Greek New Testament, the word usually translated as "race" is *agon*, the same word employed by ancient Greek playwrights to describe the conflicts of their plays, thus informing our words *protagonist* and *antagonist*. A form of the word also describes the internalized conflict—the doubt—Jesus experienced in the Garden of Gethsemane: "And being in an *agony* [*agonia*] he prayed more earnestly."[36] Christ's *agon*, of course, reflected awareness that his body would be betrayed and tortured to serve as the "flesh and blood" medium of salvation.

Mass Appeal and *Doubt* remind us that, like Christ, Christian tradition is also subject to doubt and betrayal. Significantly, the Latin root of *tradition* means "handing over," as in *traduce*. Just as Jesus was betrayed and *handed over* to the Roman authorities, Christian traditions are

35. Heb 12:1, NRSV.
36. Luke 22:44, RSV

handed over to future generations, who, doubting their current relevance, often betray them *in order to* preserve the Gospel message. As church historian Dale T. Irvin notes, "Without a bit of treason performed in the act of handing over, the tradition remains inseparably bound to the world in which it was formed, hence not only irrelevant but incomprehensible."[37] Something similar could be said of film adaptation: without a bit of treason performed in the act of handing over a play to cinema, a text remains inseparably bound to the arena in which and for which it was formed. Or, in the words of Carlo Rim, "An honest adaptation is a betrayal." One must doubt the mass appeal of a tradition in order to preserve it. In both Christianity and film adaptation, betrayal of the medium is essential to the message.

Bibliography

Bazin, André. "The Ontology of the Photographic Image." *What Is Cinema?* Vol. 1. Translated by Hugh Gray, 9–16. Berkeley: University of California Press, 1967.

———. "Theater and Cinema—Part Two." *What Is Cinema?* Vol. 1. Translated by Hugh Gray. Berkeley: University of California Press, 1967.

Bordwell, David. *On the History of Film Style.* Cambridge, MA: Harvard University Press, 1997.

Davis, Bill C. *Mass Appeal.* New York: Dramatists Play Service, 2002.

Derrida, Jacques. "Above All, No Journalists!" In *Religion and Media*, edited by Hent de Vries and Samuel Weber, 56–93. Stanford, CA: Stanford University Press, 2001.

Downing, Crystal. *Changing Signs of Truth: An Introduction to the Semiotics of Communication.* Downers Grove, IL: IVP Academic, 2012.

———. *Salvation from Cinema: The Medium is the Message.* New York: Routledge, 2015.

Furstenau, Marc. "Introduction." *The Film Theory Reader: Debates and Arguments.* New York: Routledge, 2010.

Irvin, Dale T. *Christian Histories, Christian Traditioning: Rendering Accounts.* Maryknoll, NY: Orbis, 1998.

Jordan, Glenn. *Mass Appeal.* Intelecom, 1984.

McLuhan, Marshall. *Understanding Media: The Extensions of Man.* New York: McGraw-Hill, 1965.

Ostwalt, Conrad. "No Easy Answers: John Patrick Shanley's *Doubt.*" *The Cresset* 73.1 (2009) 40–42.

Shanley, John Patrick. *Doubt.* Buena Vista Home Entertainment, 2008.

———. *Doubt: A Parable.* New York: Theater Communications Group, 2005.

Sturrock, John. "M. Sartre Goes to Hollywood." *The New York Times.* October 12, 1986.

37. Irvin, *Christian Histories*, 41. For a book length assessment of the betrayal necessary to preserve Christian tradition, see Crystal L. Downing, *Changing Signs of Truth*, 315–15, where I discuss Irvin more fully.

Truffaut, François. "A Certain Tendency in French Cinema." *The French New Wave: Critical Landmarks,* edited by Ginette Vincendeauand Peter Graham, 113–27. New York: Palgrave Macmillan: 2009.

Usai, Paolo Cherci. "The Unfortunate Spectator" *Sight and Sound* 56.3 (1987) 170–74.

Watkins, Gregory. "Religion, Film and Film Theory." In *The Bloomsbury Companion to Religion and Film*, edited by William L. Blizek, 80–88. New York: Bloomsbury, 2009.

Roundtable on Doubt

Michael Leary (ML), Joseph Kickasola (JK), Crystal Downing (CD) and Taylor Worley (TW)

TW: If we were to accept the methodological paradigm proposed in this book, in which we aim to receive films as spiritual phenomena to be experienced, how might our experiences with films shift?

ML: H. W. Dannowski once said that cinema may be capable of rescuing the church from the "deep sleep of the habitual and the always known." Among the crises facing the Christian church in our era is our lack of vocabulary. We have a difficult time connecting the vital drama of Christian theology with the different narrative worlds we all live in every day. Cinema can be this vocabulary, or at least, it can teach us the kinds of words and gestures that make the gospel intelligible to ourselves and others. This is not because cinema is a catalog of basic themes matching up to aspects of Christian theology, but because it is an ever-expanding index of the dreams, doubts, and dreads that inspire any movement from despair.

CD: Consonant with Dannowski's challenge to "the habitual and the always known," Paul Ricoeur defines metaphor as "the strategy of discourse by which language divests itself of its function of direct description in order to reach the mythic level where its function of discovery is set free." An artistic film, then, might be seen as a kind of metaphor: a strategy of discourse that encourages discovery at a mythic level. But for this to work, viewers must divest their own habitual dependence upon direct description mediated merely through story and dialogue. Such divestment will allow for the discovery of metaphor in and through the artistry of objects on the screen.

JK: Viktor Shklovsky has a famous quote aimed at discovering the art-fulness of an object, which he believes is buried by everyday concerns. I think he is largely right about habitualized life, and the arts' role in helping us to see and feel again. However, I don't agree that "knowledge" should be so rigorously split from perception, nor would I say the "object is not important." I think a large part of the value of art is the way it encourages us to reconnect with "the object" in something closer to its existential (and spiritual) fullness, in spite of the many ways we reduce it. In this way, I think the cinema reorients us toward the miracles that are already there. Does it give us a new vocabulary, with which to speak with others? I think it does, in that four of us could watch the film and relate to it on some existential and human level and agree, more or less, on what we saw. Our experiences may vary, but we found a common ground for those experiences. I'm reticent, though, to drift too far into the realm where theological language and concepts are to be abandoned in favor of polysemous but existentially meaningful experiences. It has to be a balance.

ML: I would not want to suggest that we abandon the task of theology for the kinds of experiences we have in cinema. But as Walker Percy says, "The old words of grace are worn smooth as poker chips." Our theological vocabulary often lacks incisiveness and nuance. The experience of cinema you describe could possibly enrich the way we "do theology."

CD: Michael's delightful "poker chip" metaphor echoes Nietzsche's famous statement that truth is composed of "worn-out metaphors which have become powerless to affect the senses, coins which have their obverse effaced and now are no longer of account as coins but merely as metal." Christians most certainly need to confer when their metaphors are "worn-out." Martin Luther's theses nailed to that church door in Wittenberg were largely about a worn-out metaphor. The signifier "indulgence" originally signified the radical concept of grace made available through Christ. By Luther's day, of course, "indulgences" had degenerated into something bought with literal coins. So, yes, cinema can provide us with new coins to invest in expressions of spirituality. But it is a gamble, making the "poker chip" metaphor appropriate; after all, Nietzsche put all his money on a problematic new coinage: "God is dead."

JK: I admire the courage shown by the editors in this endeavor, because I think they have wandered into dangerous but essential territory. Are films spiritual phenomena? Can they be? I think so, if one is careful to qualify what we mean by "spiritual." If we mean that film is more adept at tapping into the Divine by its material nature, then I would say "no," this is not true. Film is not a talisman, it is not a lucky rabbit's foot, and it has no magical powers. But it does have powers, and some of those powers are unique . . . they need not be described as "spiritual," and most film theorists don't. They prefer terms like "psychological," "political," "aesthetic," etc.

But the person of faith sees God Himself as the source of the spiritual, and the Christian doctrines of Creation as well as the Incarnation suggest that God may appear in all sorts of places and media, and when a particular medium (such as film) demonstrates consistent powers of the sort described above, we might contextualize all those powers within a larger theological scheme—the way God has created the world, the way God has created us, and the way God mysteriously works in and through his creation.

CD: The metaphor "eyes of faith" is very appropriate to our enterprise: it's all about how we *see* cinema through the lens of faith. Viewers in parts of the world where cinema has been censored might inspire our own viewing practices. In *The Politics of Iranian Cinema*, Saeed Zeydabadi-Nejad tells of Muslim viewers who surreptitiously gather to discuss movies, seeking to tease out "oppositional messages" lurking underneath censored surfaces. For them, "eyes of faith" is a communitarian issue.

ML: My experience of global cinema has deeply expanded my concept of how and where God reveals himself to us. If there is any rationale for pursuing this theology and cinema conversation, which presumes that films are spiritual phenomena to be experienced, it is on these terms. Why would we not be intrigued by the Venn diagram latent in this collection of essays, which loosely coordinates God, human experience, history, time, space, and the deeply strange, illuminating process of art-making?

TW: At what point in your own development as a filmgoer did you begin to sense some philosophical potentialities in film? And how did that experience shape you? What kinds of spiritual phenomena through cinema should Christian communities be attentive to?

ML: I discovered the experimental films of Stan Brakhage while in semi-nary. For one series of films, he painstakingly pressed moth wings and bits of grass or flowers between 16mm strips, which were then contact print-ed. Something magical happens when each handmade frame achieves the speed of projection; they become something different, evolved and elevated into narrative by Brakhage's trust in the medium. This experi-ence solved a puzzle I had been agonized by for some time, in trying to coordinate my daily experience of God, a desire to communicate this experience in a constructive way, and the emphasis in scripture on the materiality of God's presence in nature, Christ, and his people.

We tend to think that theology and cinema connect at the level of theme. This is a very thin view of art and cinema. We should be atten-tive to the acts of communication occurring more fundamentally in the way craft, composition, form, and performance generate possibilities for shared experience. Francis Schaeffer described this experience of art as "titanic communication." It is a way of knowing each other and listening to each other through aesthetic channels, which can bypass the static of conflict and self-interest that make meaningful conversation difficult. It is also a very here-and-now type of communication because it involves bearing collective witness to an act of creation. In light of this, I think the spiritual phenomena we should be attentive to are the *people* involved with the filmmaking process, and the traces of divine glory present within their creative decisions. In cinema terms, "what does this mean?" is always a deeply spiritual, collaborative question.

CD: I became interested in the "philosophical potentialities" of cinema due to a group of close friends: four couples who would gather to watch foreign and auteur films and then talk about them until either the night or the wine had wanted. Because half of us were Christians and the other half skeptics, our conversations inevitably became philosophical, necessi-tating articulation of how and why we saw spiritual implications (or not) in particular films. I was in grad school at the time, studying the applica-bility of continental philosophy to literary studies, so I inevitably looked at film through the binocular lenses of Christianity and phenomenology. Interestingly, when I previously mentioned Muslim viewers, it did not occur to me that their communitarian practices most likely stayed with me due to my own experience of a "safe space" among friends.

JK: Like Crystal, I come from a phenomenological perspective and believe that Maurice Merleau-Ponty (and Edmund Husserl before him) recognized that there is a world of knowledge outside of the categorical/intellectual/verbal realm. Whereas Crystal connects phenomenology with continental theory, classic film theory, and what would later be called (by Neil Postman) the "media ecology" of McLuhan, I tend to focus on the ways phenomenology and the cognitive sciences overlap. Film is a poor pastor, an incomplete theologian, and an inconsistent philosopher, in my view, but it is a tremendous counselor and a remarkable source of inspiration, giving us scenarios and freedom to work out our sense of the real, the true, the good as well as the fake, the ugly, and the false. My approach is what has generally become known as the "embodied simulation" account, which is a loose confederation of thinkers who believe that knowledge is more than articulable facts and meaning is a dynamic, multisensory process of engagement. Everything we have learned in the last twenty years of brain science has confirmed what many phenomenologists were saying many decades previous, on these topics, at least.

CD: As to the phenomenological power of cinema for Christians, I endorse the insightful statements of my colleagues. In addition, I would caution against approaching the movies as spiritual-insight generators, demonstrated, for example, in the over-abundance of "Christ-figures" extracted from cinema. Instead, I would rather have Christians regard the *imago Dei* as apparent in the creativity of cinema itself. As Dorothy L. Sayers notes in *The Mind of the Makter*, the *imago Dei* (Gen 1:27) is established in a context where God is Creator. Hence, humans manifest the *imago Dei* when they exercise life-enhancing creativity. This, of course, resonates with that Joe tells us about Tarkovsky, who believed that "our capacity to create is evidence that we ourselves were created in the image and likeness of God." Such a view allows us to see "common grace" in any well-made film: though its message may not be Christian, the creativity of the work itself celebrates a Creator who glories in beauty from around the world. And I like how Michael adds a communitarian element to the appreciation of creativity when he mentioned in his comment our "*collective* witness to an act of creation*."

TW: Crystal writes that, "One must doubt the mass appeal of a tradition in order to preserve it. In both Christianity and film adaptation, betrayal of the medium is essential to the message." In light of such experiences of

doubt being essential to the medium and tradition, will you each reflect for a moment on the ways in which our engagement with doubt might open up new possibilities for fidelity to the tradition?

ML: This is a fascinating observation to explore in cinema terms. I have to confess at least a small amount therapeutic reasoning for watching as much film as I do. A cognitive dissonance has grown over my years in the classroom and in the church. I feel a constant tension between the solid, historic boundaries of Christian essentials and the slippery mess that is the normal condition of life, which often forces me to wonder which is most important to emphasize. And I believe the answer is neither. Or maybe both. Rather than try to resolve this cognitive dissonance, I have had to learn that it really is the normative space of Christian faith. Good cinema has always been a safe place to live with such contradictions. I am exposed to dissonant forms, discordant patterns and textures, planes of extraordinary tension—and all within the span of one frame, reminding me again and again of a far greater unity that binds together all the things I do not feel matching up in the present.

JK: Crystal's point about content itself necessarily changing with each medium shift is absolutely true and very timely. Discernment requires people of faith to understand that the religious truths to which they subscribe have been shaped by the media through which they have received them, and one cannot treat these forms of media as utilitarian buckets within which one can carry any manner of content. I love Crystal's use of hyperbole, but I do urge the reader to recognize it as such. Use caution when making creative use of terms like "doubt" or "treason" or "betrayal" to describe theological matters. Doubt is a useful tool, when balanced with things like tradition, doctrine, and repentance and humility, but it is not doctrine itself.

My engagement with the cinema is a process whereby I engage my own doubts, as well as my own beliefs, and allow the shaping/re-shaping process to occur. This happens in real life as well, of course (and the real life occurrences in social life: church, family, work, the neighborhood) cannot be replaced by the cinema any more than real relationships can be replaced by a relationship with one's therapist (however helpful your therapist may be). But therapists do help us to see, precisely in the safe space they give us to experience and verbalize our doubts, imagine alternate futures, and help us to see our joys and blessings more clearly. In my

experience, cinema can also do that in an embodied way: affective, and effective.

CD: Joe is right about the problem of vocabulary, what I elsewhere call "the power and poverty of language." Hyperbole—outrageously exaggerated metaphor—can lead people astray, as when Nicodemus responds to Jesus. Nevertheless, Jesus was fond of hyperbole: "If you right eye causes you to sin, tear it out" (Matt 5:29–30). Jesus, I would argue, recognized that the currency of religious language in his day no longer had purchasing power; the coins were "worn-out." So he shocked people into thought by minting new coins. This, of course, is what cinema can do: give new metaphors—some of them hyperbolic—to shock us into new ways of seeing. Dale Irvin meant to shock us into thought, I believe, by employing the hyperbolic terms "treason." And I quote him because the term accords well with my emphasis on "adaptation as betrayal." Nevertheless, agreeing with Joe about the need to balance change with tradition, I prefer a different coinage: (re)signing truth. With this neologism I synthesize two meanings at once: 1) in order to maintain Christian orthodoxy we "resign" ourselves to doctrines established at the first four Ecumenical Councils; 2) at the same time, we need to "re-sign" how we talk about those doctrines. In other words, manifesting the *imago Dei*, we create new signs that might draw people to the Gospel rather than perpetuating their indifference by playing worn-out coins. However, it takes me over 300 pages to explain how and why Christianity needs to (re)sign in *Changing Signs of Truth*, so let me simply end here by affirming the (re)signing power of good cinema.

TW: Joe highlights the productive energies of doubt made available to us through patient struggle on display in Tarkovsky's *Rublev*: "It is in the somber, liminal space between unbelief and certainty that Tarkovsky finds living faith and living cinema." How do you think the experience of film can make us more aware of these kind of spaces in our own lives?

ML: Joe Kickasola describes this machinery very well in his essay on Tarkovsky. In cinema, we are presented with a mystery, which leads to a feeling of trust in the director, which leads to an "adventure in perception," which then leads to revelation. Each component of this process is worthy of consideration, but the first two strike me as particularly relevant to this question. First is the mystery itself, which is an image or sequence or

composition that de-familiarizes something we thought we had a handle on. We see it again, in cinema, as if for the first time. This makes us a little afraid because it is an encounter with what Otto referred to as a "fearful and fascinating mystery." But then, and this is where every cinephile is born, we encounter a feeling of trust in the director. We sense that the director is going to build on this de-familiarity. We are going to leave the film differently than when we began. I think this is a thumbnail sketch of how cinema can have an actual effect on who we are becoming.

JK: Exactly. I recall Christian Smith talking about second-order desires (desires about other desires) in his book *Moral, Believing Animals*. The notion is that second order desires are uniquely human, and inescapably tied to the ethical. So, part of being human is we might be intrigued by a car crash (desire to look) but our second order desire is to scrutinize the first desire and ask "but is this the sort of voyeur I want to become, or do I value humanity more than this?" That we might be both things at the same time is the curse, but also the blessing of being human. As I said before, I more or less subscribe to an embodied simulation account of the cinema, which suggests that we use the cinema to experience things "off-line" . . . we have simulations of experiences where it is "safe" to experience them (that is, without the serious ramifications of such experiences in real life). This helps explain the appeal of some horror movies, but also theologically-loaded films like those of Bergman! It is also more than simply "safe," but often liberating . . . to experience something we love completely anew, to revive it and see the value in it to rise above its instrumental value.

ML: Similarly, I was coming at your concept of de-familiarity in the Tarkovsky essay from Ricouer's "second naivete." We get to see ourselves as if for the first time, having passed through the self-critical experience of cinema. But what makes cinema such a rich theological medium is that it is a medium of the body, of the person acting and moving in space. So a clear benefit of conceiving of cinema as a spiritual or theological exercise is that it may reduce the intellectual disconnect between body/praxis and thought which plagues "doing theology" in other modes.

JK: This is very insightful, and it shows the potential of really good cinema; but it takes great skill to pull it off. I have a great interest in multi-sensory perception through cinema, and a great interest in embodied experience

of religion through cinema. I'm finding an arena where science, theology, and the arts are all saying the same thing: experience matters. And the connection with Ricouer is great. I hadn't thought of pairing that idea with the neo-formalist/Shklovksian idea of de-familiarization in art, but it really does point to the importance of "seeing" and "re-seeing." Art (especially cinema) can be really helpful in that regard.

CD: I was thinking of Ricoeur as well, especially his "hermeneutics of suspicion." Applied to cinema, we might regard it as a suspicion of filmic surfaces: of stories with artificial happy endings and conventional characters, as in "He is a cop/detective/coach/teacher/superhero/vampire who doesn't play by the rules": the convention of unconventionality. In contrast, Iranians who meet to discuss censored films are practicing a hermeneutic of suspicion. And I bet that what they look for are moments of de-familiarization, liminal spaces that open up the possibility of oppositional readings. We might also call it a "hermeneutic of doubt." The best filmmakers, of course, encourage such a hermeneutic through cinematic technique, more than through story, dialogue, and characterization: long takes with no movement or words, disorienting crosscutting, baffling inserts, indecipherable close-ups. The medium itself becomes the message. As Joe puts it: "Tarkovsky's hope was that the aesthetic dimensions of the film would speak effectively in places where intellectual formulations have fallen short." Making this relevant to spaces in our own lives, I would argue that strange, dialogue-free moments in film gesture toward the apophatic tradition within Christianity itself, also know as "negative theology," formulated on the assumption that language cannot fully explain God. There is a mystery to existence that transcends the ability of words to capture it. This makes mysterious language-free moments in film all the more important for us to attend to, almost as a spiritual discipline.

TW: Michael highlights the ways in which "Bergman's version of doubt becomes a communion, the prelude to more complicated, mysterious realities that cannot be subsumed by either an easy collective religion or individual rationality. It also becomes a formal statement about cinema as a mode of communication, a collaborative space to reimagine doubt as an opportunity, a recovery, or a second chance." In your experience of doubt through film, how has this communion unfolded? In other words, what spaces have opened up for belief in new ways?

CD: Michael's focus on the communion and communication of doubt helped me better understand Woody Allen, whose films repeatedly quote Bergman, both verbally and visually. For example, at one point in *Annie Hall* (1977) we see Alvy (Woody Allen) waiting for Annie (Diane Keaton) in front of a movie poster advertising Bergman's 1976 film *Face to Face*, as though signaling Allen's own unlikely affinities with Bergman. Indeed, *Annie Hall* obliquely, if far more humorously, echoes Bergman's 1969 film *The Passion of Anna*. Both break the illusion of cinema while visualizing problematic love relationships. Bergman inserts shots of actors commenting on characters they play in the film, while Allen's Alvy repeatedly breaks the fourth wall to address us, the film viewers. I read each break as a kind of liminal space that, by forcing us to doubt the "realism" of the film's world, encourages to doubt our understanding of "reality" as we experience it. In other words, just as there is an audience beyond the screen of each film, Bergman and Allen seem to interrogate the possibility of a Transcendent Audience beyond the frame of quotidian existence. Nevertheless, to quote Michael's apt comment about Bergman, Allen is "deeply ambivalent about the validity of religious experience," manifest most clearly in his films *Crimes and Misdemeanors, Hannah and Her Sisters,* and *The Purple Rose of Cairo.* There is a communion between Bergman and Allen over the issue of doubt and faith, and I commune with them, ultimately choosing faith over doubt. Nevertheless, believing that faith without works is dead, I also believe that faith without doubt is dead.

JK: My encounter with Bergman was very much like Michael describes it: a unique space in which one could not feel alone in my doubt, and recognize—once more—that faith is not the absence of doubt, but the grace to live through and with it in hope. Even at Bergman's most doubtful, as in his films of the late 1960s and early 70s, he does not pretend the theological questions are trite or irrelevant or a sideshow. They are the very ground upon which this battle over life and death is fought. And though God is very much in question in the wake of the massive suffering, in *Cries and Whispers* (1972) for instance, he cannot resist evoking the image of the Pietà in that film, by which he consciously reminds us of the paradoxical beauty and comfort Christ's suffering (and Mary's agony) has yielded. Theology—true or not—is the thing with Bergman.

ML: Another important element of Bergman's cinema involves the physicality of his work. He was very dependent on collaboration with his actors, as his harrowing scripts and very exacting dramaturgy required a lot of interaction on the part of everyone involved in the filmmaking process. So while theology is "the thing" with Bergman, anything Bergman did in the filmmaking process was also a very human, material, active sort of collaborative theater. So if theology is Bergman's thing, then it is very much a theology from below, exercised in creative community.

JK: Sure. But when we talk about theology from above or below, we are usually talking about people approaching questions from an intellectual point of view or a heart/action/practical point of view. I think the strength of Bergman is he presents both pretty strongly (albeit in a questioning, often negative way).

ML: This type of indeterminacy may be what a director like Bergman has to teach theological method—that we cannot so simply subtract human expression from our search for the divine.

JK: One finds this in other seriously "doubting" and theologically vexed filmmakers but not, in my estimation, with the same integrity as Bergman. I also have some difficulty with the conception of Bergman as a "realist," for this reason: there are many things that Bergman characters do that most people I know—religious believers or not—would not do. We don't sleep with strangers, we don't mutilate ourselves (even at our most desperate moments), etc. But when Bergman works (and he sometimes doesn't), he achieves that miracle of solidarity between me and the person who is not like me. What we don't share is action, but what we do share is desperate need, and I find myself reaching for every spiritual resource in my mind and heart to save that character, because I have come to love her and recall that I have been saved myself, again and again. Perhaps, in that way, Bergman's realism is more like a reminder that we might, possibly, be more than monsters if grace and love be joined.

CD: "Realism," of course, is a problematic term, reduced by positivists to the empirically-verifiable: what is accessible to the five senses. This roundtable conversation is valuable because it privileges moments in cinema, accessed through the senses, that can nevertheless open viewers to that which exceeds empirical "reality."

ML: I hear what you are saying, Joe, about all these characters, and this is a fitting criticism of where Von Trier bends his reliance on Bergman too far in many cases. Yet, I think Bergman is an important realist of his era in a formal sense, because he was searching for ways to express the psychology of family and interpersonal conflict in authentic ways. I think he recognized the shifting mood of modernity toward doubt and indecision, and found in cinema a medium capable of expressing the feeling and sensation of this emerging cultural paradigm. This is a similar motivation we find in other strands of realism of the time, such neo-realism or the more noir crime films beginning to appear. But with Bergman, this is a realism of religious experience. It was a realism other directors didn't seem as willing or capable of achieving at the time.

This sense of solidarity you describe is really intriguing. It is worth pursuing the idea that realism is about enacting solidarities that otherwise wouldn't exist.

JK: Your comment on late modernity, and Bergman's place in it, reminds me of Deleuze's attempts to express the time-image (as opposed to the more traditional movement-image of the classical cinema). Though "realist" was a term Deleuze tended to avoid, he would have chimed a bit with what you are saying, I think, in that the sensations generated by filmmakers like Bergman resonate powerfully with us, at that particularly intense and meaningful pitch. Regarding solidarity, I tend to approach human communication (and the cinema) phenomenologically, which is to say that solidarity is a type of miracle that we constantly seek (cf., Martin Buber, Levinas, etc.) In this sense, the solidarity is not only "real" but it is where the significance of the real is made manifest.

CD: Also helpful in this regard is Jacques Lacan, who distinguished "reality" from what he called "the Real." (Unfortunately, Lacan has been demonized because apparatus and Screen theorists appropriate and applied his insights in dehumanizing ways.) For Lacan, "reality" is what culture trains us to see, as when seventeenth century Christians actually *saw* the Alps as ugly, whereas most today see them as beautiful. Hollywood, of course, panders to cultural constructions of reality, whereas artist filmmakers like Tarkovsky and Bergman encourage us to contemplate a "Real" that exceeds reality. This is where I find Deleuze helpful. He wants us to see time itself: a Real that cannot be categorized according to common understanding of "reality." Cinema, however, has not changed what

I believe to be "Real," God Incarnate making possible the gift of salvation. Cinema, instead, helps me to better understand how I am embedded in a fallen "reality" that impedes my recognition of the Real. In more positive terms, I find cinema suggesting the existence of a Transcendent Real any time directors who are antagonistic toward the religious traditions shaping them, like Bergman and Allen, grapple to uncover a *more* to existence. Their films beautifully communicate a doubting of their own doubt.

ML: I have not been lead to believe in different things, in terms of content. I have been lead to believe in a different way. The manner and habit of my believing in God has grown more charitable, more alert to signs of life. I think we often fail to perceive art as an act of survival. So is theology. This is primarily what makes them such compatible disciplines.

Dread

Beyond Death?

Alejandro González Iñárritu's Grief Trilogy

Taylor Worley

Now everything is quiet. I can no longer reach her. A frightful emptiness surrounds me. Everything I encounter impresses me with the contrast between visible, earthly reality and the puzzling absence of the one I love. I have lost the one human person loved by me without measure or comparison. I am caught up in the tedium of life. I am filled with disgust and emptiness over the rhythm of everyday life that goes on relentlessly—as though nothing had changed, as though I had not lost my precious beloved!

—DIETRICH VON HILDEBRAND,
JAWS OF DEATH, GATE OF HEAVEN[1]

To have a friend, to look at him, to follow him with your eyes, to admire him in friendship, is to know in a more intense way, already injured, always insistent, and more and more unforgettable, that one of the two of you will inevitably see the other die.

—JACQUES DERRIDA, "THE TASTE OF TEARS"[2]

Suffering is optional, but pain is inevitable.
—ALEJANDRO GONZÁLEZ IÑÁRRITU[3]

1. Quoted in Neuhaus, ed. *The Eternal Pity,* 84.
2. Derrida, *Work of Mourning,* 107.
3. Quoted in Deleyto and Azcona, *Alejandro González Iñárritu,* 126.

Introduction: Love, Loss, and Dread

With brutal clarity, Ludwig Wittgenstein reminds us, "My death is not an event in my life." As many philosophers before and since have affirmed, we are never present to our own deaths. The reality of death is instead something we have to experience in the death of another.[4] We must see our death in the death of the other; and many of the greatest works of art simply return us to this tragic truth. This, I understand, to be the function of dread in art. By their intimate attention to the reality of the other's death and the enduring weight of human grief, the films of Alejandro González Iñárritu (Mexican, b. 1963) offer a renewed awareness of our fragility and impermanence.[5] Their anxiety over death extends far beyond the flatly depressive. Rather, these films fill us with an animating dread—a dread that quickens our attention to what is left of our own lives. His is a dread with redemptive aims.

Beyond mere elegy, Iñárritu's films catalyze feelings of dread through a subtle but poignant interplay of bodily presence and absence. By de-stabilizing the emotional distance felt by his protagonists between the lives of loved ones both present and gone, we are haunted by the emotional inversions embedded within our own experiences of love and loss. Such inversions emerge when we realize that being receptive and responsive to another entails being fully present to the reality of that other's eventual departure. Or, to perceive the full loss in the death of another means to know and grasp their imagined presence in the event of their absence. Dread inhabits this experience of knowing absence in another's presence and sensing presence in another's absence. We must indeed find ourselves here and accept this emotional hesitancy, this feeling of being caught in the back-and-forth of time with and time without our loved ones. Iñárritu's subtle power lies in presenting us with an arresting and elusive image of this experience. His films rehearse such moments

4. Following thinkers like Simon Critchley, this essay takes as a foundational starting point the more recent rejection of Heidegger's assertion that death is only one's ownmost. For example, Critchley pushes back on Heidegger in this way: "I would want to oppose it with the thought of the *fundamentally relational character of finitude*, namely that death is first and foremost experienced in a relation to the death or dying of the other and others, in being-with the dying in a caring way, and in grieving after they are dead." Simon Critchley, "Enigma Variations," 169.

5. While I am aware of the fact that this director's surname in his native Mexico is a combination of "González" from his father and "Iñárritu" from his mother, I will keep with the practice in English-language marketing, journalism, and scholarship to simply refer to him with only "Iñárritu."

of emotional instability, and in their mournful vertigo they restore us to the vain but all-too-human pursuit in attempting to stall the death of a loved one.

Iñárritu's Trilogy of Grief

As one of the few remaining auteurs in contemporary commercial film, Iñárritu occupies a distinctive place in recent film history. His status in the pantheon of contemporary filmmakers is unique in that he fiercely guards his artistic choices and follows his creative pursuits without hesitation, and yet the accolades and awards continue to mount up, especially in the wake of 2014's *Birdman: Or (The Unexpected Virtue of Ignorance)*. Though he collaborates with some of the most creative figures in filmmaking today, much of the attention centers on Iñárritu himself because of the way in which he continues to play so many roles in the production of his films, often writing, directing, producing, and even editing these works. Simultaneously a business outsider and a critical darling, he continues to press questions of ultimacy and timeless significance while remarkably maintaining a richly emotional center to all his films. On this point, he remains unapologetic:

> There is this apocalyptic urgency that has been treated with irony for years, and I try to stay away from irony, which I personally don't like. Irony is a great tool to deal with things. It's an intellectualization, a way to go above things, which can work. But I think that, in the last fifty years, pop culture has been a victim of an excess of irony, and anything earnest or truthful or emotional isn't cool anymore. Every institution has collapsed. And if there's nothing, if everybody agrees that the way to approach it is with a degree of irony, there is nothing else.[6]

For much of his career, Iñárritu has paired the un-ironic tone of his stories with a novel storytelling technique: the multi-linear, multiprotagonist drama. While films like Akira Kurosawa's *Rashômon* and Robert Altman's *Short Cuts* came before him and lots of filmmakers are still trying their hand at the format, no one has harnessed the pathos of the multiprotagonist film like Iñárritu. Effectively disorienting his audience and confounding their ironic sensibilities for a time, to experience Iñárritu's films is to enter into a tangled web of imperfect lives mutually

6. Mitchell, "Alejandro González Iñarritu."

effected and shaped by each other's frail choices. Reflecting on *Babel,* he explains how this jumbled approach to storytelling helps foreground the emotional essence of the films:

> *Babel* is the culmination of my exploration of scrambled narra-
> tive patterns. It's a fragmented emotional experience, which is,
> after all, what cinema is about. Movies rely on the juxtaposition
> of several elements that, from a rational point of view, shouldn't
> provoke any kind of emotional reaction, but our brain links
> these two images, and there's an emotion.[7]

While he ended the strictly multi-linear approach with *Babel,* the con-
sistency of technique in his earliest films resulted in being designated
a trilogy after the fact. This multiprotagonist trilogy (i.e., *Amores Per-
ros, 21 Grams,* and *Babel*) has often been referred to as Iñárritu's "death
triology."[8] For the purposes of this engagement, we will limit ourselves to
what we might label his grief trilogy (i.e., *21 Grams, Babel,* and *Biutiful*).
It is, after all, the emotional landscape and not the visual aesthetic that
takes precedence in his work. We will therefore leave out his first experi-
ment *Amores Perros* and his recent comedy *Birdman. 21 Grams, Babel,*
and *Biutiful* are the best examples for how Iñárritu dramatizes the inter-
play of love and loss, the inversion of presence and absence—the dialectic
of death, if you will. These films simulate the experience of the phantom
limb as an emotional or spiritual reality. Death's amputation can distort
but not ultimately remove the emotional structure of Iñárritu's charac-
ters. They are forced to re-negotiate themselves in relation to the world by
means of navigating the force of these losses. When asked about the role
of fate and chance in his films, Iñárritu responds from a primarily ethi-
cal rather than purely epistemological perspective. He concedes that we
cannot tell the difference, but we must react and respond regardless. His
films focus on how his characters respond to fateful or random tragedies:

> We react to a crisis, to an illness, to a tragic event. We also gener-
> ate things ourselves, but to a much lesser extent. These events
> force us to make decisions and confront us with our deepest
> feelings and our links with other human beings. . . . How does
> somebody react to an accidental and tragic event? Where's the
> line between destiny and coincidence? It's difficult to tell. But I
> personally think that it is our reactions to things that move the

7. Deleyto and Azcona, *Alejandro González Iñárritu,* 131.

8. Iñárritu himself alludes to this trilogy in conversation with Deleyto and Azcona.
Ibid., 133.

world. There is this sentence that my father used to say and that has always traumatized me. I used it in *Amores Perros*: "If you want to make God laugh, tell him your plans."[9]

Within this trilogy of grief, Iñárritu's use of the death theme shifts and contorts, manifesting complementary but distinct experiences of cathartic pain and suffering. In their own way, each of these films leaves us shaken and somehow also steeled against the loss of love around us. They make us freshly aware of death, attuned to the inevitable loss of all and yet already grasping their memory with us now.

21 GRAMS

While similar to its multiprotagonist antecedent and successor, 2003's *21 Grams* remains Iñárritu's most austere and oppressively heavy film to date. Surpassing even the straightforwardly somber tone of *Biutiful*, this film also represents his most disorienting experience of cinematic time. While *Amores Perros* and *Babel* play with a sense of narrative simultaneity, *21 Grams* is completely jumbled and non-sequential. We must forestall our reflex to order the narrative so as to reckon with the emotional weight of what its characters convey to us. Iñárritu explains his editing choices in this way: "I was looking for an emotional structure in a completely atemporal storyline."[10] What results is an experience of a sort of pure grief, a stark and severe grief that can present itself to us in harshly religious terms. The cruel convergence of the lives in this story forces its characters, and by extension the film's audience, to ask impossible questions and probe into the sheer mystery of how such disparate lives would be bound together in tragedy and grief. To invoke such answers is to invoke the divine other.

When Jack Jordan, the recently released convict and newly converted believer, accidentally kills a father and his two daughters in a hit and run, three lives become inseparably bound together in the mutual implications of his crime. Shattered by the loss of her husband and children, Cristina Peck descends into a destructive spiral of self-abuse and lust for revenge. Paul Rivers and his chronically ill heart have a new lease on life because Cristina's husband was an organ donor, but gratitude for his renewed health prompts him to seek out the donor's story, which quickly

9. Ibid.
10. Ibid., 130.

leads to infatuation with his donor's wife. Paul's efforts to protect the wounded and fragile widow soon make him complicit in her attempted revenge against Jack. Though audiences can only piece together this picture of the three entangled lives, each strand of the story begs the same question. In the parallel struggles with their grief, each character appears to ask: Why can't we move on? Why can't we ever start over? The raw and rigid refusal to move on, however, is nowhere better seen than in the response Cristina offers to the tragedy at the heart of the film.[11]

FIGURE 19

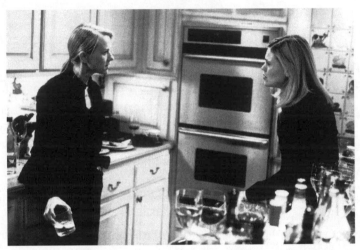

In a scene following the funeral of Cristina's husband and daughters, her father attempts to console her. This is a moment of seeming insignificance, but in fact, we learn that it bears the crux of Cristina's defiance. When Cristina's father relates his experience of the loss of his wife and her

11. Though Cristina's pain emerges as the most poignant one in the film, the other characters invite the same question with perhaps more pronounced irony. Though Jack Jordan has left the penitentiary and even "found Jesus," both he and his wife seem tragically condemned to repeat the cycle of mistakes and suffer new and profound misfortunes. Even when he wins a new truck through a lottery, we find him stuck in the same forsaken place once we learn this is the vehicle that killed Cristina's family. Perhaps more ironically, Paul Rivers cannot accept his new heart as a gift and is driven to find the source of his new life. At one point when his wife questions his interest in the donor, he responds by telling her: "I want to know who I am now." And later, Cristina even confronts Paul and asks him, "Who are you?" So overcome by the prospect of his own death, it is as if Paul doesn't want to get better, and indeed he ultimately chooses a short life with Cristina over a medically prolonged life with his own wife Mary.

mother, he reassures her that, "Life goes on."[12] Even in her shocked and raw pain, Cristina will not abide his counsel. She responds: "You know what I thought when mom died? I couldn't understand how you could talk to people again, how you could laugh . . . again. I couldn't understand how you could play with us. And no, no that's a lie; life does not just go on."[13] Rather than try and carry on, Cristina is fully exposed once more to her deepest demons. She is rendered utterly powerless and begins to descend once more into a dark place of despair and self-destruction. In her rigid despair, she seems stunned by the events that follow, haunted by the questions arresting her. Though completely gone from her, Cristina's family remains a constant presence for her, and by her own confession, she is "paralyzed" against the grief. She is struggling to know if her husband is somehow still present through the transmission of his heart to Paul. If not, has she committed adultery against him and thus betrayed her husband by receiving Paul in his place? Her grief is palpable, and Iñárritu allows his audience the means to feel it too. Like his character Cristina, he stares down the harsh reality of our pain: "I try to explore human behavior through a violent event or a violent act with a fatal outcome. Death has weight in my films. It's important. When a character dies, it's not like a pebble falling on the ground. It makes a difference. I think nowadays people run away from those realities."[14] And there is no easy recovery for Cristina either. In the end, she is forced to choose between her love for Paul and her lust for revenge. Jack Jordan lives, and Paul Rivers dies. The only comfort we are given from her stark choice is the glimpse we receive at the close of the film of Cristina's anticipation for her new child. It seems that Paul's sacrifice has propelled her over their wall of grief and offered her a new hopefulness beyond sheer suffering.[15]

12. Iñárritu, *21 Grams*.

13. Ibid. Later in the film, she rebuffs Paul's attempts to stem her grief by reminding him that she "can't go on with her life," and compares herself to an amputee.

14. Deleyto and Azcona, *Alejandro González Iñárritu*, 126.

15. Again, Iñárritu reveals: "I prefer to explore suffering from the perspective of the circumstances that lead characters to extreme situations. Those events cause pain, and pain is inevitable in our lives. Suffering is optional, but pain is inevitable. You can't understand or speak in any depth about life except from the perspective of death." Ibid., 124–25.

BABEL

As Iñárritu explained to Deleyto and Azcona, "Borders are ideological and nationalistic territories that make us smaller."[16] This sentiment represents a particular viewpoint charged by the difficult realities of life in a post-9/11 world, and as a result, 2006's *Babel* is fixated on transgressing borders.[17] These, however, are not merely the borders represented in Americans abroad in North Africa or residents of LA crossing over into Mexico.[18] Neither are they simply the moral transgressions that confuse and frustrate the tangled web of stories in *Babel*: a marital infidelity, an indiscriminate shooting spree, evading border patrol agents, propositioning a police detective, or any other such indiscretions. Rather, the borders of state security in Iñárritu's cinematic landscape should direct us to more intimate forces of restriction and limitation in his characters. The director himself explains these transgressions this way:

> *Babel* is the last film that completes my trilogy which began with *Amores Perros* and *21 Grams*. It is a film made up of four stories on three continents and in five languages. As in the two previous films and beyond the implicit political and social commentary that it contains, *Babel* is a film about the complex relationship between parents and their children. It is also about the borders that not only divide nations and cultures, but the real borderlines that live within ourselves that can only be erased by compassion,

16. Ibid., 126. Describing his own connection to Mexican cinema, Iñárritu relates a good deal of ambivalence: "I think art should have no nationality. When a work of art is reduced to a geographical territory, often with a nationalistic sense, it's always diminished." Ibid., 122.

17. Iñárritu relates the following details of the first days for his family when they relocated from Mexico to Los Angeles: "When I arrived in Los Angeles, it was four days before 9/11. Then, all of a sudden, everything changed. Fear took over, and there started to grow a new racism based on fear." Ibid., 127.

18. Iñárritu explains his choice in leaving Mexico in an interview for *The Telegraph*: A former radio DJ—for five years he presented a show on the most popular station in Mexico City, before taking a film course and becoming a director of television commercials—Iñárritu has had a public profile in Mexico for much of his life, but it was the rapturous international reception of *Amores Perros* that made him a widely recognized face; that was when the troubles started. "At that time in Mexico, kidnapping was kind of a sport," he says. "My seventy-two-year-old father was kidnapped, gone for six hours. It was horrible. My mother was assaulted, her teeth broken, my brother was assaulted, too—it was insane. I couldn't focus on work anymore, I was constantly worrying about my children. So we had to leave." Benjamin Secher, "Alejandro González Iñarritu Interview for *Buitiful*."

something that we have been losing for the last many years and is what drove me during the process of making this film.[19]

Like in the complex narrative of *21 Grams,* this film portrays a grand unraveling of small misdeeds and accidents. Somehow, a hunting rifle purchased in Morocco unleashes panic in four different families experiencing their own upheavals simultaneously around the globe. With each set of parents and children, a familiar question resurfaces—a question embedded in the film's ancient title: Why can't we communicate with one another? Again and again, the characters find each other unreachable. Whether this breakdown is the result of natural divides of time and place, the failure of the global telecommunications infrastructure, or simply an obvious and suffocating deficit of empathy, *Babel's* cast of mothers and fathers, sons and daughters, cannot seem to find each other. Despite the particulars of each situation, grief, it seems, exerts once more a threatening and oppressive dominance. Recall the overlapping and parallel strands of grief in this story: four families, three deaths, two endangered children, and one attempted suicide.[20] For the purposes of our discussion

19. Quoted in Philbin, "Globalism and the Films of Alejandro González Iñárritu."

20. The web of grief is both intricate and far-reaching here. Two young Moroccan goatherds are testing the range and accuracy of their new rifle, and with a scarcity of jackals in mid-day the younger brother turns his aim to a tour bus traveling down a nearby road. Richard and Susan are on the bus barely tolerating one another and feigning interest in the barren North African landscape when a lone bullet pierces Susan's window and lodges itself in her left shoulder. The American couple vacationing in Morocco have escaped to an exotic locale in hopes of repairing their disintegrating marriage and reconnecting with one another. As the film opens, the hopes of such renewal seem bleak at best, and the source of their conflict is revealed to be the unrelenting and alienating pain at the recent, unexplained death of their infant son. The grief of this loss has clearly shattered both of them. Richard and Susan have left their older children back home in Southern California under the care of their nanny Amelia. Determined that she not miss her son's wedding back in Mexico, Amelia takes the children with her and after the celebrations their return through border patrol takes an unfortunate turn. When Amelia and the children are stranded and then lost in the California desert, her longings to reconnect with family and friends are overshadowed by her guilt in putting the children she has cared for in such imminent danger. Across the Pacific Ocean, the original owner of the hunting rifle in Morocco is desperately trying to make amends with his distraught and estranged teenage daughter. Her deafness complicates their interactions, but it becomes clear that the real issue stems from the fact that she was the first person to discover her mother after she had killed herself. Both father and daughter are still frozen in grief and miss one another almost completely. The vacuum created by Chieko's hurt at the loss of her mother inspires the young girl to fill it with anything that might replace the void. To these three families is added the desolate grief of the Moroccan family who have their lives turned upside

here and to emphasize the overcoming of grief in Iñárritu's films, we will focus on the restoration of Richard and Susan's relationship, the American couple vacationing in Morocco.[21]

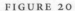

FIGURE 20

In a recent interview with Elvis Mitchell, Iñárritu revealed a bit more of his narrative logic: "I have always said that innocence is much more powerful than experience. And, in some cases, people who suddenly fall into circumstances can unexpectedly bring some virtue to them."[22] Though true of many of his characters, this logic is especially true of Richard's unexpected reconnection with his wife. Iñárritu knows all too well what Richard and Susan are facing. He understands the kind of isolating and crippling grief that his characters are experiencing, because Iñárritu and his wife lost their second son just days after his birth. Few couples

down and must face the murder of their son at the hands of local authorities outraged at his brother's mistake with the rifle.

21. While the film utilized several Hollywood mainstays and a handful of celebrated stars of world cinema alongside numerous unknowns and non-actors, its narrative deals gently with all parties involved. Such care and attention for all the citizen's of Iñárritu's global community issues from the director's self-imposed mandate: "Two words guided the making of Babel for me: dignity and compassion." Alejandro González Iñárritu, "Hollywood Must Portray Point of View of Others."

22. Mitchell, "Alejandro González Iñarritu."

can navigate such an impasse of grief without losing one another in the process. Richard and Susan are on the edge of just that when the goatherd's careless bullet interrupts their holiday. As Richard acts with equal parts desperation and heroism to save his wife, he is confronted with the prospect of a new and more tragic grief: will he lose his wife also? As Susan languishes in pain and Richard descends into panic, the reality of their desperation sets in. Yet, it is there beyond the bounds of safety and security that they find one another again. As they pass each grueling moment in worry and fear that help will not reach them, Richard and Susan share an astounding, if entirely unlikely, moment of renewed intimacy. Bereft of any means to dramatically save her, Richard is reduced to caring as best he can for Susan's momentary discomforts and pains. Delirious from the pain and no doubt dulled by the locals' attempts to mitigate it, Susan asks Richard to help her keep from urinating on herself. He finds a makeshift bedpan and gingerly assists her without aggravating the gunshot wound. In this humble, if not humiliating moment, they are able to meet one another again in the shared deprivation of their state. With Susan's life in the balance, Richard is returned to his most basic role as her lover and partner, and it is the small, mutual gesture of giving and receiving another's care that reunites them as husband and wife. Indeed, this is the moment that enables Susan's eventual rescue to be a recovery in full and not just in part. In meeting the prospect of death and grief once more, they are saved from the burden of their former grief and given another chance at the restoration of their family. Though not all of *Babel's* stories end so well, the redemptive image of Richard and Susan is powerful to behold. And Iñárritu holds out this hope for his audience: "People go through extreme pain, but that experience serves them to reinvent themselves, or to rediscover themselves or the other."[23]

BIUTIFUL

Another suffering figure emerges in 2010's *Biutiful*, and here his grief is supernatural and somehow able to see beyond itself. This time, however, Iñárritu selects a much simpler format for telling his story. The

23. Deleyto and Azcona, *Alejandro González Iñárritu*, 136–37. He continues, "I always try to point out that possibility. I don't know whether that's optimism or not, but for me it's realism, it's human truth. Pain is inevitable. I try to capture it, photograph it, x-ray it, but I never poke into it or describe it as the only way. Pain teaches us very profound things about human nature."

multiprotagonist trajectory set in motion by *Amores Perros, 21 Grams*, and *Babel* is supplanted by a much more straightforward progression. The director explains his choice this way: "The structure of Biutiful is strictly and rigorously linear. I really wanted to do something new, which was to get immersed in the journey of one single character from his point of view."[24] It seems this abrupt stylistic change is actually serving a more subtle artistic transition in Iñárritu's body of work. Whereas the multi-linear approach of *21 Grams* and *Babel* generated in the audience a preoccupation with the narrative, *Biutiful* focuses on a single figure in the whole and thus shifts from a plot-driven to character-driven orientation.[25] The slowly evolving storyline, however, adds to the somber and dark tone of the film.[26] On this point, one critic surmised that *Biutiful* was "Iñárritu's bleakest film to date. Even the Barcelona setting, drained of sunshine and looking more squalid than you've ever seen it, seems to be in mourning."[27] Perhaps surprisingly, the director does not see his film this way. "*Biutiful* is not about death," he told Benjamin Secher, "It's about life. It's a hymn to life."[28] Indeed, many of the distinctive tones and impressions of Iñárritu's cinematic vision are kept quite intact with this film. The layers of emotional decay and interpersonal conflict and confusion carry over from his early films, but *Biutiful* is provocatively unique in one seminal way. The dead are raised.

To say that the film is "rigorously linear" does not quite account for the opening and closing scenes. Although we cannot see it until the close, these moments mirror one another and function as bookends to the entire narrative. It opens with Uxbal lying in bed with his daughter telling

24. Ibid., 137–38. He continues: "I found the experience fascinating, even if for others it may be quite normal. Some people may think that multiprotagonist structures are more complex than single-hero ones, but they're also simpler in that the stories are shorter: each story is no more than twenty-eight or thirty pages."

25. On the difference between *Biutiful* and his earlier films, Iñárritu remarks: "The others were fragmented experiences, and this one was monolithic. I was with some musician friends of mine yesterday, and I was telling them that I had always seen *Amores Perros* as rock, *21 Grams* as jazz, and *Babel* as a piece of eclectic music. *Biutiful* is like the blues: a long, melancholy note." Ibid., 139.

26. "*Biutiful* is a tough film," he concludes. "It doesn't make concessions to the vulgarity of light entertainment. It's not the kind of film that you see every day in the Cineplex. But as an artist, it's the thing that I needed to do." Secher, "Alejandro González Iñarritu Interview for *Buitiful*."

27. Ibid.

28. Ibid.

her about his mother's ring that he is giving to her. The scene shifts to a barren wood with slowly falling snow. As Uxbal stands over the remains of a dead owl, another man approaches. They share a few light-hearted words, and then the man moves on with his trek through the snow. After this opening scene, we commence the slow and steady descent with Uxbal toward his dying moments and the grief-stricken steps leading there. He learns that he is dying of prostrate cancer and must get his affairs in order. This project is no small task given the fact that he is a middleman of sorts in the sordid black market underground of Barcelona. Many immigrant workers depend on him to make what little cash they can, and the authorities pursue and pressure him from the opposite direction. The webs of questionable and illegal commerce are thick and impossible to untangle. Most importantly, however, his daughter Ana and son Mateo can literally only depend on him, because their estranged mother suffers from mental illness and her sporadic attempts at family life usually end in ruin and conflict. Uxbal struggles to right his wrongs and provide for his children's well being after he is gone, but death chases him down and cuts short all his efforts. Succumbing to the inevitable beside his daughter, Uxbal passes on his mother's ring to her and begins reflecting back to his own childhood. Ana asks the same questions; her father reassures her once more. As he drifts, however, we return to the scene in the woods, and it expands a bit from what we saw in the beginning. We learn that the stranger Uxbal meets in the snowy woods is his father, and this time Uxbal follows him.

Iñárritu's return to mourning and death comes as no surprise. His theme, however, is expanded and enlarged by the often subtle, but no less unsettling, deployment of one fascinating feature. Understandably, audiences were not prepared for Uxbal to speak with the dead. As his fortunes as a black marketer rise and fall, he always manages to make a bit of cash serving as a medium between the grieving and the deceased. The stark naturalism of Iñárritu's approach to representing this phenomenon never dulls. We see the deceased figure doubled in the space, seated or standing nearby—even floating just below the ceiling. These images are startling to say the least, but our main character moves in and out of these spaces unaffected. Uxbal is constantly surrounded by grief, and yet he maintains near perfected stoicism. Anger and outrage he displays, but empathy and concern are reserved only for his children, and sometimes perhaps his alienated wife. The rigidity of his defiance toward death presents itself as somehow incompatible with his familiarity towards it. We

come to understand it even if we cannot identify with it. Having lost both his parents as a young child and suffering his own brother's profound betrayal, Uxbal must ponder the fate of his children whom he can barely manage to care for now or protect from their mother. He has no family and no friends, and yet he can keep company with the dead. The contrast could not be more pronounced: Uxbal has little contact with the living but remarkable contact with the departed. This makes him a character of immensely tragic irony, which only serves to heighten our sensitivities to the film's most basic question: What becomes of me when I'm gone? This is Uxbal's question, and we pursue it with him.

FIGURE 21

Despite his remarkable gifts and his profound capacity for grief, nothing in the natural course of this film bespeaks the resolution that unfolds. Uxbal's reunion with the father he never knew was not expected at all. The supernatural element of this film, it seems, does not reside in Uxbal's unique gifts. If anything, we should expect that he would never be able to make such a transition given his familiarity with the defiance of the dead. His gifts, however, do not limit him, but instead, when Uxbal looks upon his own dead body lying next to his young daughter, he can perhaps truly grieve for the first time as he grieves for himself. We pity him throughout the film, but perhaps it is not until he meets his own apparition that he can do so. As Uxbal witnesses—first with fear and then with calm—his soul's departure from the body, he crosses the threshold of grief to acceptance and reunion with his father. In the end, his ironic condition does not define him; redemption does. Again, Iñárritu explains: "I like to explore human beings coping with their suffering, confronting it, and recovering from it. In my films I've always tried to find redemption,

some sort of evolution in a different direction, the attainment of a certain purity, coming out on the other side with a luminosity that wasn't there before."[29] Iñárritu brings forth this theme in Uxbal with piercing force and poignancy.

Beyond Death? A Kierkegaardian Inversion

Perhaps only half-joking, Iñárritu confesses in an interview: "I'm telling the same story in every film."[30] That comment is not far off the mark. No one would deny the continuity of his vision and the consistency of tone in his films. Even his recent comedy has a dark and somber heart; despite the laughs and thrills along the way, it orbits around an unexpected suicide. Iñárritu himself, however, does not present in the way we might surmise from his films. In interviews and public appearances, he is quite affable, often funny, and always full of energy and enthusiasm. Commentators remark on the unique balance he strikes: creator of long, heavy, and depressive films and yet also a happy, well-adjusted family man. "I am not a depressive person at all," Iñárritu insists, "but I reflect a lot on my life and life in general, from the perspective of death."[31] This approach evidently works for him personally, but what does it offer his audiences? How do we benefit from the experience of his grief trilogy?

Here, I wish to turn to a voice from continental philosophy for an expanded perspective on Iñárritu's grief trilogy. Søren Kierkegaard (Danish, 1813–55) provides a helpful frame of understanding. Known to many as the precursor to twentieth century existentialism, Kierkegaard possessed a sharp and acerbic wit that he employed in the dual activity of dismantling Hegelianism as the dominant intellectual paradigm of his day and wresting authentic Christianity back from the cold clutches of Danish Lutheranism and its veritable acquiescence to the Enlightenment's terms and conditions for religion in a newly secular age. A focus for modern and postmodern discourses alike, Kierkegaard's legacy of thought is undergoing at present something of renaissance regarding its theological import. Some scholars are mounting a case for reading the Danish thinker less as a prophetic philosopher-seer harkening on modernity and more as a particularly adept and biblically astute prophet for

29. Deleyto and Azcona, *Alejandro González Iñárritu*, 125.

30. Mitchell, "Alejandro González Iñarritu."

31. Secher, "Alejandro González Iñarritu Interview for *Buitiful*."

the ancient essence of orthodox Christianity. Seminal to this recovery is a re-evaluation of Kierkegaard's rhetorical genius, not the least of which is the development of what he calls the "inverse dialectic" (*omvendt Dialektik*) or "the dialectic of inversion" (*Omvendthedens Dialektik*). Sylvia Walsh summarizes the strategy this way: "Briefly stated, in inverse dialectic the positive is known and expressed through the negative, what appears to be negative may be indirectly positive (and vice versa), and the positive and the negative, Christianly understood, are always the inverse of the natural, human, worldly, and pagan understandings of these terms."[32] In other words, Kierkegaard's "inverted dialectic" remains an attempt to safeguard the ineffably mysterious core of Christian faith from the flattening rationality of the Enlightenment's improvements to religion. He would rather see the faith retain its "double vision" and still find joy in despair and hope in hopelessness. As Walsh and others have pointed out, Kierkegaard's inverted dialectic informs the majority of his edifying writings on the Christian faith. The rhetorical force of this move permeates much of his oeuvre, and its imprint can be found throughout his works. Consider his reflections on death from 1845's *Three Discourses on Imagined Occasions:*

> Death in earnest gives life force as nothing else does; it makes one alert as nothing else does. . . . No bowstring can be tightened in such a way and is able to give the arrow such momentum the way the thought of death is able to accelerate the living when earnestness stretches the thought. . . . So, then, let death keep its power, "that all is over," but let life also keep the right to work while it is day; and let the earnest person seek the thought of death as an aid in that work.[33]

Such reflections seem quite in concert with the force of Iñárritu's films. Both are deeply concerned with staring down death for the sake of renewed vigor in this life. Both seem to call for a new form of living in view of death, a life that holds continually before it the thought of death.[34] Could the director be trading in the very same strategy as Kierkegaard's "inverted dialectic?" Perhaps, like Kierkegaard in his time, Iñárritu's grief trilogy holds out for us the choice to face death and let it compel us to live more fully present to our own lives. In a cultural age that resists the

32. Walsh, *Living Christianly,* 6–7.
33. Hong and Hong, eds. *The Essential Kierkegaard,* 166–67.
34. Walsh, *Living Christianly,* 111.

thought of death by every means possible, such a cinematic project offers us immense theological help. Namely we are able, like Derrida in the eulogies of his friends, to comprehend the bond of eventual mourning in the present moment of love. Derrida reflects, "From the first moment, friends become, as a result of their situation, virtual survivors. . . . Friends know this, and friendship breathes this knowledge, breathes it right up to expiration, right up to the last breath. These possible survivors thus see themselves held to the untenable."[35] Therefore, even though it may never quite feel like it, grief is a gift. We wish it were otherwise, but it cannot be. Grief—either potential or actual—charges our days with a sense of urgency for one another, a gravity to love. We are bound, as Derrida claims, to the impossible, but we are bound together. Iñárritu's grief trilogy exposes us in jarring ways to this harsh gravity of love, but essentially and perhaps restoratively he also reassures us that we are not alone in it. Someone is still there even when they are beyond death.

Bibliography

Critchley, Simon. "Enigma Variations: An Interpretation of Heidegger's *Sein und Zeit*." *Ratio* 15 (2002) 154–75.

Deleyto, Celestino, and María del Mar Azcona. *Alejandro González Iñárritu*. "Contemporary Film Directors." Champaign, IL: University of Illinois Press, 2010.

Derrida, Jacques. *The Work of Mourning*. Edited by Pascale-Anne Brault and Michael Naas. Chicago: University of Chicago Press, 2001.

Elvis Mitchell, Elvis. "Alejandro González Iñarritu." *Interview Magazine*. October 9, 2014. Online: http://www.interviewmagazine.com/film/alejandro-gonzalez-inarritu/.

Hong, Howard V., and Edna H. Hong, eds. *The Essential Kierkegaard*. Princeton: Princeton University Press, 2000.

Iñárritu, Alejandro González. *21 Grams*. Universal, 2004.

———. *Amores Perros*. Lion's Gate, 2001.

———. *Babel*. Paramount, 2006.

———. *Birdman: Or (The Unexpected Virtue of Ignorance)*. Twentieth Century Fox Home Entertainment, 2014.

———. *Biutiful*. Lion's Gate, 2011.

———. "Hollywood Must Portray Point of View of Others." *New Perspectives Quarterly*. 24.2. (2007) 6–9.

Neuhaus, Richard John, ed. *The Eternal Pity: Reflections on Dying*. South Bend: Notre Dame Press, 2000.

Philbin, Robert. "Globalism and the Films of Alejandro González Iñárritu." *Nthposition*. 2007. Online: http://www.nthposition.com/globalismandthefilms.php.

35. Derrida, *Work of Mourning*, 173.

Secher, Benjamin. "Alejandro González Iñarritu Interview for *Buitiful.*" *The Telegraph.* January 29, 2011. Online: http://www.telegraph.co.uk/culture/film/filmmakersonfilm/8288951/Alejandro-Gonzalez-Inarritu-interview-for-Buitiful.html.

Walsh, Sylvia. *Living Christianly: Kierkegaard's Dialectic of Christian Existence.* University Park, PA: The Pennsylvanian State University Press, 2005.

Aesthetics of the "Made"

Exuberant Authenticity in the Films of Wes Anderson

Kathryn Reklis

The struggle for existential authenticity is a fiction created to provide meaning to a certain way of experiencing the "modern world." Be it Nietzsche's tragic hero persevering in a godless wasteland,[1] or Weber's "iron cage" locking us all in the mechanistic processes of calculable, rationalistic bureaucracies,[2] modernity is a bleak state of affairs. Whether one thinks we have gained more than we have lost—reason over superstition, rule of law over tyrannical despotism, truth over fantasy—or been abandoned to the sad world of our own making once we rejected the holistic beauty of divine providence, this story of modernity is one of loss. Loss of God, loss of depth, loss of purpose, loss of beauty, loss of enchantment. The modern world is disenchanted, non-teleological, and inherently meaningless. Humans, who have not lost their need for meaning, must wrest it from this world through heroic struggle, paradox, anxiety, and uncertainty.

This is an easy story to tell because many of us experience it as true. It is, by and large, the story we are telling in this volume when we focus on "dread"—or the "anxiety of authenticity"—as one locus for spiritual experience in film. To call it a fiction is not to call it definitively false,

1. This theme runs throughout Nietzsche's work, emerging even in *Birth of Tragedy* (1871), gaining playful coherence in *The Gay Science* (1882) and reaching aphoristic perfection in *Thus Spoke Zarathrusa* (1883–91).

2. Whether or not Weber himself meant something as bleak as the metaphor "iron cage" implies in English, is up for debate (cf. Peter Baehr, "The 'Iron Cage' and the 'Shell as Hard as Steel'"); nevertheless, the metaphor has a life of its own.

but to highlight the way it is a mode of interpretation, a lens for making sense of an experience that is itself partially created in the interpretation. Perhaps more importantly for a conversation about Wes Anderson, a "fiction" is a constructed story. From the Latin *fingere/fictio*, meaning "to form," fiction draws attention to its "madeness." We have made this story of the meaninglessness of modernity—"we" philosophers, political theorists, economists, theologians, ordinary humans—to make sense of a real experience. At the same time, the story we have made comes to shape and define our experience.

The story of disenchanted modernity cannot be told apart from the story of the secular. It is fundamentally a narrative of losing one's religion writ-large. It is a story that makes sense, especially, to those for whom keeping or losing religion is the fundamental question of modernity. That is, whether one heroically embraces the disenchantment of the modern world or battles against it, an assumption of disenchantment is a useable fiction to orient one on a secular-religious scale.

The narrative of secularization itself is no longer very coherent; or at least we have come to realize that the scale is sliding. In the disenchantment story, "secularism" and "religion" become two sides of the same coin: "secularism" is another kind of "religion." "Religion" is reduced to a set of metaphysical propositions that can be "proven" true or false.[3] In this story, a wide array of human experiences that do not fit the paradigm are hidden from our view. There is no way to account for people who do not experience modern life as fundamentally meaningless or who continue to find moments of enchantment outside the "secular-religious" divide, except to write them off as living under false consciousness.

I would wager that if you asked any devoted fan of Wes Anderson's films to describe his work, "dread" would not feature prominently in the list of adjectives returned. While melancholy and loss haunt all of his films to greater and lesser degrees, the most common criticism of his style

3. Since at least 2007, when Charles Taylor published his magisterial book *A Secular Age*, there has been a growing academic discussion since labeled "secularlism studies" that investigates the variety of "secularisms" that emerge in conjunction with the work of defining "religion" as a transhistorical and transnational phenomenon. A few key titles in the discussion include: Craig Calhoun, Mark Juergensmeyer, and Jonathan VanAntwerpen, eds. *Rethinking Secularism*; Philip Gorski, David Kyuman Kim, John Torpey, and Jonathan VanAntwerpen, eds. *The Post-Secular in Question*; Michael Warner, Jonathan Van Antwerpen, and Craig Calhoun, eds., *Varieties of Secularism in a Secular Age*; Courtney Bender and Ann Taves, eds., *What Matters? Ethnographies of Value in a (not so) Secular Age*.

is that it renders serious themes and experiences too precious. Indeed, Anderson is usually blamed as exemplifying, if not leading, the "twee" aesthetic revolution.[4] The hard world of adulthood (as experienced by the individual or collectively in "history"), critics complain, is candy-coated in a perpetual child-like dreamscape that resists the difficult struggle for existential authenticity in the modern world.

Here is where Anderson blows open our conversation in interesting ways. If Anderson's filmic worlds do not conjure dread, it is because he offers us an alternative to the modern struggles of anxiety and meaninglessness. It is not that Anderson's films do not take place in our recognizable world. Indeed, many of the markers of a disenchanted modernity persist: bureaucratic entanglements, class conflict, and death experienced as meaningless. At the same time, his films offer us a "not quite reality" marked by persistent enchantment. To be more precise, the quintessential Anderson "hero" resists the flat materiality and soul-crushing narratives of bureaucratic middle-class modern life through exuberant attachments to their own self-narratives.

I use the word "hero" self-consciously and playfully (instead of, say, "protagonist" or simply "character"). In philosophical discourse, historical hagiography, and Hollywood films, the "hero" is usually a lone, brilliant, brave, extraordinary character who saves the day. They must face trials of physical, emotional, and spiritual endurance and their singular action is salvific for more than just themselves. Pertinent to our conversation, they are also usually the most "authentic" of those around them. By conquering whatever threatens to destroy them—super villains, oppressive political and economic regimes, enemies of war, psychological despair—the hero becomes "who he really is" in a feat of tremendous self-exertion. Part of the logic of the hero is the promise that individuals can overcome whatever woes the modern world through strength of force—be it physical, psychological, or spiritual—alone.[5]

Part of our disenchantment story assumes that making meaning in the modern world is a weary, bleak, difficult, or nearly impossible task.

4. Anderson's work features prominently in Marc Spitz's book *Twee: The Gentle Revolution in Music, Books, Television, Fashion, and Film;* and in James Parker's essay "The Twee Revolution."

5. This does not exempt the hero from suffering for his (very occasionally her) heroism. Indeed, suffering is often, though not always, required of the hero: the necessary price that he must pay for his escape from the iron cage. Think of Wolverine, the Batman, or any character John Wayne ever played (cf. Reklis, "Heroism in the Age of Terror, 236–38).

The hero of meaning in a meaningless world must face the abyss head on in order to move beyond it (a la Kierkegaard's leap to faith,[6] Nietzsche's ecstatic laughter,[7] or Camus' violent assertion[8]). Anderson's heroes assert their authenticity—the experience of a full, integrated life that in some meaningful way expresses "who one really is"—in the face of modern disenchantment. But they do so outside the confines of a secular/religious debate, and they do so with an exuberance and confidence that sometimes blinds us to the existential nature of their assertion. Heroes like Dignan in *Bottle Rocket*, Max in *Rushmore*, Mr. Fox in *The Fantastic Mr. Fox*, and Gustave in *The Grand Budapest Hotel* swerve around the abyss of meaninglessness, thereby carving out other fictions of modern meaning. And in the carefully crafted world of Anderson's films themselves, we are invited to participate.

FIGURE 22

This is not a chapter to explore the many streams that feed into the history of modernity's creation or the stories that give it meaning (or assert the absence of meaning as one of its key features). I am playing

6. Cf. *Concluding Unscientific Postscript* (1846)

7. The necessity, tragedy, and triumph of laughter can be traced throughout Nietzsche's corpus, but I am thinking in particular of *The Gay Science, Zarathustra*, and *Will to Power* (1888).

8. Cf. *The Stranger* (1942). In so far as Camus drew on the tradition of American hard-boiled fiction (his indebtedness to James Cain's *The Postman Always Rings Twice* is well documented), we can see more direct links between the philosophical traditions of modern heroism and popular culture.

fast and loose with a large philosophical and political history here. But I hope the sketch is recognizable. If it is true that one of the struggles of the modern age is the question of existential meaning—of embracing, making, or asserting meaning that authentically expresses something true about oneself and the world one lives in; and if it is also true that the question of existential meaning is in some way connected to the ways "religion" and "secularism" have come to be defined in this age, then it seems worthwhile to spend some time with a filmmaker who plays with these questions, who shifts them around on their side, and who takes seriously their fictiveness. For if something is made—not simply given whole—it can be unmade, remade, or made in a better way.

I want to think through some of Anderson's films as a way to explore three key features that mark Anderson-authenticity: exuberance/expertise (an Anderson hero is "all in"), friendship (his heroes only exist on a heroic plane when recognized and affirmed in deep relationality), and material attachments that exceed commodity fetishization.[9] This last quality extends to the experience of his films themselves. In his famous attention to detail, fastidious attachment to visual symmetry, and minutely crafted object-worlds, Anderson offers the viewer an experience of authentic self-discovery through artifice and craft. The very "madeness" of his filmic worlds—and the "madeness" of the characters who populate them—is not the antithesis of authenticity, but such madeness may be a key to unlocking modern authenticity beyond the narrative of disenchantment.

Exuberance and Expertise

You've just gotta find something you love to do and then . . .
do it for the rest of your life.

—MAX FISCHER, *RUSHMORE*

Perhaps nothing marks an Anderson hero as much as exuberant commitment to, well, whatever they commit to. In the case of Dignan and Mr. Fox, it is "the perfect crime." In the case of Max, it is his private boarding

9. I am indebted to Jane Bennett for this formulation, offered in her book *The Enchantment of Modern Life: Attachments, Crossings, and Ethics*. While I share her interest in the ability of commodities to "do" more than we give them credit for, my discussion of materiality in Anderson's work is of a fairly different nature, as will become clear.

school and then, later, a teacher he meets there. For Gustave, it is his hotel and clientele. And in more complicated ways, Royal (in *The Royal Tennenbaums*) is committed to his family and Steve Zissou (in *The Life Aquatic with Steve Zissou*) to a life of exploration and adventure. The unifying theme is being "all in."

The object of commitment, however, is not beside the point. In every case, Anderson's heroes choose their object over and against the narratives of class determination that would usually define them. Rather than accept his fate as a lower-middle class manual laborer (just another second rate landscaper), Dignan crafts a narrative of criminal mastery and gangster expertise. Gustave rises above his lowly origins as bellboy to orchestrate the extravagance of the Grand Budapest Hotel. Aware of his outsider status as a scholarship student at a fancy private school, Max masters whatever he sets his mind to, excepting traditional academic success. All the Tennenbaum children are not just good at what they do, but "geniuses."

Anderson has a love of the underdog. In other stories, an Anderson hero would be the comic throw-away or the wacky sidekick who exists as a foil to the real hero. In a Judd Apatow bro-mance, for example, Dignan might just be a weirdo roommate who fills out the roster of "characters" who must, eventually, be left behind in order for the real hero to grow up. In any number of teenage rom-coms, Max would be, at best, a goofy best friend who highlights the protagonist's compassion and "zany" side. By making these characters the center of his stories, Anderson rejects the standard narratives of adult progress, romance, and success that drive so many Hollywood movies.

His heroes, however, are not unaware of those standard narratives. Indeed, they are often reminded by less sympathetic—almost always richer, more traditionally successful—characters who they "really are": hired help, scholarship kids, washed up deadbeats. "Exuberant commitment" is a way to refuse the disenchanting narratives of bureaucratic and capitalist modernity. But because exuberance can easily disguise dilettantism, Anderson's heroes also seek expertise. This is an essential part of their commitment. All his heroes aspire to be the best at whatever they do, be it home robbery or chicken heists, school clubs or the service industry. There is no greater insult to the Anderson hero than the charge of half-hearted commitment. As Max yells to Herman Blume when he

complains that he sank $8 million into an aquarium to win a woman who refuses to acknowledge it: "Is that all you are willing to spend?"[10]

Expertise—proficient mastery of a discrete skill set or area of knowledge—could easily feed into a modern tale of disenchantment. The bureaucratic "expert" cloistered in his or her tiny part of the institutional matrix is the stuff of a Kafka tale or your weekday visit to the DMV: each worker responsible, expertly, for this form; this process, but not the other one you need. A different line/office/cubicle for every task and no one who can see, interpret, or unite the whole.

Anderson's heroes avoid this pitfall by choosing areas of expertise that signify failure by any reasonable measurement of capitalist-driven success. Exuberant expertise leads, more often than not in an Anderson film, to disaster. Max, perhaps the committed exuberant *par excellence*, fails out of his beloved school precisely because his commitment to so many organizations and initiatives has worn his studies thin. Gustave and Dignan both spend time in prison. Mr. Fox leads his entire community from a safe underground natural habitat to life in a sewer. Royal becomes an elevator operator at the hotel from which he was expelled. These heroes wreck their own lives. They fail spectacularly. They refuse to narrate failure as failure. More precisely, they assert a counter-narrative about their own lives that flip conventions of success and failure on their head.

FIGURE 23

This might be a kind of folly. Or a kind of narcissism. These counter-narratives, after all, might guide the hero, but they also wreck other lives. Dignan considers landing in the big house a mark of his criminal

10. Anderson, *Rushmore*.

expertise, but Bob's house still gets robbed. Mr. Fox outwits his human nemeses, but his whole community has to flee their homes. Esteban and Ned die in their pursuit of Steve's final documentary. In his efforts to secure his inheritance and foil his dead lover's nefarious children, Gustave imperils Zero and Agatha and contributes to Kovacs's death. This exuberant commitment to ends not traditionally worthy of expertise is, I think, what critics have in mind when they accuse Anderson of creating "childish" or immature characters. They do not reckon consequences in a "rational" or "adult" manner; they proceed with their harebrained (sometimes selfish, almost always outlandish) schemes despite rational objections, and often to ruinous results.

But if Anderson's heroes are often child-like, or even immature, this is because adulthood and maturity are so often the representation of the very disenchanted modernity that is being resisted. One of the oldest metaphors for the passage of the Western world through "enlightenment" into modernity is "growing up."[11] What is true for the whole civilization must be repeated in every individual life. There are different variations on this tale, but they all end in "rational, responsible adulthood." For Sartre we must "man up" to the inherent meaningless of the world—without a providential creator there is nothing inherently special about the human race much less the individual human—and forge our own meaning nonetheless.[12] In Freud's telling, we must let go of the bedtime stories of God and heaven that placate our fears and tame our unruly desires by embracing life through the clear eyes of science (including the science of psychoanalysis).[13] And in every romantic comedy we are reminded that the real end of life is settling down in reproductive marriages, taking our place in the economic order, and letting suburbia domesticate our wild, impractical impulses.

The gender paradigm at work in these stories is not incidental to their injunction—the modern subject has long been figured as the rational, masculinist (even if female) adult. Women and children—as well as the non-serious, imaginative worlds they traditionally inhabit—are always figured as part of what must be left behind to become fully modern/

11. Articulated clearly in Kant's pithy essay "What is Enlightenment?" (1784), the metaphor permeates eighteenth century philosophy and helps to explains why education theory and the proper education of children was so central to Enlightenment epistemology.

12. Cf. *Existentialism is a Humanism* (1946)

13. Cf. *The Future of an Illusion* (1927)

fully adult: the "old wives tales" of superstition abandoned for reason, the boogeymen of children's stories abandoned for scientific truth, the playground for the office.

There is something feminist and even queer about refusing this narrative in favor of the childish. Judith Halberstam points to children's animation as a site of resistance to the rationalist, hegemonic narrative of modern, capitalistic success.[14] Anderson's heroes are, I think, another site; and in some ways a more interesting one because they exist on the plane of adulthood, even if they skate along it at an oblique angle. If his heroes are childish, they are not (often) children. They do not exist outside "real" adult life or its obligations. But they do circumambulate the disciplining powers of the narrative that to grow up means to settle down. They insist on other measures of success than money, position, self-interest, or power. They exuberantly tell another story about their lives and they stick to that story no matter how irrational or disastrous it might appear to others.

What does success look like for these heroes, then, beyond exuberant commitment? It looks like friendship, which brings us to the second characteristic of Anderson-authenticity.

Friendship

Does the fact that I'm trying to do it do it for you?

—DIGNAN, *BOTTLE ROCKET*

An Anderson hero not being driven by traditional markers of modern success does not mean he is not externally motivated. These heroes only exist as "heroes" when affirmed by other people who love and support them. Exuberant commitment is *merely* foolishness if there is no one to bear it witness. Indeed, the counter narrative these heroes tell about their lives almost always centers around, or comes to center around, friendship.

Most Anderson heroes need a gang, or at least a protégé: someone or some group to recognize and validate their vision of the world. If there is a rallying cry that unites such disparate characters as Max Fischer, Royal Tennenbaum, Steve Zissou, Dignan, Francis (*The Darjeeling Limited*), and Gustave it would probably be: "Who's with me?" And how could it

14. Halberstam, *Queer Art of Failure*. See especially the chapter "Animating Revolt and Revolting Animation."

be otherwise? The ends chosen by the Anderson hero—the perfect heist, a hit play, an underwater expedition, a prison break—are not easily achieved by one man alone.

Friendship is more than a plot device to serve the outlandish ends of the hero, though. It is, I argue, the moral center of all of Anderson's films. I will return to the ethics of these alter-narratives below. More to the point here, friendship is also a key ingredient to the making of Anderson-authenticity. It is only in the bonds of friendship that the hero and his friends realize themselves in a way that meaningfully conveys who they really are.

This is achieved through reciprocal recognition. On one level, these friendships confirm a certain kind of "conversion" or "liberation" story. The hero's friends are usually trapped in narratives of existential ennui, inauthenticity, meaninglessness, and drudgery. The friend is, like Herman, a disaffected businessman living out the parody of suburban upper-middle-class life—a cheating wife, two brattish sons, no investment in his work. Or, like Anthony, recovering from a nervous breakdown due to the meaninglessness of conspicuous consumption ("I never want to answer another question about water sports in my whole life").[15] Or, like Eleanor Zissou, bored by her own wealth and lonely in her marriage.

They are freed from these "iron cages" by the hero's alter-narrative. To be "with" the hero—to join the gang—is to confirm the alter-narrative. In turn, rallying around the hero's project, however silly, illegal, outlandish, or dangerous, opens the alter-narrative to the friend as well. This is akin to an act of conversion, allowing the friend to leave behind the drudgery of life for the promise of exuberant commitment.

This narrative might collapse into some manic pixie dream girl fantasy (without the gender politics),[16] except that the hero needs the friend as well. The friend recognizes the hero as heroic. Where the world sees only foolishness, immaturity, or irrationality, the friend sees vision, conviction, and imagination. Friendship is also the key to saving "exuberant commitment" from the narcissism that is always nipping at its heels. "Who's with me?" can easily become "if you're not with me, you're against

15. Anderson, *Bottle Rocket.*

16. The phrase "manic pixie dream girl" was coined by Nathan Rabin in a review essay of *Elizabethtown* "as a fantasy figure who 'exists solely in the fevered imaginations of sensitive writer-directors to teach broodingly soulful young men to embrace life and its infinite mysteries and adventures.'" Rabin, "The Bataan Death March of Whimsy Case File #1."

me," and the affirmation and wisdom of friendship pulls the Anderson hero back from the threat of self-destruction. The hero always faces the possibility that his exuberance is, in fact, foolishness. And he almost always pays a price for his unwise commitments—the loss (temporary or permanent) of a meaningful relationship, the actual death of a loved one or companion, failure and destruction of whatever he holds most dear. His alter-narrative—this failure is not failure!—requires the affirmation and wisdom of a friend. In fact, when true friendship is acknowledged, it is usually a catalyst to whatever true greatness the hero can accomplish (Max's play, Dignan's self-sacrifice, Steve's final documentary, Royal's final weeks, Gustave's prison break).

Friendship is what differentiates an Anderson hero from someone like the Kierkegaardian knight of faith, whose foolish assertion must be purely individual, and from the "holy fool," who lives outside the rules of society or in contradiction to them (though the Anderson hero shares something in common with both of these characters). To speak more abstractly, the threat of meaninglessness always hangs over the Anderson-hero. The abyss is always at his feet. But he cannot simply will himself, through strength of his own mind/will/faith, to overcome it. He must be accompanied in his strange dance around it. It is the strength of friendship that keeps his eyes above the abyss and enables the strange swerve around it. This is also part of Anderson's deeply ethical vision of the world, but I will return to that soon.

First I want to talk about the most discussed part of Anderson's work: his elaborate visual worlds and attention to material objects. Anderson heroes build their alter-narratives through intense attachments to actual stuff.

Material Attachments

Francis: *Is that dad's car keys?*
Peter: *Yes.*
Francis: *You can't just take dad's stuff and use it for yourself as if it was yours.*
—DARJEELING LIMITED

Anderson has developed one of the most recognized and unique visual styles among contemporary filmmakers. From his signature use of the futura font and the use of literal frames to create perfect visual symmetry,

you know you are in an Anderson film from the opening shot.[17] While this aspect of his filmmaking is the most well-dissected,[18] I want to pay attention to his attachment (as a director) and his character's attachments to particular material objects, as well as his creation of micro-worlds as a way of inducing a not-quite-reality that allows him to resist standard narratives of disenchantment.

Although traditional religious imagery does not feature prominently in Anderson's visual landscapes, his reliance on material objects is perhaps the best hint of his own Catholic upbringing. Stuff is never just stuff in a Wes Anderson movie. Material objects are a window into a world of meaning and intention that shape and reflect the inner world of his characters. In this way, material objects are never (just) commodities. Unlike commodities, these objects do not have value in a marketable way. They perform serious existential (meaning-making) work that exceeds their value or meaning as objects that can be bought and sold.

Anderson heroes use material objects to form meaningful connections to their idealized sense of self. These objects—often uniforms or personal accessories—are talismanic and ritualistic. They are not valued for their conventional usefulness; rather, they are put to uses that take on powerful agency in the lives of the characters. The white nose tape is Dignan's way to transform his group of friends into his idealized gang. Max refuses to stop wearing his Rushmore uniform even when he starts attending public school as a way to mark his exceptional vision of himself. All the members of Team Zissou wear matching jumpers and red beanies to unite them in a common purpose. Peter hoards his dead father's belongings as a way to enact his mourning and shield himself from grief. Richie only removes his sweatband and wristbands in a moment of self-annihilation.

Objects are also means of forging friendship and reconciliation, of attaching characters to each other. Max allows Herman to choose between two of his prized Rushmore pins (awarded for punctuality and attendance) as an unspoken sign of forgiveness. Richie sleeps in the sleeping bag he and Margo used during their childhood escapades as

17. Though Anderson employed new fonts in both *Moonrise Kingdom* and *The Grand Budapest Hotel*.

18. Of many such discussions, I would recommend Matt Zoller Seitz's book *The Wes Anderson Collection* and the series of video essays he produced for www. rogerebert.com. http://www.rogerebert.com/mzs/the-wes-anderson-collection -chapters-1-7-and-the-substance-of-style-chapters-1-5.

a way of staying close to her in adulthood. Ash and Kristofferson form their friendship in the shared quest to steal back Mr. Fox's tail.

If this is true for objects in Anderson's films, it is also true of the films themselves, as visual and narrative objects in and of themselves. All of Anderson's films take place in our recognizable world, but many are focused entirely on what we could call "micro-worlds"—self-enclosed life worlds that operate according to particular rules and codes with their own elaborate props and costumes: a boat, a boarding school, a passenger train, a hotel, a summer camp, an old family home. These micro-worlds allow Anderson's love of dollhouse sets and carefully crafted props free range. His sets are bursting with attention to minute detail (a place for everything and everything in its place) made possible by limiting the scope of his scenery to the contained world of the set.

At the same time, this constraint gives expression to a whimsical expansiveness that presses the reality of his landscapes to the breaking point. These worlds are real and not-quite-real. They offer a kind of more-than-reality. The India of *The Darjeeling Limited* is both real and more-than-real—bursting with sound, color, pattern, and symmetry. The underwater world of *The Life Aquatic* is recognizable and magnificently impossible, vibrant with imaginary creatures and almost cartoonish botany. The hotel in *The Grand Budapest Hotel* exists on the margins of history flooded with a grandiose magnificence that boarders on fantastical. Even the family house in *The Royal Tennenbaums* is so perfectly frozen in time it takes on a mythical or symbolic quality.

These more-than-real landscapes blur the line between the world of the film itself, and the world of the viewer. An Anderson film wears its "madeness" on its sleeve, highlighting the craft and artifice of the fictive world of the film. This fictiveness—the quality of being made—has a distancing effect. These are not worlds that perfectly mirror our own. One is always aware that one is watching something carefully, minutely crafted. But in its explicit madeness, the film itself becomes an object offered to the viewer, like Dignan's tape across the nose or Max's punctuality pin—a gesture of "who's with me?" and an invitation to join the alternative narrative of the hero.

Anderson's critics usually have this fictive quality in mind when they accuse Anderson of a "twee aesthetic" or of candy-coating reality in his own precious "more than reality." But the experience of giving oneself over, both imaginatively and affectively, to an Anderson film is also the experience of entering a bizarre world where success looks like

failure, failures are heroes, and meaning is made in relationship. Our identification with this fiction, even temporarily, recalibrates a sense of authenticity (what it might mean to be "really oneself") in the face of a meaningless modernity.

The Limits of Schematics and the Ethics of Fiction

I've offered a tri-partite parsing of Anderson authenticity, comprised of exuberant expertise, friendship, and material attachments. There is much this analysis neglects; it works more perfectly for some of his films than others, particularly his two earliest films, *Bottle Rocket* and *Rushmore*, which I implicitly treat as paradigmatic for his larger directorial and authorial vision. I am not worried about providing a complete taxonomy of his whole body of work, as much as I want to suggest something compelling about some of his major preoccupations.

I am more worried about offering a vision of Anderson's filmic worlds that suggests they are purely enchanted. That is, I do not want to paint his films as some kind of escape from the grimness of modern life. Indeed, if my vision of authenticity in Anderson's work is compelling, it depends upon his heroes confronting the travails of modern life with their own alternative self-narratives.

FIGURE 24

Anderson heroes are not all cut from the same cloth, even though I am suggesting they share common features. Exuberance is not always

naiveté or optimism. Indeed, some Anderson heroes are optimists (Dig-nan, Max, and Mr. Fox chief among them) and some pessimists (Steve, Peter, and Richie chief among them). Exuberant commitment is a stance against being defined by narratives of capitalist success and modern progress more than it is an affective state. Or rather, an Anderson hero can rally all the optimism of Dignan or all the world-weary despair of Steve Zissou and still exuberantly commit to an alternative self-narrative that defies the story others would tell about them.

Whether they do so optimistically or warily, there are many ways in which Anderson's heroes confront modern reality, many of which I have tried to detail above (class conflicts, bureaucratic entanglements, failure as measured by capitalist standards of success). But perhaps noth-ing reminds us that we are still within "the real world" (even if there is a "not-quite-real" quality about it) as the presence of death in all of Ander-son's films. Parents die (*Rushmore*, *The Darjeeling Limited*), children die (*The Darjeeling Limited* and *The Life Aquatic*), friends die (*Bottle Rocket*, *The Life Aquatic*, *The Fantastic Mr. Fox*, *The Grand Budapest Hotel*), and even main characters die (*The Royal Tennenbaums*, *The Life Aquatic*, *The Grand Budapest Hotel*). Death hovers over these films as a reminder that no alter-narrative is ultimate. Even the stories Anderson's heroes tell about themselves are fictions made in the face of death, a force that cannot be out-narrated. If, as Edna St. Vincent Millay said, "childhood is the kingdom where nobody dies," the presence of death firmly plants Anderson's films, for all their whimsy and craft, in the world of adults.

But to insist on a darker, edgier, more "adult" reality to Anderson's world is also to fall back into the trap that the "real hero" of the mod-ern age is one that must grimly stare down the disenchanted abyss and emerge victorious over it.

I'd like to suggest, instead, that Anderson offers us a way of imagining deep ethical engagement without meaninglessness. Real adulthood—and with it, existential authenticity—is found in a profoundly ethical vision of human life. "Growing up" for an Anderson hero is not about achieving success (reproductive, marital, or capitalistic); rather, it is about nurtur-ing virtues of generosity, kindness, forgiveness, patience. To express one-self as one really is—to be true to that self—is to embody these virtues in relationship to others. Exuberance, friendship, and a carefully crafted life are elements that enable these ethical responses in Anderson's characters.

We are often offered two options in "modernity": meaning is either absent or given whole, wrested heroically from nothing (god-like modern

man!), or claimed on the fragile thread of faith. Anderson's films suggest that in a world of selfishness, bureaucracy, and soul-crushing conformity, there is another way to be, another fiction to make. Meaning is not just violently wrested from the abyss or given in the absurdity of faith, but is sometimes made—crafted, built, and sustained in beautiful and careful effort.

This, it seems to me, is a profoundly spiritual insight and a word of great hope. "Madeness" is not the enemy of authenticity, but may be one of our best shots at imagining the moral visions we need to sustain deep engagement with our world. In the carefully crafted objects of Anderson's films, we are invited to our own exuberant commitment and to participate in fictions that might foster alternative narratives of authenticity in our own lives.

Bibliography

Anderson, Wes. *Bottle Rocket*. Criterion Films, 1996.

———. *The Darjeeling Limited*. 20th Century Fox Home Entertainment, 2007.

———. *Fantastic Mr. Fox*. 20th Century Fox Home Entertainment, 2009.

———. *The Grand Budapest Hotel*. 20th Century Fox Home Entertainment, 2014.

———. *The Life Aquatic with Steve Zissou*. Buena Vista Home Entertainment, 2004.

———. *Moonrise Kingdom*. Universal Studios Home Entertainment, 2012.

———. *The Royal Tenenbaums*. Criterion Films, 2002.

———. *Rushmore*. Touchstone Home Video, 1999.

Baehr, Peter. "The 'Iron Cage' and the 'Shell as Hard as Steel': Parsons, Weber, and the Stahlhartes Gehäuse Metaphor in the Protestant Ethic and the Spirit of Capitalism." *History and Theory* 40.2 (2001) 153–69.

Bennet, Jane. *The Enchantment of Modern Life: Attachments, Crossings, and Ethics*. Princeton: Princeton University Press, 2001.

Bender, Courtney, and Ann Taves, eds. *What Matters? Ethnographies of Value in a (not so) Secular Age*. Columbia University Press, 2012.

Cain, James. *The Postman Always Rings Twice*. New York: Vintage, 1989.

Calhoun, Craig, Mark Juergensmeyer, and Jonathan VanAntwerpen, eds. *Rethinking Secularism*. Oxford University Press, 2011.

Freud, Sigmund. *The Future of an Illusion*. New York: W. W. Norton, 1989.

Gorski, Philip, et al., eds. *The Post-Secular in Question*. New York: New York University Press, 2012.

Halberstam, Judith. *The Queer Art of Failure*. Durham: Duke University Press, 2011.

Kant, Immanuel. *An Answer to the Question: What is Enlightenment?* New York: Penguin, 2010.

Kierkegaard, Soren. *Concluding Unscientific Postscript*. Cambridge: Cambridge University Press, 2009.

Nietzsche, Friedrich. *Birth of Tragedy: Out of the Spirit of Music*. Translated by Shaun Whiteside. New York: Penguin, 1994.

————. *The Gay Science*. Translated by Walter Kaufman. New York: Random House, 1974.

————. *Thus Spake Zarathustra*. Translated by R. J. Hollingdale. New York: Penguin, 1978.

Parker, James. "The Twee Revolution." *The Atlantic*. July/August 2014. Online: http://www.theatlantic.com/magazine/archive/2014/07/the-twee-revolution/372273/.

Rabin, Nathan. "The Bataan Death March of Whimsy Case File #1: "*Elizabethtown*," *The AV Club*, January 25, 2007. Online: http://www.avclub.com/article/the-bataan-death-march-of-whimsy-case-file-1-emeli-15577.

Reklis, Kathryn. "Heroism in the Age of Terror: the Dark Knight of the American Soul." In *Religious Faith, Torture, and our National Soul*, edited by David P. Gushee, Jillian Hickman Zimmer, J. Drew Zimmer. 236–42. Macon, GA: Mercer University Press, 2010.

Sartre, Jean-Paul. *Existentialism is a Humanism*. New Haven: Yale University Press, 2007.

Seitz, Matt Zoller. *The Wes Anderson Collection*. New York: Abrams, 2013.

Spitz, Marc. *Twee: The Gentle Revolution in Music, Books, Television, Fashion, and Film*. New York: It Books, 2014.

Taylor, Charles. *A Secular Age*. Boston: Harvard University Press, 2007.

Warner, Michael, Jonathan VanAntwerpen, and Craig Calhoun, eds. *Varieties of Secularism in a Secular Age*. Harvard University Press, 2010.

Lacanian Psychoanalysis
and Cinematic Eschatology

A Not-So-Theologically-Correct Meditation on
Jeff Nichols's *Take Shelter*

By Carl Raschke

Tornado dreams are not only relatively common, they are the occasion for exercises in cheap psychoanalysis, or low-end, pseudo-spiritual pontification. Supposedly such dreams are symptoms of a person's ongoing emotional turmoil, or feelings of helplessness in the face of life's overwhelming burdens and challenges. They may—in theory, at least—amount to transparent insights about impending disasters.

Jeff Nichols's award-nominated film *Take Shelter* starring Michael Shannon and Jessica Chastain is, on the surface, about a blue-collar worker in Ohio who has vivid and recurring dreams and visions concerning a devastating tornado and other creepy scenarios that slowly force him and his family to question his sanity. Part of the problem, though, is that the lead character Curtis LaForche (played by Shannon) is not sure whether his dreams are merely symbolic or eerily predictive of an actual devastating tornado destined to strike in the near future. Not too long into the drama it becomes obvious that Curtis, like so many men of his class and culture, is not willing to go along with any "talking cure" for his inner struggles and dilemmas, even though he is well-aware that there is a history of mental illness in his family, especially his mother, who is institutionalized for schizophrenia.

It soon becomes evident that he opts for the literal, as opposed to the figurative, meaning of his experiences and starts to make secret

preparations for the anticipated apocalypse. He goes so far as to borrow, without authorization, a backhoe from his job (a form of risky business that soon leads to him being fired from his job as a construction worker) and to apply for an expensive home improvement loan with the aim of building a well-outfitted, underground storm shelter for his family. His wife Samantha (Chastain), of course, is not aware of what is going on, and becomes distraught and very concerned about his state of mind when she finally finds out. After he herds his family into the shelter during a violent thunderstorm, which does not turn out to be a real tornado, and demands that they wear gas masks through much of the ordeal, Samantha convinces him to get serious psychiatric help. He is preparing to go into a treatment facility when his doctor advises him to go ahead and take a family vacation to the seacoast in the Carolinas. The movie has a surprise and quirky ending at the point where Curtis, now persuaded that he is indeed most likely delusional, suddenly, along with the rest of his family, witnesses over the ocean the very apocalyptic storm apparition, which even the film's viewers have now accepted was some kind of paranoid fantasy.

FIGURE 25

Both lay audiences and professional psychologists have been entranced with the cinematic capacity of *Take Shelter* to toy with ready-made assumptions about the fluid boundary between psychosis and justified anxiety. After all, Curtis does live in one of the northern swathes of "tornado alley," and the genuine question of his behavior has more to do with his tendency to rely on his inner "spiritual" messaging system rather than the kinds of empirical evidence that one would normally call

forth if one were to prepare for damaging windstorms. Building an underground storm cellar in that part of the Midwest in itself seems like an act of prudence, expensive though it may be. What makes Curtis's actions suspect is the covert and unapologetic manner in which he makes such preparations. One cannot easily discern if Curtis is some kind of common clairvoyant, a taciturn Noah-like figure following his own confidential divine prompt despite all the scoffers, or whether he is simply mad. This tension is the exact effect the director seeks to create in viewers.

It is easy to decipher this film as some kind of coy statement on the modern day regime of psychiatry, where the presumed "vindication" of the protagonist at the end somehow squeezes onto the same page with the radicalism of a Thomas Szaz or an R. D. Laing from a now long-forgotten era. Although the film is obviously a munificent lode for various philosophical iterations of modern psychoanalysis, it is not really about whether Curtis—or his ilk—can be considered "insane." I insist that it comes down to the question of whether theology is ultimately framed by eschatology. By this I mean to question whether we can really consider the question of the "spiritual" as the kerygmatic motif of a certain theological intervention apart from the notion of the eschaton, the "end" of all things.

Before we dive into a more intricate and nuanced analysis of the film itself, we need first to examine carefully the historical *modus vivendi* between the "methodology" that has persisted over the ages between the psychological and the theological. As Michel Foucault has reminded us in his exhaustive study of the connection in his lectures at the Collège de France, entitled "Hermeneutics of the Subject," what today we call "spirituality" amounts to something called "care of the self," which harks all the way back to the "practical philosophers" of ancient Greek and Rome—the Stoics, Epicureans, and Cynics. These thinkers were the original theoreticians of what today we would call "ethics," the grounding of knowledge in the aims and objectives of singular lives, which may or may not have had a "political" dimension to them at all. The shift in Hellenistic thought from the primacy of the ontological to the "ethical" went hand in hand with the new cultural focus on what today we would term "soteriology," a preoccupation with the achievement of some kind of compelling justification for the construct of the self. Ethics in this regard has always been inseparable from the philosophy of personal identity. The concomitant prepossession in the Hellenistic age with "eternal life," a trend on which early Christianity capitalized with great success, or what

today we term "wellness" in all its psychosomatic as well as supernatural inflections (the implication of the Greek *sozo*), was the very context in which the ideal of "care of the self" (*cura ad se*) might somehow flourish.

The familiar pagan, and generally philosophical, ethos of self-care became the cultural matrix for the birth of modern therapeutic psychology. It was both sustained and augmented throughout the long era of Christendom, as Foucault has also observed, by the tradition of personal confession and pastoral guidance. In modern psychiatry this relationship morphs into the role of the analyst versus the analysand. But self-curation in relation to a network of mastering signifiers that define the "ethical" aim of the project itself, the "teleology" of the undertaking as a whole, requires a sense of cosmos whereby the conditions for the pursuit of human well-being is at minimum authorized, and maximally guaranteed, in the first place.

Either the role of ethics is to ensure the rebalancing of the cosmos through a boundary-setting against the excesses of subjective freedom, or it is to call the cosmos itself into question. In Christian "eschatology" it is the latter function that prevails. The quest for a certain psychological "normalcy," which psychiatry conventionally both advocates and underwrites, is ultimately cosmological, insofar as it strives for what Philip Rieff has termed the "triumph of the therapeutic," the classical "devotion" (*therapein*) to the equipoise of "divine" forces that keep the universe in its stead and in its stay. Psychology and cosmology remain forever intimately aligned. But what if there were a higher, historical power whose actual aim is to dissolve the cosmos entirety in the name of a transcendental ethos itself? From Abraham to Mohammed, that certainly seems to be the purpose of monotheism itself. It is the monotheistic "One God" who speaks a profounder, more shocking, and incalculable truth as the insurgent voice of the desert whirlwind, who calls into question the platitudes of psychotherapy (the "reasonable" argument of Job's friends) while emphasizing, if with only a grand literary flourish, something even Feuerbach would not have imagined, namely, that theology must become not so much anthropology as eschatology.

Curtis thus becomes our unlettered, in-house eschatologist—a Forest Gump for all grand narratives. He is the only one who can rightly appreciate that there is a divine power with its "fearful symmetry" at work within the quotidian shuffle of events, but even he remains incapable, especially in light of the banal fixations and psychic pressures of his family, co-workers, and peers, of seeing it for what it actually is. Toward

the end, Curtis, by agreeing to enter into treatment, surrenders to what Jacques Lacan would term the "symbolic order," the merciless regime of signifiers that determine what is supposedly "real" when, in fact, they are the curtain of deception, which in the grand finale must be pulled back to disclose what is ultimately Real.

The Midwestern small-town domesticity of Curtis's wife, whose persistent focus is the family budget and the well-being of their deaf daughter, combines with the almost stifling small-mindedness and insouciance of everyone with whom Curtis seems to come in contact, including even the members of the "helping professions." They are the enforcers of the linguistic regime, much like Job's interlocutors, to which Curtis "courteously" listens and pays respect while resisting to internalize their messaging for as long as possible. Theology follows the more familiar line of discourse. It is the voice of the "religious," the priestly, the "curatorial," the parlance of mental and spiritual "health," the "real" with a little "r." Eschatology is that eerie sense of what both Nietzsche and Freud termed "uncanniness" (*Unheimlichkeit*) that sticks in the craw of the self-certifying syntactics of every *ordo symbolicus et theologicus*. It belongs to a dream logic, the idiom of the "unconscious," not so much the repressed as the unspeakable, or what remains still to be spoken. It inhabits the realm of "events" that are yet to come, but as the philosopher Alain Badiou reminds us, the event is not locatable in a "place" but only a "(s)place," a singularity of both extraordinary vision and bold, if not "insane," venturing.

Curtis glimpses the meaning of the "event" but cannot "place" it. All he can do is make willful and defiant gestures, like mortgaging the family's livelihood to dig a storm shelter. But the uncanniness and "out-of-placeness" of *l'eventement*, which even teeters on the edge of undecidability between *folie à deux* and verifiable heroism at the film's scandalous conclusion, is all we can imagine within this theater of the everyday. Curtis is perhaps reconciled with his family, but we as viewers cannot at all be reconciled after this perplexing quasi-melodrama with our previously accepted norms for making judgments about "reality." The Lacanian "Real" with a big "R" that always forces its way, like a savage alien into the cracks in the façade of the "real," (with a little "r") is this kind of violent vortex suggested by the tornado: an anxiety-generating *Unheimlichkeit* that stalks the borderlands between sleep and waking, which remains impossible to resolve as either epiphany or incontrovertible madness. Call it the "God-particle," a particle not of matter but of speech, which

conditions, but does not "account for" in any inferential or explanatory fashion what the very unsayable of everything we end up saying in the theological discussion truly amounts to.

FIGURE 26

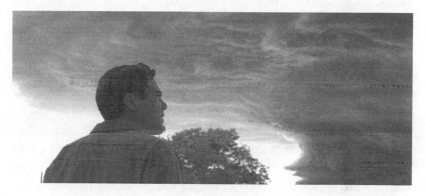

I offer this notion of such a "particle" because it offers a way out of the impasse, which the more recent fashion of using Lacan's thought to take on more conventional theological issues has created. The discovery of the importance of Lacan by theologians has tended to circulate around the former's seventh seminar, entitled "The Ethics of Psychoanalysis," which was conducted in the years 1959–60. The seminar is of particular value to the theologically minded because it tends to deal with the question of "God" by coyly refusing to come to terms with the notion as a genuine question at all. In fact, as Lacan himself emphasizes midway through the text, the analyst has to assume the "death of God" before he can become effective in leading the analysand toward the capability of naming one's own desires. What that all implies is somewhat opaque when it comes to going about the business of theological "inquiry" in the way most religious thinkers are used to. Interestingly, if we consider the movie *Take Shelter* as a whole, it ends up doing much of the same thing. Not once are religious questions, or religious "answers" to these venerable questions, ever posed. At the same time, though, the script is saturated with implicit theological motifs that we cannot ignore.

One of these motifs is that of fidelity to the divine prompting itself. The comparisons with the figure of Noah, as previously mentioned, are of course a bit striking. Curtis is a quiet, yet resolute rebel against the reigning cognitive paradigm.[1] His dreams are at once lucid and disturbing. It

1. Both have not only a certain steely interiority that drives them as pioneers of a

is those who rigidly deny and can in no way accept the possibility that the *unheimlich,* as Nietzsche put it, glowers at them from the doorway as the "strangest of guests, may be the ones, we suspect, who turn out to be genuinely delusional." Curtis is the only one who has doubt, but doubt always moves with faith, that is, as Kierkegaard so elegantly puts it in *Fear and Trembling,* by virtue of the "absurd."

Curtis in this respect does fulfill Kierkegaard's criteria for the "knight of faith." He does not initiate a harangue about why he thinks he must do something that no one, including his wife, will understand, let alone confer some credit upon. His gesture, like Abraham's, is utterly "inward." It is a "leap," and it is furthermore an act of will that has no rationally structured motive. It is what Kierkegaaard called the "teleological suspension of the ethical," although the actual teleology is a little different in Curtis's case. He does not violate the commandment of "thou shall not kill," especially one's own son, as was the case with Abraham. It is what he is simply "required to do" as a mere "ethics" of obedience to One who calls, which is not at all the ethics of acting in conformance with a "universalizable" maxim according to the demands of a universal law *a la* Kant—Kierkegaard's touchstone in the case of Abraham. The ethics of obedience to the One who calls cannot call forth a maxim to justify it at all. It is in this context that the Lacanian account in the seventh seminar becomes especially relevant and compelling.

The seventh seminar, as most of the literature on Lacan repeats tirelessly, revolves around the problem of disentangling the feints of desire from the imaginary register in which they are systematically encrypted. The task of "ethics," which from Aristotle on down has be tantamount to signifying properly the notion of the "good" in relationship to our quest for final human satisfaction (*jouissance* in his terminology), amounts in Lacan's dialectical gymnastics throughout the seminar to the process of finally being able to name what desire is. The ethical question is not whether you have acted in keeping with some principle of the *summum bonum,* the "highest good," but whether one has "acted in conformity with your desire." That Lacanian precept, which is also identical with the axiom of treatment, positions psychoanalysis itself at the crossroads

new sphere of consciousness that what happens down the road alone can truly justify, but also conflicted about their very role. They are not in any way plaster saints, or simple cardboard cutouts from among our little Christian Golden Books. It may seem counterintuitive to make such a claim, but Curtis is not the one who from the very beginning lives in a fantasy world.

between psychology and theology, insofar as it seeks both to demystify the Great Commandment and to reveal the deep structure of the very "libidinal economy," as Freud put it, that undergirds all religious devotion.

The "paradoxes" of ethics—which are at the same time, for Lacan, the aporias of desire—can be discerned in the so-called Great Commandment, about which Jesus spoke forcefully:

> Hearing that Jesus had silenced the Sadducees, the Pharisees got together. One of them, an expert in the law, tested him with this question: "Teacher, which is the greatest commandment in the Law?" Jesus replied: "Love the Lord your God with all your heart and with all your soul and with all your mind. This is the first and greatest commandment. And the second is like it: Love your neighbor as yourself." All the Law and the Prophets hang on these two commandments.[2]

The command to love one's neighbor, according to Lacan, is subtly equivalent to a command to "enjoy" one's neighbor. But such "enjoyment," so far as Lacan is concerned, could just as well come down to exploitation of one's neighbor. In dissecting the entire Kantian reasoning about ethics as resting on a "categorical" imperative that obligates us to the moral law, which putatively is an attempt to translate the rabbinic mitzvah into a scheme of righteous intentions and "just" behavior, Lacan draws the shocking conclusion that overshadows the legacy of the entire seminar itself. Lacan wants to argue that the one authentic Kantian—and, by extension, the genuine practitioner of "ethics"—is the Marquee de Sade. Sade has no qualms about articulating the meaning of desire, as he does in his infamous *Philosophy in the Boudoir*. But, strangely, this Sadean "law" of desire is also the divine law. To "love God" means, in effect, to postulate a pure desire. Loving one's neighbor "as oneself" is to understand the unity of pure love and *amor prope*, love of oneself, which is at the same time the affirmation of love as uncharted desire. Lacan quips that Kant, in his attempt to formulate the absolute grounding element of what we today would call a "science" of ethics, might have just as well composed not a critique of "pure reason," but a "critique of pure desire." The "deconstruction" of law as desire, which Lacan does ruthlessly and convincingly throughout the seventh seminar, is the inevitable outcome of the "death of God."

2. Matt 22:34–40, NIV.

In section xiii of the seventh seminar Lacan gives a certain explanation in his usual rambling style on what the "death of God" has to do with such a critique of desire. Here Lacan starts with the broader, theoretical issue of the origin of religion. In his now well-established, equivocal habit of "returning" to Freud when he is in fact moving beyond him, he seeks to leverage Freud's own sources in taking up the matter. In this setting is the German phenomenologist of religion Rudolf Otto. The religious, as Otto had famously underscored in his landmark work of 1917 entitled *Das Heilige* ("The Idea of the Holy"), arises from the experience of the "numinous," the investiture of what would otherwise be a rather ordinary region of cognition with a sense of profound mystery that both engenders awe in our reaction and draws us toward the object. Otto's formula for the numinous was the Latin phrase *mysterium tremendum et fascinans*. The story in Exodus where Moses spots the burning bush becomes exemplary for such an analysis. It exhibits the linguistic as well as the affective properties of the "numinous" that both Otto and Lacan consider telling for the theory of religion.[3] The tornado in Curtis's psychic field of vision becomes what, again using Lacanian language, we might dub a "master signifier" for the *mysterium tremendum et fascinans*.[4] Lacan seems to

3 Now Moses was tending the flock of Jethro his father-in-law, the priest of Midian, and he led the flock to the far side of the wilderness and came to Horeb, the mountain of God. There the angel of the Lord appeared to him in flames of fire from within a bush. Moses saw that though the bush was on fire it did not burn up. So Moses thought, "I will go over and see this strange sight—why the bush does not burn up." When the Lord saw that he had gone over to look, God called to him from within the bush, "Moses! Moses!" And Moses said, "Here I am.""Do not come any closer," God said. "Take off your sandals, for the place where you are standing is holy ground." Then he said, "I am the God of your father, [a] the God of Abraham, the God of Isaac and the God of Jacob." At this, Moses hid his face, because he was afraid to look at God.

4. Although I do not usually indulge in personal story-crafting in these kinds of analytical exercises, I think it is worth retelling of an incident from my own life when I was twelve years old that has profoundly shaped, if only unconsciously, so much of my own "hermeneutical" attitude in arriving at the perspective I offer in this very article. Growing up in Oklahoma and Texas and traveling as well living for much of my adult life on the eastern planes of Colorado, I am no stranger to the sight of tornadoes. But the first time I ever encountered one "face to face" was when I was twelve years old and residing in Denison, Texas on the Red River, about an hour north of Dallas. It was one of those banner days in the Southwest when tornadoes seemed to be everywhere, and of course all over the news on both radio and television. There was no internet in those days. My middle school had let out early because of the warnings that were being broadcast, and almost the minute I arrived home I was warned to "take shelter." My mother was hours away at a conference in another city. But my father, whose place of work was on the other side of town, called me and sternly instructed me and my

think, so far as the seventh seminar is concerned, that the relationship between desire and the "numinous" comes down to the displacement of the alleged desideratum into a fateful distribution of different "religious" symbolic codings, which from a clinical perspective might count as a symptomatology.

grandmother, who was home at the time, to go lie down in the bathtub, a routine emergency procedure, because a tornado was bearing down on us.

Interestingly, the city of Denison had always been touted at the time for never in its eighty year history having been struck by a tornado, probably because of the terrain surrounding it consisting of low, forested hills, which are not as conducive as open prairie and farmland to sustain the energy of funnel clouds. Of course, I had to go see with my own eyes what my father was warning about, and I ran out into the back yard and there it was. We lived at the very edge of town. To the southwest I could see a giant "twister" no more than two miles away with swirling debris in its frightening maw heading directly, as my father had stipulated, toward me. That of course happened now decades ago, and it also happened very fast.

In addition, the memory has become powerfully iconic in both my memory and imagination as some kind of "founding trope" for other major intellectual adventures. But what has always stood out in my evolving moments of self-reflection is how I, indoctrinated by parents, school, and community into the abject fear of tornados (and as a child as I was always terrified of lightning storms), did not at that moment obey my father. Nor did I even run back in the house. I simply stood there awe-struck and emotionally paralyzed. It was indeed a brief interval of the *tremendum et fascinans*. There was a kind of ecstasy in the reckless thrill of standing there, bearding that mighty whirlwind. I should not be here today to tell this tale, but something perhaps not so unusual from a meteorological standpoint happened. Within perhaps a half or quarter mile from the house, the twister lifted up into the sky and dissolved somewhere up in the clouds. The angel of death had passed over us.

For years I did not know what to make of this experience, but in my later adolescence, after we had moved from Texas, I started to spin the yarn concerning "the moment I stared down the tornado." Of course, I didn't really "stare it down" I was hypnotized by it. My "instinct," if one can call it that, was not to take shelter, but to throw my emergence sense of subjecthood into its full, sublime fury. In my own case the tornado, then as well as now, comports with the strange, Lacanian construct, taken from Kant, of *das Ding* ("the Thing"). *Das Ding*, related in a certain measure but not entirely to Kant's notion of "the thing in itself" (*das Ding an sich*), is one of the most daunting and prickly concepts in the Lacanian corpus. The "Thing" is a theme Lacan is compelled to introduce in the seventh seminar for much the same reason Kant has to posit it in his first critique. If for both Kant and Lacan "meaning" can occur only at the level of the epistemic, or in Lacan's case the "symbolic," then the question of the genesis of its placement within the cognitive field also has to be considered. In fact, we know now, particularly in light of the translation and publication of Derrida's master's thesis, that the question of genesis haunted the history of transcendental idealism from Kant all the way up through Husserl, and it becomes the *point d'appui* for the venture known as deconstruction. But when it comes to the "numinous," the question of genesis becomes even far more problematic.

The history of religions consists essentially of establishing the common denominator of religiosity. We stake out the religious region in man within which we are required to include religions as different as one from Borneo, Confucianism, Taoism, and the Christian religion. It's not without its difficulties, although, when one sets out to produce typologies, there's no reason why one shouldn't end up with something. And this time, one ends up with a classification of the imaginary, which is in opposition to that which characterizes the origin of monotheism, and which is integrated into the primordial commandments insofar as they are the laws of speech.[5]

The opposition between "religion" and "monotheism," Lacan suggests, is at the heart of the enigma of the "Thing," which confounds any symbolic resolution of the great moral commission we call "ethics." Desire would not be possible without the "Thing," but how is this connection instantiated in the first place? Contra Aristotle, ethics can never be a strategy for realizing the telic kernel of desire as the quest for "happiness," the "good life," or even *eo ipso* the good itself. Only a philosopher can theorize about how to mobilize the miscellany of "goods"—value determinations with their perverse genealogy, as Nietzsche reminds us, which masquerade as ontological first principles—in order to live in accordance, as contemporary moralists would put it, with our "full potential." As Tad Delay relates his recent exploration of the connection between psychoanalysis and theology, "Morality begins with desire, both as a universalized axiom and as a simple object we aim for without quite knowing the goal."[6] For Lacan, morality is in a strict sense always neurotic; it is inextricably tied in with the prohibition of desire (the "thou shalt not") inscribed in the divine commandment as the distinguishing mark of monotheism.[7] That,

5. Lacan, *Ethics of Psychoanalysis,* 175.

6. Delay, *God is Unconscious,* 60.

7. Indeed, the proscription contained in the mitzvah, or commandment, intensifies and even clarifies desire. Lacan writes, "Whoever enters the path of uninhibited *jouissance,* in the name of the rejection of the moral law in some form or other, encounters obstacles whose power is revealed to us every day in our experience in innumerable forms, forms that nevertheless perhaps may be traced back to a single root." For we must "accept the formula that without a transgression there is no access to jouissance, and, to return to Saint Paul, that . . . is precisely the function of the Law." For there is a "tight bond between desire and the Law."

as Lacan recognizes, is the essence of Paul's famous insight in Romans that the Law induces sin.[8]

That summary, of course, amounts to a standard outline of the Lacanian field as a whole. What Lacan brings up in the seventh seminar—and which in many respects he cannot transcend, because he delves to the very marrow of the relationship between "religion," Judaism, and morality overall—is that "love of God" with all one's heart and mind constitutes an invitation to granting the nihilism of any metaphysics of desire *tout court*. The operative dictum of Lacanianism is not, as the old pop song goes, "you can't always get what you want." Rather, you don't even know what you want, and the more you try to get what you don't know, the

8. Rom 7:7-12, NIV; Yet Lacan goes well beyond this well-known Pauline paradox. The paradox lies at the heart of monotheism itself, Lacan tells us, because it is not at all a "religious" conundrum. It draws our attention to the dirty little secret that monotheism is actually the end of religion because it necessarily entails the death of God, and therefore the loss of the ability of desire to deflect, redirect, or economize itself as anything other than its own desire. That is where the factor of *das Ding* comes in. In the seventh seminar Lacan playfully substitutes the word "thing" wherever Paul uses the expression "sin" in the above passage in order to drive home his point. The Law magically conceals the vacuous center of its own prohibitionist design. Lacan ties directly the halakhic ban on images to the death of God. It is an argument that has been made by critics of radical monotheism in some version in both the ancient and contemporary world. If it is impossible—indeed, absolutely forbidden—to "represent" God other than in terms of the standard signifier that forecloses the very content of signification (*ha-shem*, "the name", "the Most High", "G-d", etc.), then what does "desire" as the unconditional love of God and neighbor imply besides what Spinoza would have called a conatus striving after the forbidden "object" itself.

In fact, the "object" of the forbidden desire is not really an object at all, so far as Lacan is concerned. Its signifier is always a "sliding" one. The "object" is one phantom flickering in a shadow play of imaginary substitutions for the impossible aim of a desire born of the negative commandment itself. That is why the Torah in Lacan's as well as Paul's estimation must be recast as "sin" (hamartia, a "missed mark" necessitated by the fact there is there is no "target" for the desire born of the regulation itself). The object he elsewhere terms the *objet petit a,* or "object little a," where "a" stands for the French word *autre,* or "other." In Lacan there are different registers for "otherness", depending on the degree to which the analysand understands the functioning of desire within their own psychic administration. There is the "Big Other" (designated in Lacan's notational calculus as capital A for Autre, or simply "Other") which both demands and rewards as well as produces anxiety and guilt in the subject-field. It is the hypostasized "I" of the "I am that I am", who also makes a claim on the subject in the "thou shalt not" of the *mitzvot*. The goal of analysis is to persuade the patient that there is no "Big Other," but that is not an issue we need to take up here. The need for analysis itself is impelled by the inability of the analysand to recognize the fraud in the various sorts of "others" with a little "a" to which they seemed to have hitched both their desires and their subjecthood.

more neurotic, if not psychotic, you become. If *jouissance* somehow requires the barring of the fulfillment of desire because of the prohibition inherent in the law, it is on account of the impossibility of even a "theoretical" satisfaction, given the nature of monotheism itself. The real object of monotheistic desire (if we may call it that) is what Lacan describes as the "temple" that is "destroyed without trace." The temple was "only supposed to be the cover of what was at its center, of the Ark of union, that is the pure symbol of the pact, of the tie that bound him who said 'I am what I am,' and gave the commandments, to the people who received them, so that among all the peoples it might be distinguished as the one that had wise and intelligent laws."[9] No material "image"—read here *Vorstellung*, or "representation"—will suffice.

For Kant, the *Vorstellung* always suffices for "the Thing," because *das Ding* is unknowable. In fact, all cognition shuffles through and is enmeshed within the different "representational" processes that serve to manufacture what we take to be the objectivity of the thing, which is not anything "there" in the immediate sense, only something mediated through the "transcendental" claims made by the apparatus of knowledge at its deepest layer. For Lacan, though, even if the "Thing" is not knowable, it remains eminently desirable. And it is what we really desire in conformance with the Augustinian scheme of the "love of God" ascending to the celestial heights of the Supreme Good. The difference is that Lacan, the "bad" Catholic, informs us that the joke is on us. Our hearts are always "restless," but they can never truly "rest in Thee." God is "dead" because he is the faceless presence on Mount Sinai, the mysterious and contentless "ark" at the center of the temple, the *Unheimlichkeit* of the empty tomb. That is what we really desire. As Lacan writes, "that is why Christians in their most routine observances are never at peace. For if one has to do things for the good, in practice one is always faced with the question: for the good of whom? From that point on, things are no longer obvious."[10] The "Thing," however, is not some grand cosmic tease, the ultimate what that is paradoxically not. As Marc De Kesel argues, "despite its agility within the realm of signifiers, the subject is now presumed to remain simultaneously "attached" to something that is not a signifier: something that is beyond all signifiers and which Lacan, with

9. Lacan, *Ethics of Psychoanalysis*, 175.
10. Ibid., 319.

Freud, names . . . the 'thing.' It is this 'thing' that gives the subject's slippery libidinal economy its ultimate consistency."[11]

The proposition sounds rather Faustian, but there is a distinct factor that distinguishes Paul from Goethe.[12] Paul understands in his own way that what we call "God" is neither the imaginary nor the symbolic, but the Real. And our destiny is not merely one of a grand a-telic striving toward the unknown in conformance with the "restlessness" of our ever-roiling subjective inclinations in conjunction with a vast and expanding kaleidoscope of desiderata, or object-ridden phantasms. It is the *jouissance* of truly becoming our true desire. If there is a Lacanian "cure," it is of that kind precisely. The "Thing," as opposed to the fantasized object, is necessary to the cure. For Lacan, it is perhaps tragic clarity. For theology, it is the death of God, i.e., the crucified Christ who now "lives" in us as true desire, once we have shorn ourselves not only of every *petit a*, but also the Big Other.

So now what does that all have to do with *Take Shelter*? We can perhaps consider it a Lacan-like (notice I did not say "Lacanian" per se) parable of Christian jouissance when "God is dead." Curtis is the only one who has any inkling that in both the imaginary and symbolic management of the day-to-day, including those everpresent clerks of the biopolitical bureaucracy we know as "therapists," that something is strangely amiss. *Das Ding* cannot be enunciated. It can only appear as a frightening, visionary challenge to all signifying orders in a single, recurring dream. During the few times Curtis actually vents his frustration, he exclaims: "You think I'm crazy? Well, listen up, there's a storm coming like nothing you've ever seen, and not a one of you is prepared for it." But of course the rigid regime of signifiers continues to reign. Contrary to

11. De Kesel, *Eros and Ethics*, 11.

12. Why is *das Ding*, the empty, non-signified present absence manifesting in our "conscience" (*Gewissen*), as Kant would put it, as the categorical voice of command that transforms desire into an insoluble conundrum the key to the problem of ethics at all? Why are we "attached" to it inexorably as our "destiny," as Lacan puts it a little later in the seminar, when in fact it brings (in Paul's words) "death?" Of course, that is the second—and perhaps far more important—shocking revelation that Lacan has in store for us in his effort to hone the import of "ethics." Desire is all about the "death drive." It is because of this disclosure that he spends a good part of the last half of the seminar analyzing the tragic fate of Antigone and her strange obsession to bury her brother regardless of the "laws" of the polis. It is the death drive that "saves" as much as it kills, because it is what constantly incites us to a lifelong adventure of seeking to attain impossible gratifications. "Being desire, man can never be done with desire because, should he succeed, he would also be finished off."

Curtis's slowly evolving "madness," his friend Dewart tells him kindly: "You've got a good life, Curtis. I think that's the best compliment you can give a man; take a look at his life and say, 'That's good.'" Aristotle would of course be proud, but Curtis detects that something is rotten in the state of "goodness." The question is whether he is actually fortifying himself against the threat of "the Thing," a curious Lacanian construct that points toward what Otto termed the "wholly other"(what has been come to be termed in psychoanalytic exegesis the "Other of the other"), or against the destructive deception of what Kant would characterize as the "heteronomous" moral "good," the ethical signature of the Big Other. Given the dynamics of desire, we cannot say.

Yet what we can argue is that the "Thing," the full fury of the Holy One of Israel, the One who died and "rose again" while thereby annihilating the systematic religious imagination with one gigantic *coup de force*, cannot be assimilated by any theological argument whatsoever, insofar as Lacan tacitly views the enterprise of theology itself as an exercise in sewing together all the loose threads from the discourse of desire in keeping with his notion that there must come a point—his *point de capiton* or "quilting point"—where the sliding signifiers condense around an object of enunciation. Finding the quilting point removes from us the responsibility for a time of confronting the impossibility of what we are really seeking.

In a profound way Curtis reaches that quilting point when he accepts his creeping "insanity" and agrees to be treated. But, as we have insisted, theology understood in this Lacanian manner must become eschatology (what we would name a genuine "theo-eschatology"), because the seams around the point eventually give way. We no longer have the suspicion of psychosis, but revelation. At the moment the "absent presence" of the overweening and tempestuous *Ding* becomes the entrance to the real. Curtis's final words to his "unbelieving" wife, when they look out over at the ocean at the apocalyptic inbreaking of the funnel clouds he has only seen in dreams, are telling. "Sam," he calls, urging her to look up at the sky. Sam's "ethical" reply: "Okay."[13]

13. Nichols, *Take Shelter*.

FIGURE 27

Bibliography

Delay, Tad. *God is Unconscious: Psychoanalysis and Theology.* Eugene, OR: Wipf & Stock, 2015.

De Kesel, Marc. *Eros and Ethics: Reading Lacan's Seminar VII.* Translated by Siggi Jöttkandt. Albany NY: State University of New York Press, 2009.

Lacan, Jacques. *The Ethics of Psychoanalysis 1959–60: The Seminar of Jacques Lacan, Seminar VII.* Translated by Jacques-Alain Miller. New York: W.W. Norton, 1992.

Nichols, Jeff. *Take Shelter.* Sony Pictures Home Entertainment, 2011.

Roundtable on Dread

Carl Raschke (CR), Kathryn Reklis (KR), Taylor Worley (TW)
and Zac Settle (ZS)

ZS: If we were to accept the methodological paradigm proposed in this book, in which we aim to receive films as spiritual phenomena to be experienced, how might our experiences with films shift?

KR: We have all chosen films that do not, in any obvious ways, register as "religious" (or often even as "spiritual") and that might not show up on any traditional "Christian film" lists, and we produced, I would argue, compelling reflections on why they should count as "spiritual." Continuing in this line of analysis seems like a good thing for all future "film and religion" or "film and spirituality" (and maybe especially for the more specialized "film and Christianity") conversations. There is another level to this analysis that I think about often, but do not always know how to incorporate into my own "readings" of films: shifting our focus away from "content" entirely, to means of production, sensuous embodiment, and audience reception. There is a growing body of work concerned with how film achieves various sensuous responses (beyond the visual and aural, but including them, of course) regardless of content. So that plot, character, "meaning" (as understood along a "textual" paradigm) fall more to the wayside and the actual play of light, pacing, sound, viewing atmosphere create a sensuousness that might also be understood "religiously" or "spiritually." The intro hints at some roots of this in Deleuze's study of film. The area that is increasingly interesting to me is "viewing atmosphere" which blends into "audience reception." Are there ways we could, borrowing more from popular cultural studies, media studies, and sociology, incorporate more analysis about how films are watched, by

whom, to what ends into our sense of "the spiritual in film"? How might this, in turn, press us to consider the mediated ("mediatizied" to use the media studies buzz word) nature of religion more broadly?

CR: My own view is that there is too much cultural reductionism in film theory and commentary. Deleuze's two—admittedly very difficult— books raise a question which film theory rarely addresses, what is the "semitoic instrumentality" in terms of coding and communicating what we experience. In other words, there is a distinct "language of film"—as there is a language of the visual arts—that film theory, because of perhaps not only its socio-political functionalism or vulgar Marxist or possibly its philosophical retardation, refuses to deal with. Take the example of *Take Shelter*. I would argue that this film is not really about religious themes, or even the prospect of dementia. It is really about the experience of what psychoanalysis since Freud has called "the uncanny" (*das unheimliche*) which is a category that compares with the notion of anomalism in the philosophy of science. I have to admit that I am not a big fan of reader response—or viewer response—theory. I think it ignores the role of communication theory and theories of signification in the process.

Just as I think you have to read artist statements to understand art, I think you have to look at narratives of production to understand film. The viewer response of spiritual films is naturally to pigeonhole it in familiar, popular categories (e.g., pscyhoglogical, political, religious, etc, or sexual). I do not think *Fifty Shades of Grey* was about sex at all, but that is how the viewer response community regards it. I would strongly agree with the importance of the category of "viewing atmosphere." Could we coin a term that relates to the esthesis of film as perhaps "filmic atmospherics"?

TW: Yes, indeed! I would propose something similar—"filmic landscapes." In his essay "Cinema as a Democratic Emblem," Alain Badiou describes cinema as "a painting without painting." By this comparison, I take him to indicate the complex interplay in film between what is art and what is non-art. In other words, cinema, like theater, employs the raw material of embodied performance, but unlike theater, it has been composed and edited for the benefit of a synthetic experience. Cinema is, therefore, the most impure art form we have today. It has the construction of a world, and that world appears to us as a whole, populated by the perfectly mundane yet harmonized with synthetic features of film

composition. Badiou would say: "A world painted without paint." Hence, "filmic landscapes." For many, this perceptual familiarity, no doubt, breeds contempt. For others, however, this is film's singular spiritual potency. It operates in a mode that is at once immanent *and* transcendent. Like any other religious accoutrement, how we wield it reveals more about us than the instrument itself. In light of the categories employed in this text, we must ask what use we still have with dreams, doubt, and dread. Are these places of retreat and refuge from the world? Perhaps, they are. Could they be other than that? I would hope so. I would hope that after traversing the imaginative terrain of such worthy filmic landscapes we might be returned anew to our material world, our social communities, and even ourselves to find these places more ripe for exploration.

KR: I would agree with all of this, but I want to push back a bit about the value of paying attention, to the entire mediated experience that is "film," beyond the individual work or even meditations on the "genre" or "material dimensions" of film as a category of "art" or "experience." *Fifty Shades of Grey* is a fantastic example, in fact. I would agree that the movie is not about sex. But I would disagree that this is the sum of the audience response. In almost every review I read of that movie, the reviewer alluded to the nervous or sometimes raucous laughter that erupted during what were supposed to be dramatic moments in the narrative. To account for that misplaced laughter would require an analysis of the narratives of production that take us all the way back to a *Twilight* fan fiction website. Which is perhaps to say that the "narratives of production" and "filmic atmosphere" extend beyond the intentionality of the director and include at least some attention to the networks of production (including viewer response/participation/anticipation) that are now inseparable from the act of making film. This is most obvious in "popular" film, but also true of more rarefied projects. I think one way to signal what I am trying to suggest is to highlight the difference between analysis or interpretation of film and film criticism. The art of criticism has fractured into a thousand pieces in the digital age and has, I think, become a confused genre. But it is also due for more sustained reflection and practice. For me, Robert Warshow, David Foster Wallace, and Walter Benjamin still provide essential resources for thinking the "experience of film" that highlight what Adorno would call its "truth and untruth" (not unlike, I think, what Taylor was suggesting). It is easy to fall into an overly pronounced distinction between the philosophical analysis of film and the cultural criticism of

film. While I am drawing attention to that distinction here, I think the way forward to consider what film is, how it works, and what it means requires more overlap between the two—or the creation of some new third way that includes both.

ZS: At what point in your own development as a person did you begin to sense some potentialities in film—catharsis, exercising your own dread, spiritual phenomena, etc.—that the Christian community has typically overlooked? And how did that experience shape you?

TW: I appreciated the personal anecdotes in Carl's chapter a great deal. If I can be permitted to follow that pattern, I would share a brief story about my first encounter with Alejandro González Iñárritu's films. A friend had recommended that I see 21 Grams, and that was really the only preparation I had for viewing it. I knew nothing about the film's story or the director, but I trusted the recommendation. It was for me—as I'm sure it is for many others—an intensely emotional experience. After watching the film, I was, in a sense, tortured by doubt for the next several days, if not weeks. I say that because the experience of the film caused me to reflect on my own life in new and profound ways. My own mother died very suddenly of a heart attack when I was a kid, and our family was shocked to learn that a routine physical from her physician just months prior to her death revealed no warnings signs at all of impending heart failure. This memory had been buried for a number of years, but Iñárritu's film had unearthed it. Confronted with the character of Cristina and her unrelenting blame toward her family's killer, I was able to feel the weight of our responsibilities to each other with a new capacity. I had not thought about my mother's physician in many years, but this film alerted me to how much this man had potentially affected my life. I wondered about his life for the first time. Did he know about his patient's death? Was he shocked by the loss in any way? Did he wonder about his role in it all? Unlike the characters in the film, there was no action for me to take—nothing for me to pursue, but without the experience of the film I don't think I would be as fully present to my own loss as I am after vicariously experiencing Cristina's grief. Perhaps it's cliché to suggest that films can still function in this directly cathartic way, but it's true in my case.

KR: My own biographical account is clichéd in another way (maybe that can't be avoided!). I grew up in a (sometimes) strictly enforced "secular

media is corrupted and corrupting" environment. Some of this relaxed in my teenage years, but with a continued hierarchy about the levels of wickedness one would encounter as you climbed the ratings list. The first movie I remember seeing that absolutely blew my mind was *Pulp Fiction* (I was fourteen). I was not scandalized at all by the violence, sex, or obscenity (I had been told my whole life to expect that from "secular" culture). But I was beside myself with excitement at my first taste of narrative complexity. This was before I really started reading great fiction, but once that began, and certainly in college when I was a literature major, the great revelation of my life was that the Christianity I had been immersed in (and mine was a full-immersion experience) was flat, one-dimensional, moralistic. Fiction, encountered in film and literature, gripped me with something like "the depth of human experience." Indeed, fiction seemed to me to do everything that Christianity was supposed to do for me and in that way I was able to think of fiction as an extension of Christianity. For a time (and maybe even still sometimes I fall into this) I made sense of this "complexity" as a diagnostic within a Christian framework: film (or literature) could diagnose what was wrong with the world (reveal the hidden depths of human self-deception, confusion, god-longing) but only Christianity (theology) could answer or solve it. Increasingly, though, as a human (and especially as a professor) I think there is salvation/solution simply in activating what Benjamin might call the "role of the storyteller"—giving to us some kind of "communicability of experience"—in an age of over-information. Which is probably why I am drawn to thinking about artifice and "madeness."

ZS: Carl's chapter examines the way in which Curtis, of *Take Shelter*, refuses the "talking cure for his inner struggles and dilemmas," opting for the "literal, as opposed to the figurative, meaning of experiences and starts to make secret preparations for the anticipated apocalypse." How do you think that film can enable us, as viewers, the chance to properly engage our own issues in a literal rather than a figurative manner?

KR: For me "taking something literally" is perhaps one way to re-center experience beyond simply "private occurrence"—anything that happens to me. In the case of Curtis, though, it seems as though taking his experience literally only highlights the very chasm opened up by a subjective understanding of experience. His interlocutors press him to subjectivize his experience because they literally cannot receive the experience he

is trying to impart to them: there is no common ground on which this can be built. If this extends to us to viewers, though, perhaps the very act of interpreting films like *Take Shelter* (and by interpret I mean even the chatter that might happen incoherently among friends as well as the sustained reflection in written form) that we have to "take literally" the experience of experience.

But mostly I just want to talk to Carl more about the gender politics of that film and whether this is another case of the ability to imagine our own apocalyptic demise more easily than to imagine new form of social relation built on the eradication of capitalism.

CR: Clearly the sort of "American Gothic" modality of the family (with the exception of the daughter's disability, which is made to offer a sense of unease) suggests that all is not at ease under the happy surface of "morning in America." But we have that kind of esthetic going all the way back to Flaubert. The ordinariness of the couple, and the silence they both embody in not really communicating, is interesting, but again, in my mind is the scripting of familiar literary devices in the direction of something else. It is the "Great Monstrosity"—however we define it—and which can never be defined in the film, that is the real subject of this film. I don't think the usual "critical theoretical" interventions in talking about this film are of much relevance. It is like Eco's *Name of The Rose*, which really isn't about the Middle Ages, nor crime whodunnits, nor about issue of theology, nor ultimately even about Aristotle's long lost tome on laughter. Every one of those themes is a deception and a displacement, a screen for the projection of our fears and desires on to something (Lacan's *objet petit a*) which are ultimately inappropriate, something we can't name, and probably shouldn't name.

KR: I was struck by your description of Curtis as a man "like most of his class and generation." You go on to describe this demographic as one skeptical of talk-therapy, which seems true enough. But that same "class and generation" is also one for whom the supposed narratives of middle class security and identity have collapsed. I think it would be possible to read Curtis's desire to take literally the Great Monstrosity as a desire for some true Other to restore his own sense of self, his own "thereness," and even his own potency in the face of "emasculating" tedium, even if it meant undoing his sanity and the dissipation of all potency into pure Potency. But then this fantasy becomes, not so much about the sublime,

per se, but about the necessity of the sublime to undergird the masculine subject in the discourse of modernity.

TW: I like to tell friends that this film is the cheapest marriage counseling they could get. To me, there's enough in *Take Shelter* that's recognizable to my experience to empathize with the characters, but at the same time, there's plenty of distance created for the audience through the apocalyptic conflict in the film. Perhaps too obviously, it reminded me of Spielberg's *Close Encounters of the Third Kind* and the character of the father there. He's too busy receiving a revelation from heaven to worry about the family he's abandoning. The overt religiosity of Spielberg here does nothing to ground the literal nature of revelation in the way that Nichol's *Take Shelter* does. I'm still not sure how to reckon the ending of the film with the rest of it, but I take the overall force of the film to do something that *Close Encounters* cannot. The fragility of the marriage represented there is almost palpable, and in that way, it chastens our appreciation for such vows: "for better or for worse," "in sickness and in health," etc. In this light, revelation becomes both the center and the limit for such unions.

CR: I am not convinced the marriage tensions are really that essential to the meaning of the movie. I think the ordinariness of their humdrum Ohio life is sketched out in very powerful literary ways (like the 1950s novels *Mr. & Mrs. Bridges*), but as a tease so that you become more enthralled with what is going on behind the mask of the putative "madman." The tension between the "apocalyptic passion" and the skeptical, reductive ordinary mindedness of the rest of someone's relationships is a familiar literary device. You can find it all through the Gospels: when Jesus is talking about the Kingdom of God, his mother and brothers are begging him to stop the silliness and come home to attend to the family business. You really appreciate the figure of Jesus when you have these contrasting portrayals. I think the same is going on here.

TW: I agree with that. But the ending suggests that the restoration of the relationship is more integral to bearing up under the apocalyptic passion. Why does the film have that ending at all? I'm still not sure. I could see the film as doing exactly what you're talking about . . . except for the fact that the apocalyptic reality of the ending of the movie provides the guarantee for the effort they made at staying together.

CR: Yes, granted, but the relationship is restored ultimately through the apocalyptic revelation itself. There is no "see, I told you." His wife finally comes to accept him for what he is, and then you have the surprise ending. The meaning of what is going on is finally revealed, and it is far bigger than anyone thought. But it is completely indeterminate, and that is what gives the film ultimately its impact and voice.

TW: Yes, I think we're closer than it might seem. The revelation happens in the bunker not on the beach.

ZS: Kathryn, in examining Wes Anderson's films, explains that "meaning is not just violently wrested from the abyss or given in the absurdity of faith, but is sometimes made—crafted, built, and sustained in beautiful and careful effort." Does the experience of dread induced by film offer any ways of dealing with and processing external forces in the world? That is, can film offer us any sense of re-enchantment?

TW: I'm so grateful for Kathryn's chapter. I enjoyed it for many reasons but principally because it explained to me why I enjoy Wes Anderson's films so much. The burden of what constitutes a glimpse toward re-enchanted life in our late modern, post-industrial world is quite heavy, but Anderson's efforts certainly stand out from other contemporary films in this respect. As Kathryn signals, his movies remain disarmingly free from the crippling irony of so many other projects we struggle to appreciate *and* enjoy. Anderson's films can be received in just that way—with wonder and joy. Wonder for the craftsmanship and ceremony; joy in the festivity they imbue. They are not quite guilty pleasures though. Along the lines of Kathryn's argument, I think it important to consider how we enjoy them. Just as the films earnestly celebrate friendship in their own ways, it has been my experience that they are best enjoyed among friends. Friends that appreciate these films share in their festivity. Rather than just rehearsing them as absurd punchlines, Anderson's fantastically ordinary tales become the stuff of poignant self-discovery among friends. His films seem to create communities of empathy through acknowledging life's apparent absurdity. That we experience the wonder of these films as a present nostalgia and not a constrained or forced re-sacralizing of life indicates their subtle, yet potent powers of enchantment. Perhaps, the most enchanting films today need not bother with justifying themselves first.

KR: Yes! This is exactly one of those truths that is hard to reference in an essay without resorting to anecdote as proof, but Anderson's films have worked in my life in the same way. Like the Anderson hero, the films issue their own "who's with me?!" quality that draw friends and viewers into communities of sympathy. Some critiques dismiss this quality as jejune existentialism—the same way eighteen-year-olds find each other at college over a shared identification with Holden Caulfield. While I would want to hold out some hope and care for the Holdens of the world, this is not quite the same as what happens in and around an Anderson film. Anderson's worlds are narratively grounded in the demands and pleasures of friendship and foster it (or at least that seems true for you and me and our friends).

ZS: Taylor engages Iñárritu's films as a means of "staring down death for the sake of renewed vigor in this life." In what ways does film, in providing us the opportunity to experience tragedy and dread in new ways, offer us the potential to find such forms of renewed vigor in our own lives?

KR: I am going to sound like a broken record, but the experience, not just of tragedy in general, but especially of death and grief, might be the center around which any real communicability revolves. Your analysis of Iñárritu, Taylor, was very illuminating for me and if the common place is true—that modern humans have lost our sense of death (its naturalness, its necessity, its complexity, its factness)—I think you might be right that Iñárritu is one of the great masters/storytellers of this art. I don't have time to think of this in too much detail, but it seems both entirely possible that film is one of the best mediums we have to encounter death/grief in a way that both speaks to subjective experience and transcends it. In any historical/anthropological sense, the levels of mediation here might give rise to the general sense of "modern disenchantment" or "modern attenuation from experience." But perhaps death has always been mediated by (re)presentation and the mediations of film are the medium of this moment.

ZS: I'm really interested in what all of you had to say in regards the question on your personal development with film. I appreciate you being so candid with your answers. You touched on the idea that the experience of film has a distinct possibility of revealing to us the nature of our own world in new ways. Taylor, you say that vicariously experiencing the grief

of 21 *Grams* helped you to properly encounter and make sense of your own. Kathryn, you refer to film's enabling of a certain communicability of the experience in an age of over-information. Will the three of you reflect here, for a few moments, about these notions of catharsis and communicability in our own world, as its made possible through film?

TW: I appreciate the way that Richard Kearney reminds us in his work on narrative that catharsis only works when there is a productive balance created between emotional nearness and distance. I mean that we must be able to both identify with and differentiate from what we're experiencing with the film. That balance is difficult to strike for many filmmakers, but I think the particular ones that we've selected for our essays hit the right note.

CR: Catharsis has always been a key for my personal experience of film. In many respects I denote my own biographical trajectory in terms of key films, particularly when I was young. I see films as route markers for social history. You can, for example, metonymically condense such time periods as the 1960s in terms of anti-war films, or the 80s—the age of Reaganism—in terms of the career of a Stallone.

TW: Good point! I too chart my own development often with a sort of filmography. It is interesting then that our choice of films and filmmakers all come from the same time period (early 2000s to today). Carl, what do you think that means? I sort of feel bad that I didn't choose a more classic filmmaker or more canonical set of examples.

CR: I think it is important to take into account Deleuze's notion of film as the "movement image." Following Bergson, he sees film as in many the purest form of art as it expresses the elan vital, which was what expressionism always sought to do. The expresionist esthetic has always been the key to what we might term philosophical—as opposed to cultural—film theory.

The 1960s were not only one of the most turbulent periods in Western history—the passage to the "postmodern"—but they were also one of the most creative, paralleling in many respects the Napoleonic era. They had their own powerful Sturm and Drang. The breaking of new forms and the pushing of new forms, particularly in terms of expressing the depth of feeling and the probing of social contradictions, was at its

heighth then as it was for music. The film industry, however, has always been subordinated to economic forces, as well as technological, and the automatism of cinematic-like musical-production has had a lot to do with that loss of vitality. Mediatization comes in several forms. One level of intervention is in terms of stereotypes, which always seem to come into play when religion is treated in film. Movies such as Robert Duvall's *The Apostle* broke that stereotype, but that was an exception. The second level of mediatization is the degree to which the spiritual dimension of personality is explored in terms of historical models. It is interesting that the American film industry has increasingly used the figure of Jesus (the usual New Testament epic is no longer one of the stock Sunday School Jesus, but as a complicated personality) to delve into mediatization as spiritualization, but has shrunk for dealing with average religious kinds of people (with the exception of *The Apostle*).

KR: Yes! But why do you think this is? In the last several decades we have been told, sometimes triumphantly, sometimes despairingly, and with increasing frequency in the last several years, that Americans are "less religious" than ever. The rise of the so-called religiously unaffiliated or the "spiritual but not religious" suggests that religion (and spirituality if we want to separate those terms, which is another discussion altogether) is more centered in "average religious kinds of people" than ever before. Is it that we do not yet have our cultural stereotypes for this kind of religiosity so film has no "stock and trade" to deploy? Is it that these lives seem opaque by statistical measures? The majority of the religiously unaffiliated are not "atheist" or "agnostic" but the complex pattern of affects, practices, and concepts that give shape to their spiritual lives cannot be easily captured in a demographic box (e.g., "Methodist," "Buddhist," "Evangelical"). These demographic boxes, of course, never captured the affects, practices, and concepts of individuals who made sense of them, but they did lend themselves to stereotypes about "the religious individual." It may be that we are simply facing a lag time in historical consciousness and the film industry will make use of this supposedly new configuration of religious subjectivity. But it might also be that film cannot quite cognize this because film itself has contributed to the mediatization of religion. Here I am thinking of the work of media theorists Stig Hjarvard and Angela Zito—neither of whom study film in particular, but who explore the work film (and other forms of media) do for people in shaping their spiritual lives (as affect, practice, and concept,

though those are my categories, not theirs). Religion/spirituality itself, they argue, has fallen under the logic of media, which is what is meant by mediatization. If religion is mediatized, then that seems at least worth noting when we discuss the relationship between "religion" and "film" or "spirituality" and "film." I think this takes us back to our first question, really, about new directions for the conversation. I, for one, am glad to be part of this one.

Afterword

Art does not think logically, or formulate a logic of behaviour; it expresses its own postulate of faith. If in science it is possible to substantiate the truth of one's case and prove it logically to one's opponents, in art it is impossible to convince anyone that you are right if the created images have left him cold, if they have failed to win him with a newly discovered truth about the world and about man, if in fact, face to face with the work, he was simply bored.[1]

—ANDREI TARKOVSKY

With many of the authors here, I share a deep connection to films as spiritual experiences. As my friend David Dark would say, everything is spiritual. Thus the highly affective qualities of film pave the way for intense experiences of God's grace in the world; these experiences create powerful spaces of self-examination and reconnection with others. Who would argue that films still bring much meaning into our lives? I have witnessed this in others and experienced it myself. I tend to gravitate to wry and mostly absurdist melodramas like Stanley Kubrick's *Dr. Strangelove* or Wes Anderson's *The Life Aquatic*. Lately, however, I have been re-introduced to the power and poignancy of film through Terrence Malick's recent streak of profound productivity.[2]

From time to time in the history of cinema, a film comes along that changes everything, that forces critics and theorists to reassess their own categories for evaluating the field. Malick's *The Tree of Life* is one such example of a film necessitating a revolution in theory. In this peculiar case, however, the revolution in theory is spiritual or theological. Let's be honest: you can't make sense of this film without the Christian story.

1. Tarkovsky, *Sculpting in Time*, 41.
2. Thornbury, "Tree of Life: An (Un)Review."

How does this still happen? There is probably not a satisfying answer to that question. We can, however, be glad that *The Tree of Life* did emerge in our current landscape. That landscape is dominated by Hollywood's penchant for super-hero franchises and disposable, obscene comedies. Malick's marvel, by contrast, features a distinct plethora of references: to Christian Scripture, the church, and a believer's experience. However, there seems to be much more going on here than first meets the eye. In its implicit religiosity, *The Tree of Life* holds up for us all a new model for how films might work; a model, that is, that philosophers of film long for.

Over the last several decades, critical theorists like Gilles Deleuze and Jacques Rancière have come to see in film the potential to meld thought and experience—sense and concept. Film, for such thinkers, is no longer a medium by which to relay messages; rather, it is instead a mode of ecstatic thinking itself. The hope for accomplishing this long remained with ideology. It is film, though, that has won over many a contemporary theorist for this exact reason. Take for instance, the Marxist, Lacanian critic Slavoj Žižek and his obsession with cinema. He has deemed film, "the ultimate pervert art."[3] While Žižek finds the Real breaking through in all sorts of films, his assessment of cinema rings true: movies never fulfill desires by providing their object. Rather, movies show you how to desire. In other words, films have the potential to fuse image, sound, and thought; the combined package brings a potent presence with a distinctive agency for explaining the world around us. Such imaginative potency cannot help but address the most deeply spiritual concerns of our lives. I see three particular benefits of a Christian encounter with film described in this book.

First, film grants us a new perspective on ourselves and our world. David Dark, in his chapter on the work of David Lynch, argues that films have the power to "increase the scope of what we feel, what we know, of what we might yet do in the way of regarding ourselves and one another compassionately and imaginatively." I believe that to be true, and I want to be counted among the faithful recipients of such tokens of grace. It is precisely in and through the kinds of experiences that film makes possible that we can continue to have both the world and our own selves shown to us.

3. Fiennes, *Pervert's Guide to Cinema.*

Secondly, films make available new modes of faithfulness. Film causes us to hover in a space of tentative certainty or uncertainty. In their roundtable conversation, Joe Kickasola highlights in *Andrei Rublev* the productive energies of doubt made available to us through patient struggle. He writes: "It is in the somber, liminal space between unbelief and certainty that Tarkovsky finds living faith and living cinema." This is not only something modeled for us through the film's depictions but also an activity to which we are called in struggling with such a patient and profound film from an equally severe filmmaker. To engage deeply with such films is to grow as a person in the world. These are therefore the productive modes of spiritual communion put on display and made available to us in film. Our typical forms of engagement with film have yet to take full advantage of such potential.

Thirdly, the experience of film can do many different things in us, but it fails if it cannot move us back into the world as different sorts of people. As Kathryn Reklis's engagement with the work of Wes Anderson reveals, film can actually serve to re-enchant our world in powerful, lasting ways. At the same time, though, Taylor Worley calls us to engage with film as a tool through which to stare down death. Such a movement is similarly committed to a re-invigoration of life itself. It is through the vast range of experiences it produces in us that film can re-frame our vision and re-enchant our world. It is in this very real sense that the theater—as temple—sends us back into the world as changed people, with new eyes to see.

In his foreword to this volume, Rob Johnston celebrates the ways in which the theology and film conversation has grown to be something of a movement. I share his joy in this respect; I know, however, that the dialogue must continue. Doing so requires a great deal more courage than has been shown up to this point. To return to the sentiments of that titan of the cinematic arts, Andrei Tarkovsky, I concur with the Russian luminary; art is a weak messiah. Even the most dynamic and innovative filmmakers cannot escape this truth. Tarkovsky understands something about humanity that is almost too deep for words: we must be wooed and seduced by the enchanting mysteries of God's work in the world. As the authors of this volume have clearly demonstrated, the current cinematic products of our age still hold the promise of such religious enchantment. We must therefore attend to the dramatic implications of such products. The wise among us must tend and keep those imaginative vineyards not

only for the sake of theology's dialogue with cinema but also for the sake of the human spirit today.

Gregory Alan Thornbury,
President of The King's College, New York City

Bibliography

Fiennes, Sophia. *The Pervert's Guide to Cinema: Presented by Slavoj Zizek*. Microcinema International, 2006.

Tarkovsky, Andrei. *Sculpting in Time*. Translated by Kitty Hunter-Blair. Austin: University of Texas Press, 1986.

Thornbury, Gregory Alan. "The Tree of Life: An (Un)Review." *The Gospel Coalition*, July, 2011. Online: http://www.thegospelcoalition.org/article/the-tree-of-life-an-unreview.

Name/Subject Index